ARTISTS AND THEIR MUSEUMS ON THE RIVIERA

by Barbara F. Freed
with Alan Halpern

HARRY N. ABRAMS, INC., PUBLISHERS

Editor: Adele Westbrook
Designer: Lorraine Ferguson

Library of Congress
Cataloging-in-Publication Data

Freed, Barbara F.
 Artists and their museums on the Riviera /
by Barbara F. Freed with Alan Halpern.
 p. cm.
 Includes bibliographical references and index.
 ISBN 0-8109-2761-6 (pbk.)
 1. Art museum—France—Riviera.
 2. Artists—France—Riviera. 3. Art,
 Modern—20th century—France—Riviera.
 4. Riviera (France)—In art. I. Halpern, Alan.
 II. Title.
 N6849.R5F74 1998
 708.49—dc21 97-26085

Harry N. Abrams, Inc.
100 Fifth Avenue
New York, N.Y. 10011
www.abramsbooks.com

front cover:
SIGNAC'S PAINTING, *SAINT-TROPEZ, THE WHARF,* AND
DESPIAU'S SCULPTURE, *ASSIA,* FRAME A VIEW OF
SAINT-TROPEZ'S PORT FROM A SECOND-FLOOR WINDOW
IN THE MUSÉE DE L'ANNONCIADE. PHOTO: MICHEL
DE LORENZO

back cover:
THE MUSÉE RENOIR IN CAGNES-SUR-MER HAS PRESERVED
THE LIGHT, PORTABLE CHAIR UPON WHICH THE AGED
AND INFIRM RENOIR WAS CARRIED FROM HIS BEDROOM
OR STUDIO OUT TO THE SURROUNDING GARDENS WHERE
HE WOULD PAINT. PHOTO: MICHEL DE LORENZO

Barbara F. Freed received a Ph.D. from the
University of Pennsylvania and is currently
Professor of French at Carnegie Mellon
University, where she was the founding Head
of the Department of Modern Languages.
As a student, she attended the Institute for
American Universities / Université d'Aix-Marseille,
subsequently living and teaching in various
parts of France. She lectures internationally and
has published numerous books and articles
on French language and culture, second-language
learning, and study abroad.

Alan Halpern was the award-winning editor
of *Philadelphia Magazine* for thirty years,
founding editor of *Boston Magazine* and
Manhattan inc, and a consultant to a dozen
other city and regional magazines. He was
on the editorial staff of *Now Magazine* in Paris
and attended the Sorbonne. He has edited
fourteen books on subjects ranging from OPEC
to Chinese photography to hunger in America
to CIA operations in Washington and Cuba.

Contents

Acknowledgments

It is a pleasure to express my appreciation to the many individuals and institutions who, in unique and invaluable ways, have supported my work in writing this volume. An initial debt of gratitude is due the Florence J. Gould Foundation for the generous grants that facilitated my research trips to France and who thereby furthered the goal of French-American cultural cooperation envisioned by Florence Gould herself.

Additional appreciation is expressed to the College of Humanities and Social Sciences at Carnegie Mellon University, the Center for Cultural Studies at the University of Pennsylvania, and La Fondation d'Art in La Napoule for the supplemental support they each offered.

It is with great professional respect that I recognize the role played by my colleague Alan Halpern. His careful guidance, insightful questions, and valuable suggestions, plus his friendship, contributed in innumerable ways as I was writing this book. I acknowledge with equal gratitude my debt to Michel de Lorenzo, whose generosity of spirit, poetic eye, and extraordinary technique produced the wonderful photographs in this volume. I am especially grateful to Adele Westbrook for her consistently sound advice and meticulous editing skills, and to Lorraine Ferguson for her creativity in the design of the volume.

The representatives of numerous French museums, cultural organizations, and local municipalities displayed a rare and warm spirit of cooperation. They generously shared their time, knowledge and expertise with me. I would like to convey the depth of my appreciation to each of them: Estelle Berruyer, Services Culturels, Ambassade de France in New York; Pierre Chaigneau, Curator, Le Musée d'Art Moderne et d'Art Contemporain (Nice); Françoise Chatel, Conseiller Régional, Direction Régionale des Affaires Culturelles (Provence, Alpes, Côte d'Azur); Anne Devroye-Stilz, Curator, Le Musée International d'Art Naïf Anatole Jakovsky (Nice); Sylvie Forestier, Former Chief Curator, Le Musée National Message Biblique Marc Chagall (Nice) and Le Musée National Picasso "Chapelle de la Guerre et la Paix" (Vallauris); Dominique Forest, Curator, Le Château-Musée de Vallauris: Musée Magnelli-Musée de la Céramique (Vallauris); Jean Forneris, Curator, Le Musée des Beaux-Arts (Jules Chéret) (Nice); Claude Fournet, Director, Les Musées de Nice; Maurice Fréchuret, Curator, Le Musée Picasso (Antibes); Xavier Girard, Curator, Le Musée Matisse (Nice); Gottfried Honegger and Philippe Gamba, L'Espace de l'Art Concret (Mouans-Sartoux); Jean Lacambre, Director of the National Museums in PACA; Christophe Lotigie, Director of Cultural Affairs and Anne-Marie Villeri, Adjunct Curator for Les Musées de Nice (Nice); Nelly Maillard, Archivist, Le Musée National Fernand Léger (Biot); Zia Mirabdolbaghi, Director of Cultural

Affairs for the town of Vence;
Jean-Paul Monery, Curator, Le Musée
de l'Annonciade (Saint-Tropez);
Jean-Louis Prat, Director, La
Fondation Maeght (Saint-Paul);
La Soeur Jacques-Marie and les
Soeurs Dominicaines, La Chapelle du
Rosaire (Vence); Jean Paul Roux, La
Chapelle Saint-Pierre (Villefranche-
sur-Mer); Marie-Françoise Santini,
Ville de Fréjus; Hugues de la Touche,
Curator, Les Musées de Menton;
Frédérique Verlinden, Curator, Les
Musées de Cagnes.

In addition, many individuals
provided assistance and guidance
in a variety of critical ways. They
include: Alan and Lyn Davis,
Françoise Deflandre, Marie-Paule
Deslandes, Catherine Fenestraz,
Patrick Finnegan, Claude Gottlieb,
Asli Gulcur, Brigitte Hedel-Samson,
Catherine Issert, Jacques Lepage,
Jaime Lipsky, Nancy Love, Nicole
Michel, Gerry Prince, Sylvie
Rockmore and André Verdet.

Finally, my deepest personal
thanks are due my family and close
friends for their enthusiastic interest,
continual encouragement, and
unfailing indulgence.

I dedicate this book to my
husband, Sheldon Tabb, who lovingly
shared every step of the way with
me in turning the dream of writing
this book into a reality.

—*Barbara F. Freed*

Preface

This book has been written to share the excitement that overwhelmed me on my first visit to the Riviera in 1960—when many of the great artists of the twentieth century were living and working in the area—emotions that continue to be rekindled with each subsequent visit.

At that time, I had settled with my family in what was then the small hill town of Vence. My father, Maurice Freed, was an artist who quickly established a rapport with the local artistic community. It was there that I began an adventure that, in many respects, was the inspiration for this book.

Marc Chagall was one of our neighbors in Vence. We occasionally saw him at the market or strolling along the village streets. Picasso was working in Cannes but was about to move to Mougins, having already made a major impact on the revival of ceramics in Vallauris. Matisse had died some six years earlier but his Chapelle du Rosaire, which I passed daily in Vence, was a moving reminder of his presence. Cocteau was still alive, often visiting nearby Cap-Ferrat, having completed his Chapelle Saint-Pierre in Villefranche and the Salle des Mariages in Menton. The Léger Museum had been completed in Biot, and Renoir's home and garden in Cagnes had just been converted to a museum. La Fondation Maeght—a major collection of twentieth-century art—wouldn't be inaugurated until 1964, but construction had already begun. And artists such as Georges Braque,

Marc Chagall, Alberto Giacometti, and Joan Miró—all of whom collaborated in the design, together with Aimé Maeght and architect Josep Lluis Sert—were coming and going from nearby Saint-Paul.

In the intervening years, I have been enchanted with the creations these artists left behind to grace this dazzling corner of the world. The need for an English-language reference that chronicles the interrelation of the lives of these artists and the museums and chapels they created served as an additional impetus for writing this book.

My goal is to share what I magically experience with each return visit, despite the development and the steady growth of tourism that have overtaken the Mediterranean coast. As you explore ancient castles filled with modern art, and intimate, hand-decorated chapels, I hope that you will be infused with the same joy I feel every time I experience the creative energy that lies in wait, beyond the myths and legends of the French Riviera.

—*Barbara F. Freed*

Introduction

La Côte d'Azur, the French Mediterranean coast of some eighty miles that stretches roughly from Menton to Saint-Tropez, is renowned as the playground of the rich and famous. Its landscape is dotted with luxurious villas, its waters crowded with yachts, its casinos lined with royal players. But hidden along its coasts and in its villages are lesser-known artistic treasures to delight the mind, the eye, and the soul, the lasting legacy of some of this century's greatest artists—Marc Chagall, Fernand Léger, Henri Matisse, Pablo Picasso, Auguste Renoir, and many of their artistic contemporaries, drawn to this tiny coast by its light and warmth, both physical and spiritual.

This region, referred to today as PACA, an acronym for Provence-Alpes-Côte d'Azur is one of intense natural beauty and dramatic contrasts. Each section has its own flavor and mood—each characterized by varying ranges of color and light, each offering differing combinations of land, sea, forest, and beach. Some areas are enhanced by groves of cypress and olive trees, others by flowering orchards of orange and almond trees or solitary umbrella pines; elsewhere there are fragrant fields of lavender, violets, jasmine, and mimosa.

Along the coast there is the fabled "French Riviera," with its glamorous towns and seaside resorts, sparkling blue waters and dazzling beaches. To the west the earth is redder, the topography flatter and more robust as it approaches the heart of Provence. To the east the Maritime Alps descend dramatically to the sea, and scattered medieval perched villages compete with the mountains to sculpt the skyline and create a horizon of myriad contrasts.

These inland towns and villages are sometimes referred to as the "other Riviera." Many are situated high on craggy hills, surrounded by protective ramparts. Each is distinctive, easily identifiable to the trained eye, which readily distinguishes the silhouette of Saint-Paul from that of Vence, Tourettes, or Haut-de-Cagnes.

This spectacularly beautiful area has attracted dozens of twentieth-century artists who have exalted in the light that Matisse described as "soft and tender, in spite of its brilliance," the diversity of its landscape, and the intensity of its colors. Indeed, the Côte d'Azur became for French art of the twentieth century what Provence had been in the last half of the nineteenth century. These artists came one at a time, some for occasional visits or seasonal sojourns, others for extended, often culminating, periods of their lives.

Paul Signac was the first to arrive in the region, settling in Saint-Tropez in 1892. The subsequent visits made by his friends and colleagues—Pierre Bonnard, Raoul Dufy, Henri Matisse, Francis Picabia, and Cornelius Van Dongen, among others—resulted in the transformation of the once-small fishing village into one of the most-frequented artistic centers on the Mediterranean

coast. Renoir made Cagnes-sur-Mer his home in 1903, while Dufy spent the first of several seasons, beginning in 1909, painting in the hilltop village of Vence. In 1917, Matisse settled in Nice where he lived more or less permanently (with the exception of the World War II years, which he spent in Vence) until his death in 1954. Beginning in the second decade of the century, artists such as Pierre Bonnard, Georges Braque, Amedeo Modigliani, Chaim Soutine, and Georges Rouault were to spend time in the neighboring towns and villages of Le Cannet, Cagnes-sur-Mer, Mougins, Vence, Saint-Paul-de-Vence, Juan-les-Pins, and Antibes.

In 1918, Picasso visited Saint-Raphaël, returning frequently to paint and vacation in a variety of towns along the coast. In 1946, he was to spend an important period in Antibes, moving shortly thereafter to Vallauris where he revolutionized the town's ancient tradition of ceramic production, then to Cannes, and finally to Mougins where he spent the last years of his life.

Cocteau arrived in the small village of Villefranche-sur-Mer in 1924, and, in the course of the next few years, discovered the fourteenth-century chapel that he would redecorate when he returned to the coast in the 1950s. Chagall came back to France in the late 1940s, after a wartime exile in the United States, making Vence and then Saint-Paul his permanent home. Toward the end of his life, Fernand Léger, too, was to spend important periods

in the glassblowers' village of Biot.

Settling in different coastal towns and inland villages, many of these artists became honored and beloved members of their communities. In return, they left indelible remembrances of their presence. These are to be found in the unparalleled concentration of gem-like museums, hand-decorated chapels, and rich private art collections that dot the coast and countryside. They are equally present in their work—in ceramics, marble, stained glass and mosaic, tapestry and bronze—that can be found in public buildings and village squares. Others may even be seen by those who are guests in the area's legendary inn and restaurant, La Colombe d'Or, which has its own extensive collection: a lovely Braque mosaic and a stately Calder stabile by the swimming pool, a colorful Léger mosaic in the garden, and countless paintings, drawings, and sculpture by almost every important artist of the region.

Some of the artistic expressions on the Riviera may be considered among the individual artists' masterpieces, others as autobiographical references to a time and place. Their importance derives, in part, from the rare opportunity to view these objects in the actual environment in which they were created, and to reflect upon the spontaneous interaction of individual genius and local inspiration. The great concentration of these artistic treasures in such a small area is also a tribute to the unique French system of government

support for the arts.

Complementing the individual works of art are the unique settings in which they are to be found. Many are enhanced by scented gardens that surround them and enriched by the panaromas that inspired these artists' work. Unequaled are the juxtapositions of modern art with centuries-old architecture—deconsecrated Romanesque chapels, former castles of reigning nobility, and residential palaces of the ancient aristocracy. Nowhere else in the world is it possible to find, with equal abundance, the seamless integration of culturally and historically important structures with the creative expressions of major modern and contemporary artists. This is as true for the museums devoted to the work of a single artist —Chagall, Cocteau, Léger, Matisse, Picasso, and Renoir—as it is for the larger museum collections that house the work of numerous artists: Le Musée de l'Annonciade, La Fondation Maeght, Le Musée International d'Art Naïf, Le Musée des Beaux-Arts, and Le Palais Carnolès.

Although each artist and his work is distinct, their lives and their art were not unknown to each other. They arrived in the "Midi," as the south of France is called, with well-established reputations, some at the height of their fame. Many had known each other years before in Paris, some working side by side as they broke away from established traditions in art. In one way or another, each had played an important role in the avant-garde in the early years of the century. While their work evolved in radically different directions in the ensuing years, many of these acquaintances were renewed as one artist after another came to spend substantial periods of time on La Côte d'Azur in towns and villages only miles apart.

Not surprisingly, the nature of the interactions among them varied widely. Some relationships, like Picasso's with Cocteau, were periodically strained. Picasso and Matisse, on the other hand, shared a strong admiration and enormous respect, if not an intimate friendship. And Matisse and Bonnard enjoyed a close and enduring relationship characterized by mutual support.

This closeness was particularly true during the agonies and privations of World War II, which affected many of those working far from the battlefields. Even La Côte d'Azur was not totally immune from the war, enduring numerous Allied attacks. In Nice, many of the city's strategic buildings were camouflaged, while others were requisitioned. Food and materials were in short supply, and fear, even among the apolitical artists, was ever present. The work of many of them was decried or destroyed in Nazi-occupied Paris where, in May of 1943, confiscated modern art was burned in the garden of the Jeu de Paume museum and, as one commentator wrote, cries of "into the ashcan with Matisse" and "to the booby hatch with Picasso" were to be heard.

During this period, many of

the artists who were in the south supported each other morally and materially. When Matisse learned of the shortages in art materials that confronted Bonnard and Rouault he came to their rescue by supplying hard-to-find canvas and poppy-seed oil. Even the egocentric Picasso assisted the aged Matisse by verifying the security of his paintings, which had been hidden from the Germans in the vaults of the Banque de France in Paris. While many artists and intellectuals fled Paris for the south during the war years, a few, including some of those most at risk, found a temporary haven in the United States.

By contrast to the artists who openly acknowledged the genius and accomplishments of their contemporaries, other relationships were more distant, tinged with grudging praise and reluctant recognition. Some even indulged in petty jealousies or out-and-out hostility, denying the originality of their rivals' creations, or the validity of their artistic motivations. Whatever their personal relationships, these artists were unable to avoid totally the influences of each other's work and inevitable, if subtle, competitions.

Nowhere is this more evident than in the "modern" chapels of the Riviera. These chapels, completed by one artist after another—Matisse, Picasso, Cocteau, and Tobiasse— were designed and/or decorated in their entirety by the artists' own hands. Others were refurbished or enhanced with individual pieces by their contemporaries, among them,

Jean Bazaine, Braque, Chagall, Léger, Diego Giacometti, and Raoul Ubac. These chapels maintain the tradition, begun in the aftermath of World War II, of integrating modern art into houses of worship. They range from Matisse's masterpiece in Vence, used regularly for prayer by the local community, to others, such as Picasso's Chapelle de la Guerre et la Paix in Vallauris, that preserve their spiritual origins, but which have been totally secularized.

If other artistic influences are less obvious, they are nonetheless present, particularly in the media these artists turned to during their Mediterranean years. Many were led to experiment with mosaics, others innovated with stained glass and— following Picasso's dramatic initiative in reviving interest in the art of ceramics—numerous artists were to add this age-old craft to their creative repertoire. More subtle, perhaps, are the influences that resulted from the unavoidable encounters they had with each other's work, revealed occasionally in the changing colors of their palettes or by a telling flirtation with a previously untried subject matter.

The creative flame that has burned on the Riviera throughout the past century is not limited to the work of those internationally acclaimed artists who arrived on its shores in the later years of their lives. Starting in the mid-1950s, a new generation of artists, many originally from Nice and its environs, were to bring new acclaim to the area.

Painters and sculptors such as Arman, Ben, César, Noël Dolla, Yves Klein, Bernard Pagès, Pierre Pinoncelli, Martial Raysse, Claude Viallat, and Jacques Villeglé, among others, were to establish the various artistic movements associated with the School of Nice. Their work, visible in a variety of local settings, is especially celebrated in the Espace de l'Art Concret in Mouans-Sartoux and the Riviera's newest museum, the strikingly contemporary Museum of Modern and Contemporary Art in Nice.

While the careers of these twentieth-century artists—and their museums—are summarized in the twenty-two chapters of this book, it is worth noting that art on the Riviera pre-dated the arrival of these great masters. For those interested in earlier periods of art, or in the most contemporary work, numerous other collections are on view on the Riviera from Menton to Saint-Tropez. These can be found in public galleries and small museums that display temporary exhibits of contemporary art, often in splendid settings, single-theme museums (such as those devoted to dolls, automobiles, oceanography, and perfume), museums of local life and traditions, historical and anthropological museums, and private collections frequently enhanced by spectacular gardens and vistas.

Suggestions for using this book:
The first twenty-one chapters of this book are organized geographically, beginning with Saint-Tropez to the west and concluding with Menton to the east at the French-Italian border. Chapter 22 provides brief descriptions of seven additional sites of special interest. The accompanying map indicates the location of each town and village, facilitating visits to modern and contemporary art museums in the area. In addition to the major focus of each chapter, when pertinent, related points of interest in the immediate area are listed at the chapter's conclusion.

Obviously, any book which serves as a guide to museum collections is hostage to ever-changing exhibitions, as curators rotate permanent acquisitions and as their museums' holdings are enhanced by additional contributions and purchases. This is particularly true of the small museums described in this book, many of which have works of art that far exceed available display space. Therefore, visitors should anticipate the possibility that particular works of art may not be located at the precise spot indicated in this book, or may no longer be on view at all.

It is also important to note that cultural convention for identifying floors or levels is different in English and French. The French refer to the American "first floor" as the "ground floor" (the *rez-de-chaussée*) and identify the floor above it as "the first floor," the equivalent of the American "second floor." References in this

book to the first, second, or third
floors of museums correspond to
traditional American identifications.
Finally, it is also important
to be aware of the fact that museum
hours may change from year to year
and that the "holidays" when
individual museums are closed are
not the same for all sites. As a general
rule, holidays in France include
December 25, January 1, May 1, and
the variably occurring holidays of
Easter, Pentecost, and Assumption.
However, many exceptions are made
to these rules. It is always advisable
to call the museums in advance to
verify their days and hours of
admission. To call from France use
the ten-digit French telephone
number listed under the address in
each chapter. To call from the United
States, precede the French telephone
number by 011–33 and delete
the initial zero of the French number.

Modern Art Sites and Museums Along the Riviera

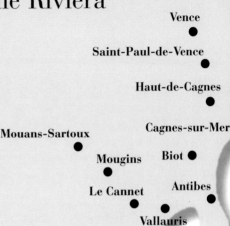

Vence

Saint-Paul-de-Vence

Haut-de-Cagnes

Cagnes-sur-Mer

Mouans-Sartoux

Mougins Biot

Le Cannet Antibes

Vallauris

La Napoule

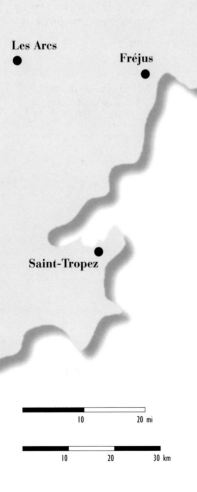

Les Arcs

Fréjus

Saint-Tropez

Antibes — Chapter 4
LE MUSÉE PICASSO
THE PICASSO MUSEUM

Biot — Chapter 8
LE MUSÉE NATIONAL FERNAND LÉGER
THE NATIONAL FERNAND LÉGER MUSEUM

Cagnes-sur-Mer — Chapter 9
LE MUSÉE RENOIR
THE RENOIR MUSEUM

Cap d'Ail — Chapter 22
LE THÉÂTRE DE LA JEUNESSE
THE YOUTH THEATER (COCTEAU)

Fréjus — Chapter 2
NOTRE-DAME DE JÉRUSALEM: LA CHAPELLE JEAN COCTEAU
OUR LADY OF JERUSALEM: THE JEAN COCTEAU CHAPEL

Haut-de-Cagnes — Chapter 10
LE CHÂTEAU-MUSÉE
THE CHÂTEAU MUSEUM

10 20 mi

10 20 30 km

Menton ●

Cap d'Ail
●

Villefranche-sur-Mer
ice ●

N

VILLAGES AND TOWNS AND THEIR MUSEUMS

LE MUSÉE DE L'ANNONCIADE
THE ANNONCIADE MUSEUM

Place Georges Grammont, 83990 Saint-Tropez
Tel: 04-94-97-04-01

Open Wednesday to Monday from 10:00 A.M. to Noon and
3:00 P.M. to 7:00 P.M. June through September;
from 10:00 A.M. to Noon and 2:00 P.M. to 6:00 P.M., October through May.
Closed Tuesday and holidays.

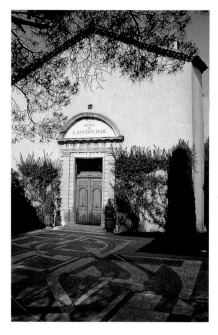

THE MUSÉE DE L'ANNONCIADE, ORIGINALLY A SIXTEENTH-
CENTURY CHAPEL, CELEBRATES THE WORK OF ARTISTS
WHO MADE SAINT-TROPEZ A CENTER OF AVANT-GARDE
PAINTING AT THE BEGINNING OF THE TWENTIETH CENTURY.
LE MUSÉE DE L'ANNONCIADE. PHOTO: MICHEL DE LORENZO

IN MID-MAY OF 1892 Paul Signac (1863–1935), then only 28 years old, sailed into the little port of Saint-Tropez on his prize-winning boat, *L'Olympia*. An accomplished sailor, a recognized artist, and a member of the artistic avant-garde, he was seeking an escape from the sadness that had surrounded him in Paris, where he had organized posthumous exhibitions for his close colleagues, Georges Seurat (1859–1891) and Vincent Van Gogh (1853–1890), both of whom had recently died. He was hoping to find refuge, too, from the artistic battles surrounding Post-Impressionism, the catch-all term used to describe the new directions in painting that followed the era of Impressionism. Signac had become a spokesman for the artists known as Divisionists or Pointillists, "bearing on his shoulders" as the Impressionist master, Camille Pissaro, said, "the weight of this new movement." It was from all this, according to his grand-daughter, Françoise Cachin, that Signac found a retreat in the tiny fishing village of Saint-Tropez. It responded perfectly to his needs and desires: ". . . . as long as I find a little nest for myself and a good

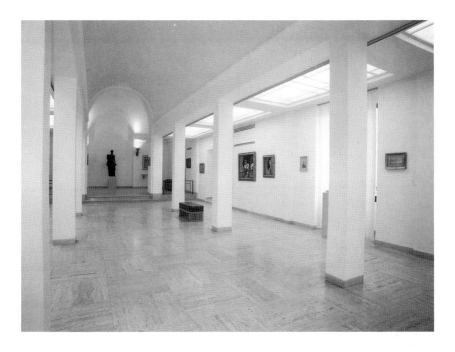

THIS CHAPEL-TURNED-MUSEUM COUNTS AMONG ITS TREASURES A SEURAT MASTERPIECE PAINTED IN 1890, SEVERAL PAINTINGS BY VAN DONGEN, AND SCULPTURES BY MAILLOL. LE MUSÉE DE L'ANNONCIADE. PHOTO: MICHEL DE LORENZO

mooring for the *Olympia*, all I ask for is the sky, the sea, the setting sun."

For Signac, as for countless other French artists, the move to the Riviera was an attempt to escape from the grayness of the north by taking up residence amid the radiant and colorful Mediterranean landscape with its extraordinary clarity of light.

A letter written to his mother shortly after his arrival expressed Signac's enchantment: "I've been comfortably settled since yesterday and am floating in joy. Five minutes from town, lost in pines and roses. . . . In front of me are the golden banks of the gulf, the blue waves coming to rest on a little beach, my beach, below. . . . In the background, the blue, (mountainous)

silhouettes of Les Maures and of the Estérel. I have enough here to work on for the rest of my life. It's absolute joy that I've just discovered."

This was the unofficial announcement of the twenty-year love affair between Signac and Saint-Tropez. He was one of the earliest of many artists—Pierre Bonnard, Charles Camoin, Raoul Dufy, André Dunoyer de Segonzac, Henri Manguin, Albert Marquet, Henri Matisse, Francis Picabia, and Kerr-Xavier Roussel, among others—to visit or settle in the environs of the village that would come to play such a major role in the history of modern European art. And no venue there is more important than the Musée de l'Annonciade, where so many of their works are displayed.

In many respects, today's museum is an outgrowth of Signac's desire to preserve evidence of the time spent in and around Saint-Tropez by some of the greatest painters of the twentieth century. In 1922, with the assurance of donations from Signac and his friends, two other local artists, Henri Reson and Arthur Turin, assembled a small collection of paintings which became the nucleus of today's museum. Known then, in Provençal, as the "Museon Tropelen,"

Situated on a peaceful side street close to the port, today's Musée de l'Annonciade, with its painted soft pink façade, multicolored mosaic courtyard and graceful limestone entrance, retains the exterior appearance of a sixteenth-century chapel. The only major change since its construction is the addition of windows to the second and third floors necessitated because Provençal churches of the period had very few windows. The chapel was originally

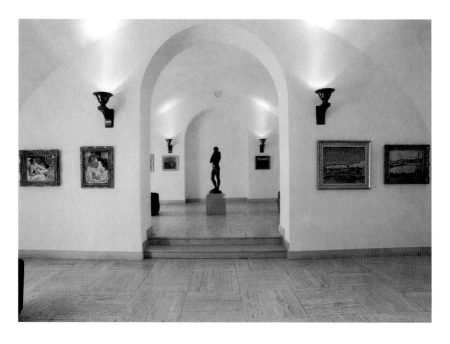

THE SECOND FLOOR FEATURES A COLLECTION OF FAUVIST MASTERPIECES, INCLUDING, TO THE LEFT, MATISSE'S *THE GYPSY* AND MANGUIN'S *THE GYPSY IN THE STUDIO*, BOTH PAINTED IN 1905–06. LE MUSÉE DE L'ANNONCIADE. PHOTO: MICHEL DE LORENZO

it was originally nothing more than a single-room gallery in the Saint-Tropez Town Hall. But the collection was not to remain there forever. Nearby, an ancient former chapel was to figure in the museum's future.

built for the *Confrérie des Pénitents Blancs* (Brotherhood of the White Penitents), whose mission it was to care for those injured in Mediterranean fishing accidents.

The fate of the chapel during the

anti-clerical French Revolution was similar to that of most other houses of worship in France. The building was taken over and put to other uses and the canvases from its religious paintings requisitioned as sails for boats. Later, its bell was removed and its marble altarpiece, silver ornaments, choir stall, and woodwork were dispersed to other areas of France. In the 1800s the interior was partitioned into several smaller rooms, which were used for making boats. At the beginning of the twentieth century, the chapel was requisitioned for a municipal orphanage.

It was not until 1937 that the industrialist and art patron, Georges Grammont, was able to gain the rights to the underused second floor of the building to create a proper home for some of the important canvases he had amassed—together with the collection that had been hanging in the Saint-Tropez Town Hall since 1922.

During World War II, the collection was sent elsewhere for protection as the former chapel endured the occupation of a succession of armies, first Italian and German, later American and French. After the war, Grammont obtained permission to renovate the chapel completely and convert it into an excellent museum. The work was carried out under the direction of architect Louis Süe, who succeeded in restoring some of the original character of the chapel with a central nave, side aisles, and choir. The resulting space is peacefully elegant and well-proportioned.

The museum, enriched with an additional endowment from Grammont—along with continuing contributions from the French government—preserves the works of those artists who made Saint-Tropez a center of creative expression. Its collection is unusually rich for such a small structure. It possesses several masterpieces representing two major movements in the history of art: Divisionism (better known today as a form of Pointillism) and Fauvism. Perhaps as important as the stellar quality of many of these paintings is the fact that they can be viewed in the very context and light in which they were painted.

The oldest of the treasures in the museum—*Étude pour le Chenal de Gravelines (Study for the Channel at Gravelines)*—is a Seurat masterpiece painted in 1890. It is a prime example of Pointillism, part of the Neo-Impressionist movement that developed in Paris in the 1880s as a reaction to Impressionism. Following Seurat's lead, a group of young painters (notably Signac as the influential leader and theoretician for this movement, along with Maximilien Luce, Henri-Edmond Cross, and Théo Van Rysselberghe) sought to revitalize Impressionism by analyzing the effects of refracted light based on contemporary optical research. Their goal was to transform the effects of light by applying to their canvases many little points or dots of chromatically contrasting colors, often small, parallel rectangular brushstrokes that had the effect of intensifying each other, and, when perceived by the viewer's eyes, of blending all the tones. This painting, done by Seurat in the last summer of his life, along with those of Signac and his contemporaries, captures the essence of the Pointillist movement.

Of the many Signacs in the collection, several reveal the evolution

of his style as he began to use larger brushstrokes and richer colors, explains Jean-Paul Monery, the curator of the Musée de l'Annonciade. *Coucher de soleil au bois de pins (Sunset in the Pine Forest*—1896) uses brilliant tones of orange, violet and red to capture the powerful sunset over the Gulf of Saint-Tropez. *Saint-Tropez, les pins parasols aux Canoubièrs (The Umbrella Pines at Canoubièrs)*, done only a year later, is a gentler portrayal of the sunset in shades of yellow and violet. Both of these paintings capture Saint-Tropez at sunset—the best time of day to discover it—portraying the groves of pines and umbrella pines, trees that are still abundantly present along the coast. Signac's love for the sea (in the course of his life, he owned twenty-eight boats) appears in *Saint-Tropez, le quai*—1899 and the later *Marseille, barques de pêche ou Le Fort Saint-Jean (Marseille, Fishing Boats or The Fort Saint John*—1907). In both, the wind in the sails is almost tangible, as is the glistening reflection of the sun on the water. It is easy to see why the brushstrokes in the later canvas have been likened to "little mosaic stones."

While Signac, during his early years in Saint-Tropez, had dismissed the power of watercolors, in later years he became enamored of this medium and several of his later watercolors are also included in the Museum collection.

His influence is obvious in the work of those contemporaries who spent time with him in Saint-Tropez. This is most apparent in the intensely bright, almost electric Pointillist works of Cross in *La Plage de Saint-Clair ou La Baie de Cavalière (The Beach at Saint-Clair or The Bay*

of Cavalière—1906–07), and Luce's *Côte de la citadelle à Saint-Tropez (Side of the Fort at Saint-Tropez*—1892).

It wasn't only students and converted members of the Pointillist movement who gathered in Signac's home and studio—Villa La Hune. At the turn of the century, Matisse, Bonnard, and Picabia—each of whose work ultimately evolved in different directions—visited Signac and painted in Saint-Tropez. In one way or another, each artist was influenced by his stay in the area. Picabia, for example, spent his honeymoon in Saint-Tropez producing numerous paintings of the little village and its surroundings. His *Saint-Tropez vu de la citadelle (Saint-Tropez, Seen from the Fort*—1909) portrays the characteristic shimmering light of the area.

Matisse, too, visited, spending the summer of 1904 at Signac's home. While there, he began studies for the historic *Luxe, Calme et Volupté (Luxury, Tranquillity and Exquisite Delight)*, a work whose title is based on a phrase from Baudelaire's famous poem, "L'invitation au voyage." The painting is considered a pivotal link between Pointillism and Fauvism. While it maintains some of Signac's signature, mosaic-like strokes, Matisse liberates them into a less systematic organization. The vigorous bursts of unexpected color—yellows, indigos, lavenders, vermilion, and crimson—anticipate the emerging Fauvist period.

The term "Fauve," French for "wild beast," was first used by the critic Louis Vauxcelles to describe the canvases of Matisse, Charles Camoin, Albert Marquet, and Georges Rouault in the Salon d'Automne exhibition in

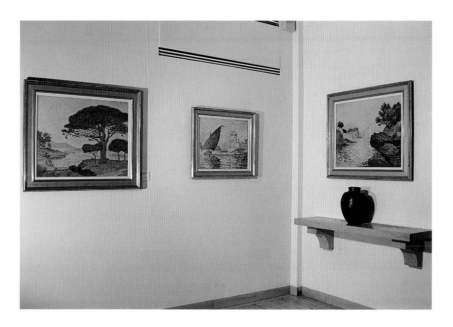

THESE THREE PAINTINGS, SIGNAC'S *SAINT-TROPEZ, THE UMBRELLA PINES AT CANOUBIÈRS,* AND *MARSEILLE, FISHING BOATS* TOGETHER WITH PERSON'S *THE INLET,* CAPTURE THE ESSENCE OF THE POINTILLIST MOVEMENT, WHICH IS A MAJOR FOCUS OF THIS MUSEUM'S COLLECTION. LE MUSÉE DE L'ANNONCIADE. PHOTO: MICHEL DE LORENZO

Paris in 1905. Struck by the assertive nature and violent colors of these works, hanging in the same room with a classic, Florentine-style nude torso, Vauxcelles exclaimed, ". . . Donatello among the wild beasts."

Among the paintings presented at this exhibit were those done by Matisse the previous summer in Saint-Tropez. The Annonciade owns a number of Fauve masterpieces painted between 1905–07. Jean-Paul Monery says with justifiable pride, "I would venture to say that the whole Fauvist movement can be studied right here in Saint-Tropez. We have everything from 1905–06: Camoin, Derain, Dufy, Matisse. Everything from the Salon d'Automne." And indeed, the presence of canvases such as Derain's

Effets de soleil sur l'eau, Londres (Effects of Sun on the Water, London—1906), Vlaminck's *Le Pont de Chatou (The Bridge at Chatou*— 1906) and *Nature Morte (Still Life*— 1907), Dufy's *Claudine vue de dos ou Nu au fauteuil vert (Claudine Seen from the Back or Nude in the Green Armchair*—1906) and even Braque's brief flirtation with Fauvism in his *Paysage de l'Estaque (Landscape at Estaque*—1906) permits an opportunity to view their varying interpretations of the short-lived Fauvist period.

Most famous among these is Matisse's *La Gitane (The Gypsy*— 1905–06), a major Fauvist masterpiece and one of the most famous paintings in the museum. Matisse's words, "I feel through color," perhaps

best capture the direction of much of his future work.

In 1909, a few years after Matisse's visit to Saint-Tropez, Bonnard visited Henri Manguin, who had come to live nearby. The experience—his first exposure to the intensity and power of Mediterranean light—revolutionized his work and encouraged a new brightness, which would last until the end of his life. He described it by saying, "Suddenly I was hit with an *A-Thousand-and-One-Nights'* experience: The sea, the yellow walls, the reflections as colorful as the light" Several of Bonnard's paintings in the Museum, some done years later, show the powerful effect of the time spent here: *Le Port de Saint-Tropez*—1914, *Nu devant la cheminée (Nude in front of the Fireplace*—1919), and the sumptuous color of *La Route Rose (The Pink Road*—1934). It is in thinking of these works, among others, that Jean-Paul Monery says, "one single word suffices to summarize this collection: 'Color'."

While the most important works in the Museum's collection date from the pre-World War I period, a portion of the collection includes significant post-World War I paintings by André Derain, Aristide Maillol, Georges Rouault, Edouard Vuillard, Maurice Utrillo, and Maurice de Vlaminck. Exceptional among these are three graceful Maillol sculptures: *La Baigneuse drapée (The Draped Bather*—1921), *Baigneuse se coiffant (The Bather Doing Her Hair*—1930), and *La Nymphe*—1930.

Saint-Tropez's days as a center of avant-garde artistic activity changed gradually. In 1913 Signac moved to Antibes and spent only intermittent periods at his home, the Villa La Hune. In the years after the war, a more literary group began to frequent Saint-Tropez, transforming it further from the small fishing port Signac discovered.

Today the "little village" overflows with jet-set celebrities, many from the world of cinema. But once inside the Musée de l'Annonciade, the visitor can still savor the charms of the old Saint-Tropez. Gazing out the window of the little museum, one is rewarded with a contemporary reflection of the village of old: glorious views of the port, glistening light, crests of the waves, the color and warmth of the surrounding landscape, all of which was captured in the paintings by Signac and his contemporaries who spent some of their most creative days here.

MAILLOL'S *THE DRAPED BATHER* SURROUNDED BY DERAIN'S *EFFECTS OF SUN ON THE WATER, LONDON* AND *BRIDGE ON THE THAMES*, TOGETHER WITH TWO OF DECOEUR'S VASES, ENHANCE THE REAR OF THE MUSEUM'S FIRST FLOOR. LE MUSÉE DE L'ANNONCIADE. PHOTO: MICHEL DE LORENZO

THIS POSTHUMOUSLY-COMPLETED CHAPEL, ONE OF SEVERAL DESIGNED BY JEAN COCTEAU, IS SECLUDED IN A COUNTRY-LIKE SETTING WHERE IT IS SURROUNDED BY CYPRESS, PINE, OAK, AND OLIVE TREES. NOTRE-DAME DE JÉRUSALEM. PHOTO: MICHEL DE LORENZO

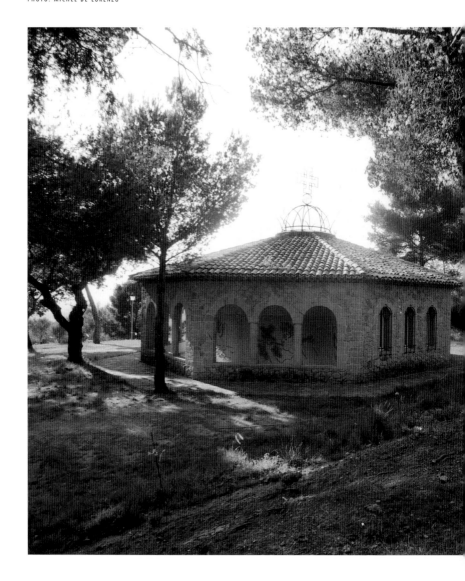

NOTRE-DAME DE JÉRUSALEM: LA CHAPELLE JEAN COCTEAU
OUR LADY OF JERUSALEM: THE JEAN COCTEAU CHAPEL

Avenue Nicolaï, La Tour de Mare, 83600 Fréjus
Tel: 04–94–53–27–06

Open Wednesday to Monday from 2:00 P.M. to 5:00 P.M. October through April;
from 2:30 P.M. to 6:30 P.M. May through September.
Closed Tuesday and holidays.

JEAN COCTEAU (1889–1963) didn't visit the Riviera in 1923 intending to paint truly striking religious art, or to sculpt, or work in ceramics, tapestries, and mosaics—although he ultimately produced all of these things and more. Despite the magnetic attraction of the sun, the light, and the landscape, as well as the community of artists and writers already working in the area, Cocteau—an acclaimed poet and dramatist—came to the Riviera mourning the death of his beloved companion, the youthful novelist Raymond Radiguet. Although this trip began in anguish and torment, it was ultimately to prove the catalyst for much of the artistic production that emerged toward the end of his life.

As Cocteau's life and career evolved, he returned frequently—and in a far happier frame of mind—to the south of France, "creating excuses for frequent pilgrimages," as he once wrote. In his later years, he developed a passion for decorating a variety of public spaces in this region that held special meaning for him.

Of all of Cocteau's creations on the Mediterranean coast, perhaps none captures his flamboyant

personality better than the chapel, Notre-Dame de Jérusalem in the town of Fréjus, about twenty miles east of Saint-Tropez. All of his work on the Riviera—the quietly religious frescoes of the waterfront fishermen's chapel, La Chapelle Saint-Pierre in Villefranche-sur-Mer (see Chapter 18), the tender murals in Menton's Marriage Hall (see Chapter 19), and the collection of mixed-media work in the Musée Cocteau in Menton (see Chapter 20)—reveals the diversity and range of his graphic and plastic talents, but none achieves the astounding impact produced by the riot of color that characterizes this final public project, completed posthumously.

Notre-Dame de Jérusalem is the last of a number of chapels Cocteau was to decorate and/or design. The first and most important among them is La Chapelle Saint-Pierre in Villefranche. Others include the tiny Chapel of Saint-Blaise-des-Simples where he is buried, near his country home in Milly-la-Forêt; and the Church of Notre-Dame de France in London. Of these, Notre-Dame de Jérusalem is the only one Cocteau was to design fully from its inception, and the only one he was unable to bring to completion.

The story of the chapel follows a fragmented history from the early 1960s, when Cocteau agreed to design it, until its completion in the early 1990s. The original plans for the chapel were an integral part of a larger project to develop a new *Cité des Artistes* (Artists' Residence) in an area of Fréjus to be known as La Tour de Mare—named for the belvedere from which one could see the Estérel coast and the sea. This building initiative followed the tragic breaking of Fréjus's dam in December, 1959, and the massive destruction that followed. While building plans for the chapel began in the early 1960s, catastrophe followed catastrophe. Cocteau was to die in October 1963, just months after the chapel's cornerstone was laid, and the project's major overseer, Jean Martinon, died in the early 1970s. Although the basic construction of Cocteau's chapel was complete by this time, it was to remain unfinished and essentially abandoned for eighteen years, until it was rescued by the town of Fréjus in late 1988.

At this point, the community turned to Edouard Dermit, Cocteau's companion during the final years of his life and his legal heir. Fortunately, Dermit knew the site and had spent considerable time with Cocteau at various spots on the Riviera, including this very location. Dermit, an artist in his own right, spent many years reviewing Cocteau's partially completed models and drawings for the chapel and then—extracting as much as possible from Cocteau's plans—ultimately painted most of it himself. The arduous process required him to project slides of Cocteau's drawings on the Chapel's walls and then trace over the projected drawings. Dermit identified the colors that Cocteau had intended for each figure by matching the colors to numerical instructions Cocteau had provided, then completed the murals with paint and pastels. Dermit was assisted by Roger Pelissier, a master ceramist and glassworker who had worked with Cocteau in the past. It was Pelissier who completed the ceramic tile decoration of the chapel's floor as well as its stained-glass windows.

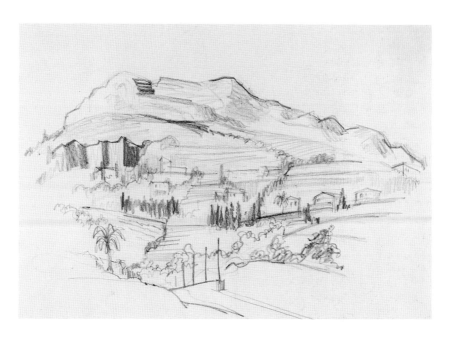

THE RIVIERA'S INLAND LANDSCAPE IS RICH IN VEGETATION, ORCHARDS, AND GROVES OF OLIVE AND CYPRESS TREES.
AS IT APPROACHES PROVENCE, NUMEROUS VINEYARDS ARE TO BE FOUND BENEATH ITS GENTLY SLOPING TERRAIN. PENCIL
SKETCH BY MAURICE FREED, 1960–61.

Approaching the chapel on the obligatory footpath, through a lightly wooded area of cypress, pine, oak, and olive trees, it is easy to understand why Cocteau was enchanted by the site. The bucolic, country-like setting—including the grazing donkeys responsible for keeping the surrounding vegetation in check—belies its close proximity to the sea. The first sight of the secluded chapel offers a rare sense of discovery.

The soft gray stone structure is built in the octagonal shape of a baptistery. Poised on top of its gently sloping roof of overlapping Provençal terra-cotta tiles is a crown, symbolizing the Kingdom of God and the Jerusalem Cross. This cross—its top, bottom, and cross arms each capped with a short bar—became Cocteau's icon for the chapel and is repeated on the walls, the altar, and the tiled floor.

Symbolically, the Jerusalem Cross represents the five wounds of Christ on the cross. It is the symbol of the Jerusalem Order of the Knights of the

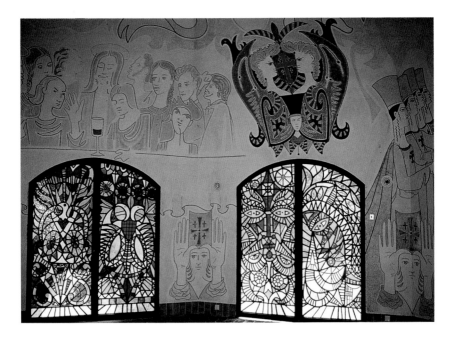

AFTERNOON SUN STREAMS THROUGH THE CHAPEL'S BRILLIANT STAINED-GLASS WINDOWS, ILLUMINATING THE INTERIOR, INCLUDING COCTEAU'S FRESCO OF *THE LAST SUPPER*. NOTRE-DAME DE JÉRUSALEM. PHOTO: MICHEL DE LORENZO

Holy Sepulcher, who guarded Christ's tomb and to whom Cocteau dedicated the chapel. The building's exterior is surrounded by an arched gallery that protects a series of six, immediately identifiable Cocteau mosaics. Each of the mosaics reveals the simple power of the line drawings for which Cocteau was so well known, many with his characteristic signature: his name or initials, followed by a star and the date.

Entering the chapel through the central, stained-glass doors, one is greeted by an unexpected blaze of powerful color from every direction. The varying shades of the cobalt-blue ceramic floor tiles are contrasted with the deep red inset of the omnipresent Jerusalem Cross. Under the cross, a white tiled banner unfurls with the words *"Dieu Le Veult"* ("God Wills It") the motto of the Jerusalem Order of the Knights of the Holy Sepulcher. The brilliantly colored stained-glass doors and flanking windows are balanced by a range of softly colored pastel frescoes that cover the walls

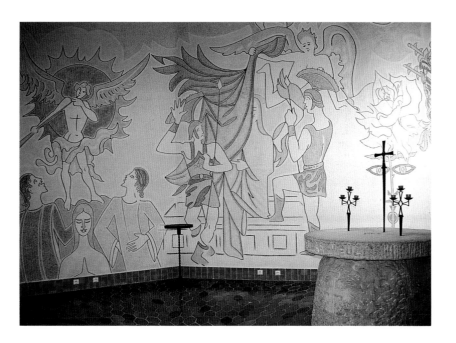

COCTEAU CHOSE A MILLSTONE FROM AN OLD OLIVE OIL MILL TO SERVE AS THE ALTAR ON WHICH HE POSED TWO CANDLESTICKS IN THE SHAPE OF THE JERUSALEM CROSS, THE SYMBOL OF THE JERUSALEM ORDER OF THE KNIGHTS OF THE HOLY SEPULCHER, TO WHOM THE CHAPEL IS DEDICATED. NOTRE-DAME DE JÉRUSALEM. PHOTO: MICHEL DE LORENZO

and ceiling. The afternoon sunlight, filtering through the glass doors and windows, further enriches the warmth of the entire space.

Cocteau's chosen theme for the chapel was the Passion of Christ. Here he has depicted various scenes—including the *Crucifixion*, which is painted in a dizzying feat of perspective, the *Resurrection*, the *Virgin of the Seven Sorrows*, and an unusual *Last Supper* in which Cocteau replaces three of the Biblical figures with a self-portrait and two

cherished personalities from his own life: his close friend of those years, Francine Weisweiller, and the actor, Jean Marais, who had played a special role in his personal and professional life during the previous decade.

Interspersed throughout the major scenes are various related episodes and symbols: Christ with the crown of thorns, armed Roman soldiers, an angel heralding the Resurrection, a series of faded roses which always symbolized life and

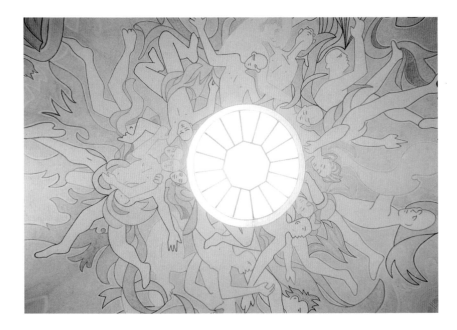

COCTEAU'S FLOATING FIGURES ON THE CHAPEL'S CEILING REPRESENT THE RESURRECTION OF THE DEAD. THEY SURROUND A CIRCULAR WINDOW COVERING THE OCULUS—THE OPENING IN THE DOME—ALTHOUGH COCTEAU ORIGINALLY INTENDED IT TO REMAIN OPEN TO THE SKY. NOTRE-DAME DE JÉRUSALEM. PHOTO: MICHEL DE LORENZO

youth for Cocteau, and a series of blue-winged angels, one of whom also has the face of the young Jean Marais.

Overhead in the cupola, a series of floating figures representing the resurrection of the dead, surround a circular window. It had been Cocteau's wish that the oculus in the center of the ceiling would remain open to the sky, permitting rainwater to sanctify the chapel. While a floor drain was originally installed directly below the opening to carry off the rainwater, it was later decided that protection of the frescoes and the security of the chapel dictated that only light be permitted to enter through the ceiling, and a transparent glass window was installed.

As in other public spaces that Cocteau designed, he assumed responsibility not only for the painted murals but for all the decorative elements as well. For the altar, he chose a millstone from an old olive oil mill—symbolic of the enormous stone that covered Christ's tomb.

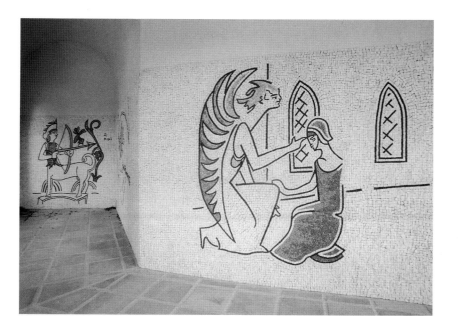

On this stone two candlesticks, again in the shape of the Jerusalem Cross, flank a third larger, hand-carved cross.

The posthumously decorated Chapelle de Notre-Dame de Jérusalem stands as the final example of Cocteau's publicly decorated spaces. After many years of neglect (due largely to lack of funds) it is now open to the public on a historically protected site that preserves the serene beauty that first captivated Cocteau. Once a year, it is returned to ecclesiastical use when the holiday of La Tour de Mare is celebrated on the weekend closest to the fifteenth of September.

LA CHAPELLE SAINTE ROSELINE
ET L'ABBAYE DE LA CELLE-ROUBAUD
THE SAINT ROSELINE CHAPEL
AND THE ABBEY OF LA CELLE-ROUBAUD

83460 Les Arcs-sur-Argens
No telephone.

Open Wednesday and Sunday from 2:30 P.M. to 5:00 P.M.
mid-September through June;
Also open Saturday July through mid-September.
Times subject to change.

ALMOST HIDDEN BY vineyards, two-and-a-half miles northeast of the medieval village of Les Arcs, is the Chapelle Sainte Roseline (the Saint Roseline Chapel). This small Provençal Romanesque chapel was part of an eleventh-century Carthusian monastery, l'Abbaye de La Celle-Roubaud, named after its founder, the monk Roubaud. The chapel and its twelfth-century cloister are all that remain of the original abbey, which achieved its greatest fame at the beginning of the fourteenth century, when its prioress was Roseline de Villeneuve (who was later to become Saint Roseline). In the years since her death in 1329, the monastery and the chapel named in her honor have had a succession of religious and private owners. At the end of the eighteenth century the chapel was separated from the monastery and purchased by the village of Les Arcs. Over the years, the traditionally decorated chapel fell into a state of disrepair.

Had it not been for the intervention of the great art patron, Marguerite Maeght, who, with her husband, Aimé Maeght, built the internationally acclaimed Fondation Maeght in Saint-Paul-de-Vence (see Chapter 11), this austere little chapel might not have become home to works of art by several modern masters. However, in 1968, Marguerite Maeght became the chapel's benefactress and oversaw its extensive renovation. She was responsible for the restoration of the chapel's major *rétables* (decorative frame-like structures which rest above or near an altar), including the highly-ornate baroque *Rétable de la déposition (Christ's Descent from the Cross)* over the main altar and a smaller, sixteenth-century *Rétable de la nativité (Retable of the Nativity)*. Mme Maeght also commissioned artists such as Marc Chagall, Diego Giacometti, Jean Bazaine, and Raoul Ubac to create new works of art that celebrate the life of the young woman for whom the chapel is named.

The story of Roseline de Villeneuve—canonized in the middle of the nineteenth century as Saint Roseline—is a simple and charming one. Daughter

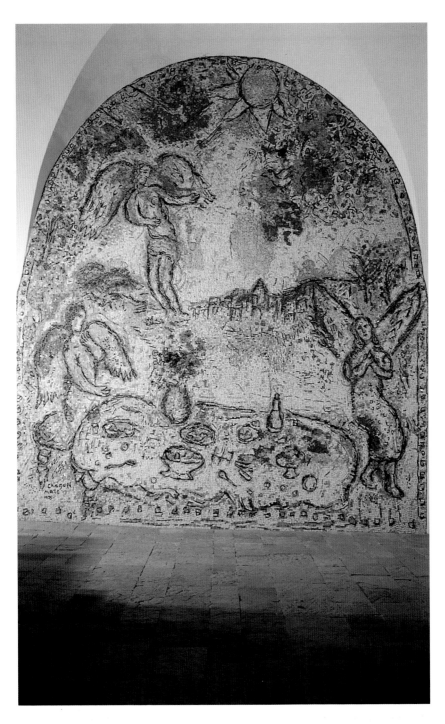

THIS LITTLE-KNOWN CHAGALL MOSAIC DEPICTS "THE ANGELS' MEAL," ONE OF THE MIRACLES ATTRIBUTED TO SAINT ROSELINE.
IT WAS DESIGNED IN 1975 SPECIFICALLY FOR THE CHAPEL AFTER ITS RENOVATION. LA CHAPELLE SAINTE ROSELINE.
PHOTO: MICHEL DE LORENZO

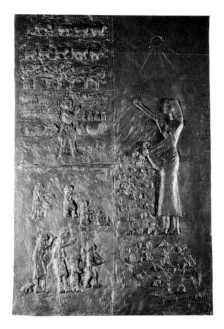

DIEGO GIACOMETTI DESIGNED THE BRONZE BAS-RELIEF THAT PORTRAYS THE "MIRACLE OF THE ROSES," ONE OF THE MANY MIRACLES IN THE LIFE OF SAINT ROSELINE. LA CHAPELLE SAINTE ROSELINE. PHOTO: MICHEL DE LORENZO

of Arnaud de Villeneuve, Lord of Les Arcs in the middle of the thirteenth century, and raised in the Château that still stands in this old village, Roseline was a generous and religious child. Even at the risk of incurring her father's displeasure, Roseline would secretly distribute bread to the poor who begged at the Château's gates.

Confronted one day by her father, who surprised her as she was sharing the bread she had concealed in her apron, she opened the apron at her father's bidding, and, in place of bread, a bouquet of roses appeared. The "Miracle of the Roses" was only the first of many wonders to bless the young Roseline's life. A few years later, when she had entered the novitiate, legend describes the "Angels' Meal," the luncheon prepared by a band of angels who came to her rescue when Roseline, deeply immersed in ecstatic prayer, failed to fulfill her responsibility of preparing the community's noonday meal.

Events such as these were the source of inspiration for the modern art that now complements the chapel's sixteenth- and seventeenth-century religious artworks. The story of Saint Roseline's life is represented in various media: Diego Giacometti, brother of sculptor Alberto Giacometti, designed the bronze bas relief that depicts several scenes from the life of Saint Roseline including the "Miracle of the Roses." He also fashioned the lectern— symbolically shaped as the Tree of Life, adorned with rosebuds—and the reliquary's bronze doors whose handles are shaped as roses.

In a totally different texture is the thirteen-foot-high mosaic that Marc Chagall completed in 1975. Chagall's penchant for angels and his frequent representations of myth and fantasy lend themselves perfectly to the story of the angels who prepared the community's meal for the praying Roseline. His portrayal of *Le Repas des anges (The Angels' Meal)* appears as if it were painted in stone. Against a neutral mosaic background, three of Chagall's celestial figures appear, including one who displays the artist's own profile. The mosaic is highlighted by the radiance of his color in the daisy-like sun, flowers, and birds—all of which float above the outline of the little village in the background.

Two artists were commissioned to execute the modern stained-glass windows. In 1970 Jean Bazaine

completed the large multicolored window to the right of the altarpiece. Designed in shades of red, pink, purple, and yellow, it represents a collection of rose petals. Raoul Ubac, whose work is also in the Saint-Bernard Chapel adjoining the Fondation Maeght, designed the four, small, blue-toned windows on the opposite side of the Chapel.

This relatively unknown and secluded little chapel, approximately sixteen miles inland between Saint-Tropez and Fréjus, stands as a symbol of the many hidden—and often ancient—villages, public squares, and houses of worship along the Riviera that have been enriched by the hands of twentieth-century artists who lived and worked in the area.

The chapel, with its celebration of an obscure French saint, is now totally independent from the original monastery (which has become part of a wine-producing estate), and has been formally designated an historic monument.

THIS SMALL PROVENÇAL ROMANESQUE CHAPEL IS DEDICATED TO ROSELINE DE VILLENEUVE, WHO WAS CANONIZED IN THE MIDDLE OF THE NINETEENTH CENTURY AS SAINT ROSELINE. LA CHAPELLE SAINTE ROSELINE. PHOTO: MICHEL DE LORENZO

LE MUSÉE PICASSO
THE PICASSO MUSEUM

Château Grimaldi, 06600 Antibes
Tel: 04-92-90-54-20

Open Tuesday to Sunday from 10:00 A.M. to 5:50 P.M.
June through September;
from 10:00 A.M. to 11:50 A.M. and 2:00 P.M. to 5:50 P.M. October through May.
Closed Monday and holidays.

THE CHÂTEAU GRIMALDI—now home to the Picasso Museum— is an imposing yet warm and inviting structure. It is easy to see why Pablo Picasso (1881–1973) was so enchanted by the magic of the building and its surroundings; it stands high above the ramparts of the old city of Antibes, buffeted by the winds and commanding breathtaking views from its windows and terraces looking out over the Bay of Antibes.

The Château's major rooms, when not totally illuminated by the dazzling Mediterranean sun, are lit with crystal chandeliers. The floors at the entrance and the stairs are composed of a wonderful series of irregularly shaped and well-patinaed tiles, ranging in color from warm terra-cotta to soft ochre blending into rose. Restored plaster angels holding the coat of arms of its former own-ers—the Grimaldi family—adorn the vaulted ceiling in parts of the Château, while elsewhere the ceilings are decorated with beams bearing the same family emblems. It was this setting that captivated Picasso in the early 1920s, when he discovered what remained of the Grimaldi family palace by following a group of young children who were crawling into a

hole in this half-crumbled Château by the sea.

This still glorious building, now restored and classified as an Historic Monument of France, was originally built in the twelfth century atop the ruins of the acropolis of the Greek village of Antipolis (the ancient name for Antibes) and a subsequent Roman camp. Over the centuries, the site underwent numerous transformations —from the sixth to the tenth cen-turies it was the target of barbarian invasions and pillaging; during the Middle Ages it housed the region's Bishop's palace; then, from 1385 to 1608 it was home to the Grimaldi family. It was abandoned as a resi-dence during the French Revolution and subsequently used as a hospital and then as an army barracks, gradually falling into disuse. In 1928 the Château was acquired by the city of Antibes and transformed once again—this time into a museum, the Musée Grimaldi-Antibes Museum of Art, History, and Archaeology. Almost twenty years later, through a serendipitous quirk of fate, Picasso— who had once thought of buying the castle for a mere 20,000 francs— was to have an unexpected encounter with the Château that would

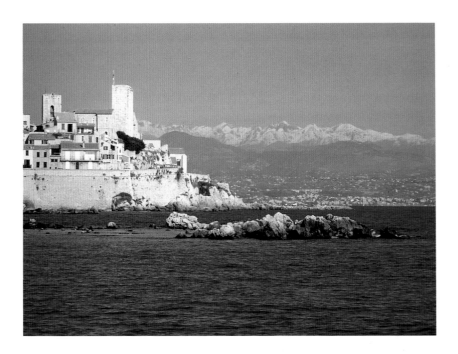

IN THE LATE SUMMER OF 1946, THE FIRST SUMMER OF PEACE AFTER WORLD WAR II, PICASSO WORKED ON THE THIRD FLOOR OF THE CHÂTEAU GRIMALDI, WHICH COMMANDS BREATHTAKING VIEWS OVER THE BAY OF ANTIBES. THE CHÂTEAU WAS BUILT IN THE TWELFTH CENTURY ATOP THE RUINS OF THE ACROPOLIS OF THE GREEK VILLAGE OF ANTIPOLIS, THE ANCIENT NAME FOR ANTIBES. LE MUSÉE PICASSO. PHOTO: MICHEL DE LORENZO

eventually bear his name.

In July of 1946, the sixty-five-year-old Picasso was living in tight quarters in Golfe-Juan with his newest love, the twenty-three-year-old artist, Françoise Gilot, who was to bear him two children—Claude and Paloma. While there, he met Jules-César Romuald Dor de la Souchère, the first curator of the Archaeology Museum. In the course of this (perhaps not entirely unplanned) meeting on the beach in Golfe-Juan, Dor de la Souchère offered Picasso extensive studio space in the unoccupied third floor of the Château. The painter reportedly "jumped at the chance to come and work in the castle."

Picasso was already an interna-tionally celebrated artist. He had first come to France from his native Spain in 1901, at the age of nineteen, estab-lishing himself there permanently in 1904. Over the next half-century, he was to break new ground in every medium he explored. During his early years in Paris, he moved quick-ly through the pathos of his "Blue" Period, the gentleness of his "Circus" Period and the classically-oriented "Rose" Period. And then, in 1907, having already acquired a major reputation, he produced a revolution-ary painting—*Les Demoiselles d'Avignon*—that heralded the arrival of a radical new art movement, Cubism.

During the next five years, he and his colleague, Georges Braque

SEVERAL SCULPTURES BY GERMAINE RICHIER STAND IN THE
MUSEUM'S GARDEN AMID SOME OF THE MUSEUM'S ORIGINAL
ARCHAEOLOGICAL COLLECTION. LE MUSÉE PICASSO. PHOTO:
MICHEL DE LORENZO

(1882–1963), would work together so
closely that their canvases are some-
times almost indistinguishable. Their
goal was to portray, through a
geometric repatterning of the planes
of an object, a fourth dimension—
an effort to represent, simultaneously,
more sides of an object than the eye
could see.

In sculpture as well as in
painting, Picasso was also breaking
with centuries of tradition. His 1912
Guitar, represents the first piece
of constructed sculpture in art
history—a piece that integrated air
and space into the design.

Cubism was to take many forms
in the hands of those painters who
followed Braque and Picasso. By the
same token, Picasso was to reinte-
grate Cubist tendencies into much of
his future work, but, more important-
ly, he was to move at a staggering
speed from one style to another,
sometimes catapulting himself

forward into uncharted territory, sometimes resurrecting a style he seemingly had abandoned in the distant past. There was no clean and absolute break from one period to the next, and his work vacillated between the tender and charming to the violent, grotesque, and horrifying. In the next thirty years he would continue to paint, sometimes with a Cubist orientation, but, just as often, in a delicate, classical style.

Between his arrival in Paris and the end of World War II, Picasso's virtuoso creativity was nothing short of protean. He produced thousands of paintings, drawings, collages, illustrations, theater and ballet sets—as prodigious and multifaceted a body of work as the world has ever seen.

ADDITIONAL BRONZE SCULPTURES BY GERMAINE RICHIER STAND STRONGLY SILHOUETTED AGAINST THE GARDEN WALL FACING THE SEA. LE MUSÉE PICASSO. PHOTO: MICHEL DE LORENZO

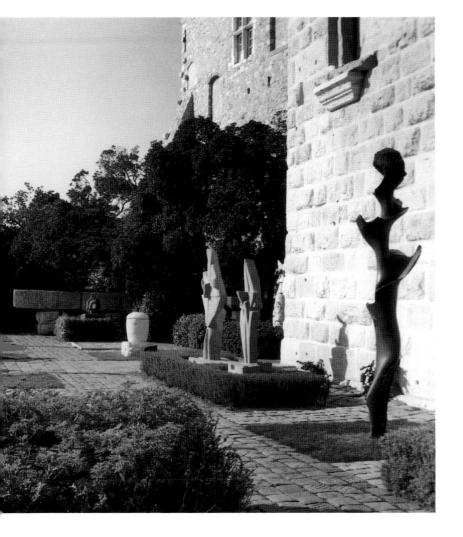

Despite the worldwide fame he enjoyed by 1946, Picasso was ecstatic at the offer of vast studio space on the upper floor in Antibes's Château Grimaldi. In short order, he happily set to work in this bright and expansive studio overlooking the Mediterranean. As Maurice Frécheuret, the current curator of the Musée Picasso describes it, "This grand and unoccupied space satisfied Picasso's fervent desire of the moment to paint in a new, larger format."

Not only was Picasso able to expand his artistic expression into this newfound space, but he, like the rest of France, was happily adjusting to the new postwar era in the first summer of peace after the war. Picasso, along with his friend, Matisse, was one of the few major French artists who had not left France during the war, spending much of the time in German-occupied Paris. He bristled under the occupation and suffered deprivation rather than accept special favors from the Germans. As Picasso scholar William Rubin describes it, Picasso reportedly said, in response to German offers of coal, "A Spaniard is never cold." He goaded German officers who came to see his work by passing out photographs of *Guernica* (the 1937 landmark painting that expressed his outrage at the brutal bombing of the little village of Guernica in Spain by the Germans who supported General Franco during the Spanish Civil War), responding to one who asked, "Did you do this?" by saying "No, you did!"

Now that the war was over, he left the bleakness of Paris and the intrusions of the Germans to spend an extended period on the Riviera, a region similar in climate to his native Catalonia.

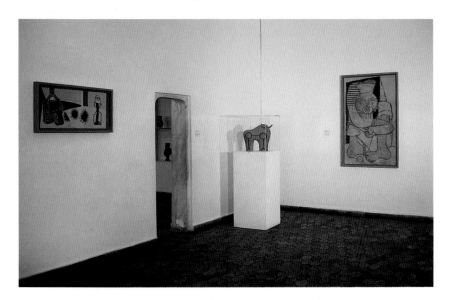

DURING THE MONTHS THAT PICASSO WORKED IN THE CHÂTEAU, HE POPULATED HIS PAINTINGS WITH REAL AND MYTHOLOGICAL MEDITERRANEAN MARINE CREATURES. *MAN GULPING SEA URCHINS,* DISPLAYED TO THE RIGHT, AND *STILL LIFE AND BASKET WITH THREE SEA URCHINS* TO THE LEFT, ARE EXAMPLES OF THE PAINTINGS THAT EMBODY HIS HUMOR AND WIT. LE MUSÉE PICASSO. PHOTO: MICHEL DE LORENZO

PICASSO'S CERAMICS WERE OFTEN "SCULPTED," SUCH AS THESE BOTTLES, METAMORPHOSED INTO FEMALE FIGURES KNOWN AS *TANAGRA*. LE MUSÉE PICASSO. PHOTO: MICHEL DE LORENZO

The aging Picasso was very happy in the company of the youthful Françoise Gilot, and his paintings reveal this. For several months, starting in the late summer of 1946, Picasso, with Gilot working at his side, painted at his usual feverish pace, completing forty-four preliminary studies in this short period, and then the twenty-five paintings known as *The Antipolis Suite*.

Perhaps the most famous—surely the most exuberant—of the paintings in the museum is *Antipolis ou la joie de vivre (Joy of Life)*. Nothing could better capture the unalloyed happiness, almost rapture, of the painting: a dancing young "flower woman" in the center of the canvas (Françoise Gilot) surrounded by frolicking goats and flute-playing fauns—set against the brilliant blue sea and sky. Not only is the painting symbolic of the new post-war period of peace, of the artist's delight in this sun-drenched

part of France at the side of his newfound love, but it also explores Picasso's continuing interest in the mythology of ancient Greece, a tendency that was reinforced by the archaeological exhibits in the ancient castle. He was to say to Dor de la Souchère, ". . . At Antibes, antiquity seizes hold of me every time."

Accompanying this painting are twenty-four others, including several still lifes and the triptych: *Satyr, faun et centaur (Satyr, Faun and Centaur with Trident)*. This enormous work presents simple outlines of three prancing figures drawn in oil and charcoal: a happy-faced flute-playing satyr, a capering faun, and a smiling centaur, trident in hand.

These paintings, along with their preparatory drawings (all sketched on a variety of paper, ranging from crumpled brown wrapping paper to fine Velin d'Arches sheets) are on exhibit at the museum.

An additional work, *Ulysse et les Sirènes (Ulysses and the Sirens)*, completed a year later when Picasso was again in Antibes, extends the dual themes of everyday life at sea and mythological reflections of the legendary Sirens' songs. And, interestingly enough, the painting is hung in such a way that one only has to glance out the window overlooking the ramparts below to appreciate the strong influence of this site on the artist.

instinct, irreverent as usual, was to work directly on the walls. While evidence of this composition, *Les Clefs d'Antibes (The Keys to Antibes)*, executed in graphite directly on the wall—remains on the third floor in the Dor de la Souchère Room, Picasso quickly realized that the humidity in the walls would eventually wreak havoc on any more murals he might attempt.

Faced with this dilemma, but still wishing to create oversized paint-

IN ADDITION TO WORK BY PICASSO, THE MUSEUM BOASTS A PRESTIGIOUS COLLECTION OF WORKS BY OTHER IMPORTANT LOCAL ARTISTS SUCH AS ARMAN, WHOSE ASSEMBLAGE OF BRONZE GUITARS STANDS IN THE MUSEUM'S REAR COURTYARD. LE MUSÉE PICASSO. PHOTO: MICHEL DE LORENZO

Picasso's creativity was not limited to the inspirations of his mind and brush—it extended to a continuous search for new media in which to work. When he first arrived at the Château, reveling in the newly available enormous spaces, his immediate

ings—as Françoise Gilot describes in her book, *Life with Picasso*—the artist turned to durable building materials that were typical of the region and in plentiful supply in France in the postwar period. In lieu of traditional canvas, he used large

plywood sheets or asbestos-cement boards (a material used to construct prefabricated houses). For paint he used pre-mixed marine boat coatings that came in a series of basic colors (blue, yellow, reddish brown, mauve, gray, and olive green—the colors of most of his paintings in the Château) applied with broad, house-painters' brushes. Most of the major works in the *Antipolis Suite* were created with these unconventional materials.

delicacy, became the focus of numerous delightful and amusing paintings and drawings: *Le Gobeur d'oursins (Man Gulping Sea Urchins), La Femme aux oursins (Woman with Sea Urchins), Nature morte au panier, aux trois oursins à la lampe (Still Life with Basket)*, and *Nature morte aux volets noirs citron, murène, rougets, seiche et oursins (Still Life with Black Shutters)*.

While the majority of paintings in the *Antipolis Suite* were crafted

MIRÓ'S *SEA GODDESS* IS AMONG THE MANY SCULPTURES IN THE MUSEUM'S SCENTED GARDEN. IT WAS ONCE SUBMERGED IN A GROTTO CLOSE TO ANTIBES. LE MUSÉE PICASSO. PHOTO: MICHEL DE LORENZO

Picasso's humor and wit are imbued in the works that cover the walls on the second floor of the Château. Many are populated with real and mythological Mediterranean marine creatures, reflecting his daily life then. The spiny sea urchin, a local

with boat paint and house-building materials, there were some exceptions. Picasso's studio was located close to the castle's storerooms and, when in search of materials, Picasso was not above appropriating an already-completed nineteenth-century

canvas or two for his own use.
Recent x-ray analysis has revealed
that *Le Gobeur d'oursins* was actually
painted over a portrait of a forgotten
nineteenth-century general in full
dress uniform, while the *Nature
morte aux volets noirs, citron,
murène, rougets, seiche et oursins
(Still Life with Black Shutters)* was
painted over a canvas of a nine-
teenth-century young woman wearing
a wide-brimmed hat. The characteris-
tic explanation offered by this
mischievous genius in his mid-sixties
was "[Art] must make way for the
young."

Picasso's initial donation of works to
the museum, paintings completed
while he was in residence there, has
since been expanded—thanks to
subsequent additional donations and
purchases. Two large sculptures—
*Tête de femme aux grands yeux
(Woman's Head with Big Eyes)* and
*Tête de femme aux chignons
(Woman's Head with Chignon)*,
Picasso's only major sculptures in the
museum—date from the early 1930s,
when Picasso was living with Marie-
Thérèse Walter in Boisgeloup, outside
of Paris. These massive and some-
what austere pieces, crafted in cement
after the original bronzes, are
complemented by a sequence of witty
engravings from Picasso's series—
*L'atelier du sculpteur (The Artist's
Studio)*, part of the *Vollard Suite* of
the 1930s, which depicts various
scenes of the sculptor with his model
at work or at rest, in the watchful
presence of the sculpted work in
progress.
A visit to the museum offers
additional surprises: the exuberantly
whimsical and original works in
ceramic that Picasso was to produce

in Vallauris. These colorful creations
are displayed in various rooms on the
museum's first and second floors.

In July of 1946, not only did Picasso
receive the keys to the Château
Grimaldi in Antibes, but he also
visited the nearby village of Vallauris
—an age-old ceramics center in
Southern France which had fallen on
hard times—to see the annual pottery
exhibit. While there, he tried his
own hand at ceramics (see Chapters
5 and 6).
This first experiment was to
prove fateful. Picasso became so
enchanted with what he was able to
create in clay that, starting the next
year, he began to work seriously in
pottery, producing some 4,000 pieces
during the span of his life. The
output—plates, pitchers, vases, birds,
and animals (many glazed in
Picasso's familiar colors) bear the
unmistakable creative signature of
their maker. The ceramics on display
in the museum are examples of his
early years in Vallauris, dating from
1947 to 1949.
In ceramics, as in everything else,
Picasso was to break new artistic
ground. These pieces of pottery, many
of which are sculptural in form,
reveal his playfulness and daring, his
ability to elevate a traditional craft
to new aesthetic heights. Putting his
own hand to the wheel, Picasso
learned that he could twist the neck
of a vase and "sculpt" a figure in
clay; he could transform an everyday
handle into an arm, a wing, or a
beak, or assemble two individually
turned forms to create a new figure.
Pieces such as *Vase en forme de
grande chouette (Vase in Shape of
Large Owl)*, *Taureau debout
(Standing Bull)*, *Chouette Ovoïde*

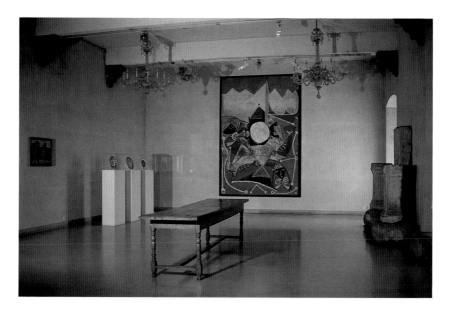

THIS VIEW OF THE SECOND FLOOR OF THE MUSEUM, WITH PICASSO'S PAINTING *ULYSSES AND THE SIRENS*, CAPTURES THE EXPANSE OF THE ROOMS THAT SO PLEASED PICASSO—AS WELL AS SOME OF THE ARCHAEOLOGICAL REMAINS THAT EQUALLY DELIGHTED HIM. LE MUSÉE PICASSO. PHOTO: MICHEL DE LORENZO

(Ovoid Owl), and a series of bottles-metamorphosed-into-female-figures known as *Tanagra*, typify this creative breakthrough.

After modeling the figures to his liking, Picasso further enriched them with decorative elements—incising or painting smiling faces, braided hair, or female breasts with variously colored pottery glazes and slips, or attaching ropy strands of hair and arms with additional clay. Several of the larger sculpted ceramics are displayed in individual cases on the second floor.

The delightful series of plates and platters, in contrasting colors and shapes, are no less innovative. In a seemingly endless series, Picasso decorated them with sketches of musical fauns, smiling faces, whimsical fish, prancing picadors, still lifes of fruits and vegetables—many

executed in his signature "childlike" style (which Picasso claimed took him years to acquire). His techniques vary, according to his caprice of the moment—some of the plates are two-sided, others have decorative rims; some are painted with enamel on iron or copper oxide under the glaze, others boast incised decorations covered with brown or green slip.

Picasso painted in his Grimaldi studio as long as he could, but the chill of winter finally forced him and Gilot to leave. Rather than crate his oversized paintings, Picasso left them behind, leaning almost casually turned toward the wall of his third-floor studio. Later he donated most of them to the Château. From this magnanimous gift emerged the Musée Picasso. When it was inaugurated in 1949, it was the first museum in

France dedicated to the work of a living artist.

Reflecting on the museum's origins, Picasso (always a contrarian), later commented to curator Dor de la Souchère, "When we started, the aims were not clear. . . . If you had said to me, 'We're making a museum,' I wouldn't have come. But what you said to me was, 'Here's a studio'. . . . That's why it's been a success, because you didn't model it on a museum."

While the genesis and indisputable major attraction of the museum is the mixed-media work of Picasso, "the story doesn't end there," as curator Maurice Frécheuret proudly proclaims. Beginning shortly after the Musée Picasso was inaugurated, its limited succession of devoted curators has passionately pursued a policy of encouraging local artists. The museum has continuously acquired works by painters and sculptors who have lived and worked in or near Antibes.

By a now-established tradition, many of the artists who contribute to the museum's annual summer exhibit donate a piece of their work to this prestigious collection. The courtyard and terrace looking out over the sea are filled with marvelous examples of highly contrasting sculptures. Internationally known local artists such as Arman and César are both represented: Arman by his mounting assemblage of bronze guitars *(A "ma jolie")*, César by an assembled sculpture known as *Le Centaure*. Seven important sculptures in bronze and/or stone by Germaine Richier stand in the terrace or on the wall against the sea, strongly silhouetted against the horizon.

Nearby is Joan Miró's delightful *La Déesse de la mer (The Sea Goddess)*, a three-piece sculpture consisting of a cement base on which a decorated ceramic body and head rest. In 1968, amid great festivity overseen by Miró himself, his mythologically inspired sea goddess was submerged in a subterranean vaulted grotto near Antibes, where it remained for almost fifteen years, protecting the "peace of the waters," just as Miró had wished. But Miró recognized the eventual corroding effect of the saltwater on his creature, and he made a gift of her to the museum. She now stands on the terrace overlooking the sea.

The long list of internationally known artists whose work is displayed either on the terrace or in the ever-changing permanent collection space includes Francis Picabia, Fernand Léger, Alberto Magnelli, Valerio Adami, Pierre Alechinsky, Jean Atlan, Alexander Calder, Corneille (Cornelis van Beverloo), Olivier Debré, Yves Klein, Jean Fautrier, Jean Messagier, Amedeo Modigliani, Edouard Pignon, Prassinos, Jacques Prévert, Martial Raysse, Jean-Michel Folon, Claude Viallat, Bernard Pagès, Anne and Patrick Poirier, Jean Amado, and Daniel Spoerri. Recently an important contribution of work by Anna-Eva Bergman and Hans Hartung has further enriched the museum.

The third floor of the Château—the space where Picasso worked—is dominated by the work of Nicolas de Staël, who painted in a studio and its terrace just adjacent to the museum. His final work, completed the fateful last week of his life before he committed suicide by jumping from his terrace, is the monumental

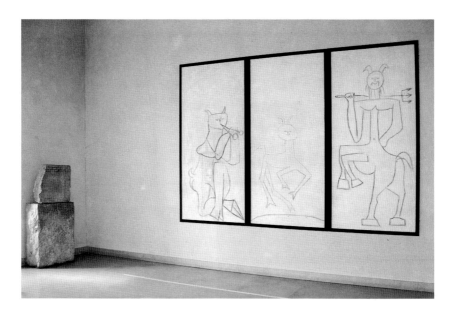

Le Grand Concert (The Grand Concert). The boldly colored canvas with its black grand piano on the left, the standing, ochre-colored cello on the right, united as it were by the musical scores which flow between them (all against a brilliant red background), was painted to fit the dimensions of the wall on which it is displayed.

Preserving the initial mission of the museum—and complementing the modern and contemporary master-pieces—are pieces from the initial archaeological collection, which are displayed on various floors and in the small chapel that was part of the original structure. These include *The Stele of the Child Septentrion* (an inscription dedicated to a slave-child who "danced at the theater at Antibes on two days and gave pleasure"), a phallic stone, a Roman tomb, and a collection of antique altar stones.

Spread throughout the museum's rooms, in its chapel, and garden are twenty-two Latin inscriptions on various fragments found in the area, the earliest dating from the first century A.D.

The juxtaposition of Picasso's daringly modern work and the remains of the original archaeological collection—all set within the elegance of the ancient site where it was actually painted—creates a unique environment within which to enjoy his works of the period. It is easy to understand why Picasso stipulated that these works were never to leave the museum: "If you want to see the Picasso of Antibes, you must come to Antibes," he repeated time and again. These works, in the words of Dor de la Souchère, are "happily united in a certain light, atmosphere, space, joy—it is a love match."

THE MUSEUM IS SET IN A SMALL COMPLEX, SHADED IN SUMMER BY A LUXURIANT PLANE TREE. JEAN-PAUL RIOPELLE'S HUGE CERAMIC SUNDIAL ENHANCES THE MUSEUM'S FAÇADE. LE CHÂTEAU-MUSÉE DE VALLAURIS: LE MUSÉE MAGNELLI ET LE MUSÉE DE LA CÉRAMIQUE. PHOTO: MICHEL DE LORENZO

LE CHÂTEAU-MUSÉE DE VALLAURIS:
LE MUSÉE MAGNELLI ET LE MUSÉE DE LA CÉRAMIQUE
THE CHÂTEAU-MUSEUM OF VALLAURIS:
THE MAGNELLI MUSEUM AND THE CERAMIC MUSEUM

Place de la Libération, 06220 Vallauris
Tel: 04-93-64-16-05 and 04-93-64-98-05

Open Wednesday to Monday from 10:00 A.M. to Noon and 2:00 P.M. to 6:00 P.M.
September through June; from 10:00 A.M. to 12:30 P.M. and
2:00 P.M. to 6:30 P.M. in July and August.
Closed Tuesday and holidays.

S ITUATED BETWEEN THE Mediterranean coastal towns of Antibes and Cannes, Vallauris is—and always has been—a potter's town. As Roland Penrose, author of *Picasso: His Life and Work*, describes it, "In a valley surrounded by pine forests, vineyards, olive groves and terraces, where lavender, jasmine and other sweet-scented plants were cultivated, there lay the small town of Vallauris. From its pink tiled roofs smoke had risen for a thousand years. It belched intermittently in great black clouds as the potters lit pine faggots to fire their kilns. The town itself had no particular charm and there was no sea view to attract tourists. Its main industries were the manufacture of scent and ceramics"

It is a land blessed with thick red earth that baked well in a kiln; a land that gave rise to a rich tradition of pottery production. Vallauris ceramics have ranged from the most utilitarian *terrailles*—the old term for Provençal pottery cookware—to the most avant-garde artistic ceramics. Memorialized

as "the town of a hundred potters," it is the site today of the charming sixteenth-century château-turned-museum, a former priory of the Lérins monks, which now preserves much of the recent history of Vallauris's "art of fire" under its complicated triple name: "The Château-Museum of Vallauris: The Magnelli Museum and The Ceramic Museum."

The museum, inaugurated in 1977, emphasizes both culinary and high art ceramics (both Art Nouveau and Art Deco), primarily those fired in the late nineteenth and twentieth centuries in Vallauris. But it also includes a small collection of Pre-Columbian (mainly Central-American) art as well as ceramics and linoleum engravings by Picasso, and, as the museum's formal name implies, the most important collection of work by the modern Italian artist, Alberto Magnelli (1899–1971), who spent a significant period of his life in the area.

The museum is set in a small walled complex just off a graceful,

almost Provençal square. The first view of it one has is of a high stone wall, adorned with a classic balustrade and two reclining lions. The inviting open stone gate leads to the Château complex. Inside is an appealing courtyard, shaded in summer by a luxuriant plane tree, the elegantly rustic sixteenth-century Château itself and its adjoining twelfth-century Romanesque chapel.

The chapel has stood on this spot for eight centuries and endured numerous transformations and abuses both before and after the French Revolution—including a period when it served as an olive oil mill. Even before renovations began in the mid-1970s to transform the Château into a museum, this little chapel had, years before, achieved that status as the Musée National Picasso "La Guerre et La Paix"—home of Picasso's riveting murals on the theme of war and peace (see Chapter 6).

Indeed, Picasso's charismatic presence in Vallauris—beginning in the late 1940s—has left its indelible mark. His unbounded enthusiasm and seemingly limitless innovations in ceramics, his gift to the French government of the murals for the chapel and a bronze statue of a man carrying a sheep, all link him inextricably to the renown and fortune of this once modest village. But that is only one chapter in the story of ceramics creation in Vallauris and of the Château-Musée itself. To appreciate the richness of the museum's collection, a familiarity with the historical evolution of the ceramic arts in Vallauris, and those who played a major role in its history, is indispensable.

As early as Roman times, the clay-rich earth surrounding Vallauris gave rise to the production of pottery. Throughout the ensuing centuries, the production of earthenware in Vallauris was intermittent until the sixteenth century, when the arrival of potters from the Italian town of Albisola, also well known for its pottery, revitalized ceramics activity.

By the eighteenth century, culinary pottery production had become the primary industry of Vallauris. The nineteenth century saw the increasing growth of pottery-making and, by 1893, three-quarters of the village's 6,000 inhabitants reportedly were potters!

The production of traditional culinary pottery: *marmites*—pots for cooking traditional *daubes* or stews—casseroles, storage containers, olive oil jars, coffeepots, vases, and a variety of wine pitchers, became the trademark of local potters, whose works made their way from the kilns of Vallauris into kitchens all over France. The finished pieces were often left unglazed, except for the interior. Sometimes, though, the cookware was covered with a lead-rich glaze known as "alquifoux," imported from Spain. This gave the pieces their typical "omelette" or warm, honey-like yellow color. This production continued to expand, more or less uninterrupted, until the end of the nineteenth century, albeit with occasional diversifications of style and enhanced decoration—which included braided handles and scalloped or zigzag ornamentation, sometimes in greens and browns.

By this time, the simple pottery had achieved a reputation of its own and—packed carefully in straw—it was shipped beyond France to Spain,

Italy, and North Africa. The arrival of train transport in 1862 expanded the export trade even further. But its future was not promising. The increased use of metal kitchen products, especially aluminum, threatened the livelihood of the local potters.

As small family-run enterprises began to falter, several larger specialized collectives emerged. Some, such as Saltalamacchia, developed what would become a long-lasting

concerns about lead-based glazes in cookware began to surface. However, another ceramics renaissance was about to emerge, one that mirrored a different nineteenth-century Vallauris tradition: that of *artistic*—as opposed to *culinary*—ceramics.

The nineteenth century was a turning point in the production of ceramics. While culinary ceramic production was at its height, a new trend in

THE ELEGANTLY RUSTIC SIXTEENTH-CENTURY CHÂTEAU THAT HOUSES THE MAGNELLI AND CERAMIC MUSEUMS IS SET BEHIND A HIGH STONE WALL ADORNED WITH A CLASSIC BALUSTRADE AND TWO RECLINING LIONS. LE CHÂTEAU-MUSÉE DE VALLAURIS: LE MUSÉE MAGNELLI ET LE MUSÉE DE LA CÉRAMIQUE. PHOTO: MICHEL DE LORENZO

and ultimately much-copied *poterie provençale* (Provençal pottery), while others, such as Foucard-Jourdan and Beretta, replicated classic designs of the Louis XV period. Despite years of prosperous activity, these too ran into difficulty in the 1950s, when health

artistic ceramics emerged, complementing but not replacing the culinary tradition of local potters. In the 1820s Pierre Maurel (1801–1871) and Jacques Massier (1806–1871) developed a specialization in artistic ceramics for home decoration.

AT THE TOP OF THE CHÂTEAU'S STATELY RENAISSANCE STAIRCASE, ENHANCED BY ITS ORNATE BALUSTRADES, IS MAGNELLI'S
SUMPTUOUS *MURAL PANEL*, WHICH GLOWS AGAINST THE WHITE PLASTER WALLS OF THE MUSEUM. LE CHÂTEAU-MUSÉE
DE VALLAURIS: LE MUSÉE MAGNELLI ET LE MUSÉE DE LA CÉRAMIQUE. PHOTO: MICHEL DE LORENZO

Beginning about 1870, Massier's sons and their cousin were to make a huge impact upon artistic ceramic design. Leaving Vallauris, they moved to nearby Golfe-Juan, where they installed their ovens and opened shops (as well as in Paris). Their work and that of some of their disciples had a brief but brilliant period of celebrity. The quality of their output stunned their clients. It wasn't merely the new designs, many of which reflected classical images of antiquity—large vases and amphora, decorative urns with garlands, and large ewers—but the glazes as well, which had a new and lustrous quality that ensured their fame. Through much research and experimentation with the use of gold, silver, and platinum powders, the Massiers were able to produce metallic-like glazes in a brilliant range of tones: shades of blue, especially an almost transparent turquoise, flame reds, and greens.

World War I and its aftermath brought a gradual end to the artistic ceramics produced by the Massiers and their followers, as well as to the dwindling culinary pottery market. However, it wasn't long before a talented new group of artists—most not originally from Vallauris and few with early formal training as potters—would arrive in the village and create an environment where culinary and artistic ceramics were to reach new heights. The work of this group prepared the setting for the meteoric impact of Picasso when he moved to Vallauris in 1948.

The first of this young and enthusiastic group were Suzanne and Georges Ramié, who founded the now world-famous Madoura pottery factory in 1938. Initially, Suzanne Ramié set to work on her own with the goal of renewing traditional forms of Provençal pottery. But it wasn't long before Madoura opened its doors to local artists—a policy that, within a few years, would bring Picasso to their doorstep.

In the next ten years, a series of talented artists and potters joined them in Vallauris, all of whom contributed to the revitalization of pottery production in the town. Some worked together, others alone, producing unique pieces in styles that represented a notable departure from the town's traditional pottery. As a group, their creations sent shock waves through the world of the traditional potters and set the stage for Picasso's arrival.

As always with Picasso, legends abound as to how he first happened to venture to Vallauris. In this case, according to Françoise Gilot, his companion from 1946 to 1953, Picasso first met Suzanne Ramié of the Madoura factory in July of 1946 on the beach in Golfe-Juan, where he held informal court.

Picasso was about to begin his historic adventure at the Grimaldi Castle in Antibes (see Chapter 4). But curious as always, he responded to Madame Ramié's invitation and visited the annual ceramics show in Vallauris later that month. Stopping by the Madoura stand, he tried his hand at decorating three pieces of freshly thrown pottery that one of the potters offered him. It wasn't until the next summer that he returned to Vallauris and, upon visiting Madoura, was presented with his three creations of the previous summer, which had been fired and put aside for him. But on his return visit he had a

surprise of his own—a huge packet of sketches of varying forms that were studies for ceramics he hoped to create. They represented his formal analysis of how the hollow forms made on a potter's wheel might be "deconstructed" and reassembled to form radically new ceramics. They were centered on a collection of both familiar and new Picasso themes— horned bulls, chubby owls, pregnant fauns, centaurs, doves, and a variety of *Tanagras* (small female figurines developed from the shape of a bottle). Once again, he experimented with some freshly thrown and still soft pots. Thus began Picasso's intense and tantalizing experiments with clay, which resulted in his purchasing a home in the hills near Vallauris and settling there from 1948 until 1955.

Picasso was fascinated with the possibilities of working in clay, a medium in which he had dabbled as early as the beginning of the century. But now Picasso would only occasionally put his own hands to the clay. More often, his act of creation began once his trusted "turner," Jules Agar, supplied him with the forms he requested—to which he would apply his own magic. Sometimes, rather than manipulating the still soft clay, he would transform it by adding bits of clay to create a border or relief, or incising the clay with a pointed tool, or painting glazes directly on its surface.

Day by day, he stretched the possibilities of the craft, expanding the limits of this age-old medium. He learned how to squeeze and twist,

A COLLECTION OF PICASSO'S GROUNDBREAKING WORK IN CERAMICS, EXECUTED DURING HIS YEARS IN VALLAURIS, IS ONE OF THE MUSEUM'S HIGHLIGHTS. LE CHÂTEAU-MUSÉE DE VALLAURIS: LE MUSÉE MAGNELLI ET LE MUSÉE DE LA CÉRAMIQUE. PHOTO: MICHEL DE LORENZO

pinch and pull, play and paint—
using his ingenuity and wit to cajole
new forms and shapes from the clay.

His son Claude, who was born
in Vallauris, reminisces about the
marvel of watching his father at
work: ". . . It was enchanting to see
[his] hands take just any old pitcher,
one that had just been made, and
twist its neck, apply some pressure,
crush it here or there with amazing
speed and, without any hesitation,
produce a woman as easily as a
pigeon."

Numerous anecdotes exist about
Picasso's adventures with clay, some
reported by Dominique Forest,
curator of the Château-Musée, in one
of her many articles on Picasso in
Vallauris. A now-famous story
concerns the comment made by the
Ramiés, who, upon observing
Picasso's unorthodox technique with
clay at their Madoura ceramic
factory, said, "An apprentice who
worked as Picasso does would never
find a job."

Beyond his novel techniques,
Picasso didn't limit his output to
artistic pieces. He took pride in creat-
ing everyday objects as well. Once,
in great seriousness, he said to André
Malraux, who was to become French
Minister of Culture: "Have you
heard? I've made plates. They're
really very good. You can eat from
them!"

Picasso was in his mid-sixties and
world-renowned by the time he
moved to Vallauris. His years there
were devoted in large part to ceram-

TRADITIONAL, UNGLAZED VALLAURIS POTTERY SITS ON THE ANCIENT SINK IN THE FORMER KITCHEN OF THE CHÂTEAU.

LE CHÂTEAU-MUSÉE DE VALLAURIS: LE MUSÉE MAGNELLI ET LE MUSÉE DE LA CÉRAMIQUE. PHOTO: MICHEL DE LORENZO

ics; by the time of his death in 1973 at the age of 91 he had created some 4,000 pieces of pottery, 3,222 of which were still in his personal possession. But he didn't cease his other artistic activities. He continued to paint, and sculpture assumed an important role in his life. In addition to cast-bronze pieces, he assembled sculptures, creating works of art with discarded pieces of iron, old shoes, cake pans, ceramic flower pots, baskets—everyday objects that he might find in the town dump or in his children's toy box. These sculptures include pieces such as *La Chèvre (The She-Goat)* whose rib cage is an an identifiable basket, and *La Guenon (Baboon and Young)* whose head is a very recognizable toy car. His preoccupation with such forms was so intense that his sometime friend, the poet Jean Cocteau, would describe Picasso in his Diaries as ". . . almost a gypsy. He lives in luxurious poverty—his houses are always a mess. One has [the] impression that you're in a king's and a rag collector's home all at once. Rag collector or king, the king of rag collectors. He goes out, collects things in trash cans, brings them back home and raises them to dignity, of serving some purpose."

Picasso's presence in the village continued to create a sensation. Despite his fame, he wasn't initially endearing to the local potters, some of whom considered him something of an iconoclast and crackpot who endangered their traditional practices. Nonetheless, he was worshiped by many and breathed new life into the ceramic craft and the town—making himself part of the life of the village.

He insisted on displaying his work next to that of the town's artisans during the annual summer exhibition, creating, by his very presence, an air of great festivity during these events.

Not only did Picasso inspire and encourage local ceramists, he attracted internationally known artists to try their hands at clay. Chagall, Miró, and Matisse—each of whom had worked in clay before— came for an adventure at Madoura. Others experimented for the first time. Cocteau was to produce his first ceramics in Vallauris. Artists and sculptors such as Edouard Pignon, Victor Brauner, Anton Primmer, and Amédée Ozenfant, to name just a few, left their studios to experiment in Vallauris—alongside the steadfast heirs of the local tradition and Picasso himself.

Much of this rich history and the work of many of these artists is preserved within the Château-Musée, which owns more than a thousand pieces of pottery from various periods, and by many of these artists who helped make Vallauris's history as the town where "everyone is a potter."

Even before entering the Château proper, the first thing apparent on its façade is a huge ceramic sundial. It was executed by a local artist, Jean-Paul Riopelle, as a so-called temporary installation. This was part of a show held in his name in the mid-1980s, which is still in place today (although perhaps not forever). To the left is a small, almost unobtrusive Romanesque door that leads into Picasso's Chapelle de la Guerre et la Paix, where several of Picasso's original ceramics are on display in the antechamber.

THE FORMER KITCHEN OF THE LÉRINS MONKS, WITH ITS HOODED BRICK BAKING OVEN, IS ONE OF THE MOST DELIGHTFUL ASPECTS OF THE MUSEUM. DISPLAYED HERE ARE SEVERAL EXAMPLES OF THE TRADITIONAL VALLAURIS CULINARY POTTERY— INCLUDING A SALAD BOWL, A PITCHER, AND *MARMITES* (STEW POTS) ATTRIBUTED TO SALTALAMACCHIA. LE CHÂTEAU-MUSÉE DE VALLAURIS: LE MUSÉE MAGNELLI ET LE MUSÉE DE LA CÉRAMIQUE. PHOTO: MICHEL DE LORENZO

Upon entering the museum itself, the visitor is first struck by the richness of the setting—the texture of the terra-cotta and cobblestone floors, the monumental Renaissance staircase with its massive balustrades (all in tones of patinaed alabaster), and the labyrinth of connecting rooms on each of its three floors.

The spacious vaulted chambers to the rear contain contemporary ceramics from Vallauris's prestigious Biennial shows, as well as exemplary pieces of ceramics from the 1950s. Located in another room on the ground floor are numerous limited-edition examples of Picasso's ceramics—vases, pitchers, and plates—from his Vallauris period. In this same room are a series of colorful posters, produced with master printer Hidalgo Arnéra, as linoleum engravings to publicize the ceramics show and bullfights that took place in Vallauris during the seven years Picasso was in residence there. At the rear of the room is the original press used for these engravings. Picasso's canvas, *Hidalgo aux colombes (Hidalgo with Doves)* hangs in the same room.

Walking up the wonderful staircase is an aesthetic adventure. The first rooms to the right present one of two dramatically different collections—both of which belong to the museum, thanks to the donations of Jean and Paulette Declein. Their large Art Nouveau/Art Deco collection overflows into an adjoining hallway and room. The masterpieces of this

collection are the highly lustrous ceramics by the Massier family. Their glazing, evident on the multitude of vases of different styles and shapes, urns, ewers, platters, bowls, ink bottles, pitchers and the like, bring to life the new, highly decorative forms and techniques they perfected in the mid-nineteenth century, a radical departure from the traditional culinary ceramics of Vallauris displayed elsewhere in the museum.

The second half of the Declein donation, the small but richly varied Pre-Columbian collection, is displayed in several rooms on the next floor. Included here are representative pieces from Mexico and South and Central America, dating mainly from the early centuries of the Christian era.

Just across the hall is one of the most charming aspects of the museum—the former kitchen of the Lérins monks, with its hooded brick baking oven, and in the small room to the rear, their clay sink. Displayed in this gallery are ever-changing examples of traditional unglazed Vallauris pottery together with work by the innovative young wave of artists who came to Vallauris from the late thirties until the early fifties, creating the town's "golden age" of ceramics. Some of the representative pieces displayed in this room include the pale yellow and softly marbleized *Saladier (Salad Bowl)*, *Pichet (Pitcher)*, and *Marmite à queue (Handled Stew Pot)* attributed to Joseph Saltalamacchia; Robert Picault's characteristically green and geometrically patterned *Four de campagne (Country Dutch Oven)*, which typifies the slogan he coined, "From the Oven to the Table;" and Foucard-Jourdan's deep green

enameled vases, plates, and covered vegetable bowls and vases.

Continuing up the staircase, past the two landings graced by Jean Gerbino's colorfully elegant *Colonnes*, clay mosaic bowls that rest on columns of sumptuously colored pieces of clay mosaic, one comes to the Magnelli Collection.

While more than half of the Château-Musée is devoted to ceramics, the museum is, as its name suggests, the home of the largest and most important collection of artwork by the modern Italian painter, Alberto Magnelli (1888–1971). Born in Florence, his early associations were with members of the Futurists and other Italian avant-garde artists. While he visited Paris in 1914, meeting with Picasso and other important figures of the Paris avant-garde, Magnelli did not move to France permanently until the early 1930s. When World War II broke out, Magnelli and his wife, Susi, like many other artists and writers, left Paris and moved south, taking refuge near the perfume distilling town of Grasse. For four years they lived with *Le Groupe de Grasse*, composed of other artists and their families—Sonia Delaunay, Hans Arp and his wife, Sophie Taeuber Arp—who worked together and morally supported each other. While they all eventually left the area, the Magnellis retained close ties to the region.

At the end of his life, Magnelli expressed the desire to see his carefully documented and chronologically organized life's work kept intact and donated to a town close to Grasse. It remained for his wife Susi to select the Château-Musée de Vallauris as a permanent home for

THIS GEOMETRICALLY PATTERNED, CERAMIC COUNTRY-DUTCH OVEN WAS DESIGNED BY ARTIST ROBERT PICAULT.

LE CHÂTEAU-MUSÉE DE VALLAURIS: LE MUSÉE MAGNELLI ET LE MUSÉE DE LA CÉRAMIQUE. PHOTO: MICHEL DE LORENZO

NINETEENTH-CENTURY VALLAURIS CERAMICS IN THE COLLECTION INCLUDE HIGHLY DECORATIVE VASES SUCH AS THESE
CREATED BY MEMBERS OF THE MASSIER FAMILY AND BY THE MAUREL BROTHERS. LE CHÂTEAU-MUSÉE DE VALLAURIS: LE MUSÉE
MAGNELLI ET LE MUSÉE DE LA CÉRAMIQUE. PHOTO: MICHEL DE LORENZO

this exceptionally rich collection.

The Magnelli collection spans the artist's career from his early figurative and subsequent abstract paintings to his later work—engravings, collages, and the great canvases of the end of his life. The early stages of Magnelli's career are marked by transitions from representational to abstract work and back again. Representative of his gradual entry into abstraction is the important early canvas, *Neve (Snow)*, followed a few years later by the colorful *Femme au bouquet (Woman with a Bouquet)*, and then the ultimate evidence of this transition in *La Japonaise (Japanese Woman)*. A new form of representation emerges in the series of thirteen paintings known as *Explosions lyriques*, where his female subjects are depicted in a broader palette of soft tones that departs sharply from the primary colors of his earlier work.

In extreme contrast to these works are *Les Pierres (The Stones)*, a series of paintings and drawings in building-block mineral forms, painted in a new, darker color range. These works—applied to variously textured papers, including rough-surfaced tar paper—prepared the way for the mixed-media assemblages of the later collages. The most tactile of these is *Les Râteaux japonais (Japanese Rakes)*.

The last stages of Magnelli's career are represented by a series of often brilliantly colored abstract canvases, some of large dimensions. The most sumptuous of these is the *Panneau mural (Mural Panel)*, which greets the visitor to the Magnelli collection. Displayed at the top of the landing, in juxtaposition to the ornate balustrades of the stately staircase, its orange, red, and yellow forms glow vividly against the old, white plaster walls on the top floor of the museum. As the museum, which is classified an "historic monument of France," looks toward the twenty-first century, it anticipates a five-year period of renewal. Dominique Forest, its curator, expects to receive several of Picasso's "assembled sculptures" of the period, which will expand the already unique collection considerably. In the interim, the museum more than fulfills its goal of providing a panorama of ceramics—the "art of fire across the ages"—and serves, Forest says with obvious pride, as "one of the rare museums of decorative arts in the region."

THE ANTECHAMBER OF THE TWELFTH-CENTURY CHAPEL THAT BECAME THE NATIONAL PICASSO MUSEUM "WAR AND PEACE" EXHIBITS NUMEROUS PIECES OF CERAMIC SCULPTURE THAT PICASSO EXECUTED DURING THE YEARS HE LIVED IN VALLAURIS. LE MUSÉE NATIONAL PICASSO "LA GUERRE ET LA PAIX." PHOTO: MICHEL DE LORENZO

LE MUSÉE NATIONAL PICASSO "LA GUERRE ET LA PAIX"
THE NATIONAL PICASSO MUSEUM "WAR AND PEACE"

Place de la Libération, 06220 Vallauris
Tel: 04–93–64–16–05 and 04–93–64–98–05

Open Wednesday to Monday from 10:00 A.M. to Noon and
2:00 P.M. to 6:00 P.M. September through June;
from 10:00 A.M. to 12:30 P.M. and 2:00 P.M. to 6:30 P.M. in July and August.
Closed Tuesday and holidays.

"OH, HOW I would love to decorate a chapel!" Pablo Picasso (1881–1973) exclaimed in 1951 at a dinner celebrating his seventieth birthday. This birthday banquet, held in the vaulted antechamber of a twelfth-century Romanesque chapel, was a seemingly unlikely setting to celebrate the birthday of the artist, who was a renowned atheist. Nonetheless, this surprisingly spontaneous and unexpected revelation resulted several years later in what Picasso called his "Temple de la Paix"—Temple of Peace.

Picasso's innocent expression of interest in the chapel at his birthday fête was met with an immediate gesture of generosity by René Batigne, the founder of the Society of Friends of the Museum of Vallauris, who declared, "It's yours!"

At the time, Picasso had been living in the ceramic-making village of Vallauris and was a much-celebrated citizen. He had early been captivated by the little chapel and had, in fact, initially placed his gift to the city—a life-size bronze sculpture, *L'homme au mouton (Man with a Sheep)*—inside the chapel.

The little chapel was all that

remained of an abbey dating back to the Middle Ages that had previously existed on the spot. The abbey had been rebuilt as a château in the sixteenth century and remains one of the few examples of Renaissance architecture in Provence. It had been converted in the 1970s into a ceramics museum, now the adjoining Château-Musée de Vallauris: Musée Magnelli et Musée de la Céramique (see Chapter 5).

Actually, Picasso's desire to decorate a chapel did not emerge spontaneously at this birthday dinner. He had earlier confided to his friend, the writer, Claude Roy, that he had been "dreaming of decorating the little chapel." Several years earlier—as Sylvie Forestier, the longtime curator of the chapel, remembers it—Picasso had expressed a wish to construct a Temple of Peace. He wanted to design, build, and decorate it in the village of Céret, close to his native Catalonia in the Eastern Pyrénées He saw it as an anti-war monument, railing against the horrors of battle.

In his vast production, only two other major works speak directly to political events: *Guernica*, the huge canvas in black, white, and gray, painted in response to the bombing of the little Spanish village of Guernica on a market day during that country's civil war in the 1930s, and the *Massacre en Corée*, which dealt with images of the Korean War in the 1950s. These grisly memories remained embedded in Picasso's soul and served as the inspiration for this chapel.

Innovator though he was, Picasso was not the first modern artist to decorate a chapel. Nor was he indifferent to the innovations of

other artists—or immune to indulging in a bit of competition with them.

In the aftermath of World War II, there was a revival of interest in sacred art in France. One by one, the country's leading artists were invited to integrate their output into the decoration of churches and chapels. Most famous of these efforts was the church of Notre-Dame-de-Toute-Grâce, built after the war in the town of Assy, near the Alps in the Haute-Savoie. This church—with stained-glass windows by Georges Rouault and Marc Chagall, a major altarpiece by Pierre Bonnard, a decorative tile panel by Henri Matisse, a mosaic facade by Fernand Léger, a tapestry by Jean Lurçat, and sculpture by Georges Braque and Jacques Lipchitz —inspired many other modern artists in the years that followed.

In nearby Vence—close to Picasso's home in Vallauris—the artist had been closely following Matisse's passionate involvement in every detail of his Chapelle du Rosaire (see Chapters 16 and 17). Matisse was not only designing and decorating a Dominican chapel, but also the furniture, stained-glass windows, and even the priestly vestments. All of this activity, well-known to Picasso, must have been seen as a challenge by the intensely competitive and egocentric artist.

Quite unlike other modern art designed for chapels, there was no possibility that Picasso's chapel would ever be re-consecrated as a holy site by the Catholic Church. A passionate anti-clericist, Picasso had initially been violently opposed to Matisse's decision to design and decorate the Dominican Chapelle du Rosaire.

In her book, *Matisse and*

PICASSO PAINTED ON HUGE PLYWOOD BOARDS THAT WERE LATER MOUNTED INSIDE THE VAULTED CHAPEL, RATHER THAN WORK DIRECTLY ON THE CHAPEL WALLS. LE MUSÉE NATIONAL PICASSO "LA GUERRE ET LA PAIX." PHOTO: MICHEL DE LORENZO

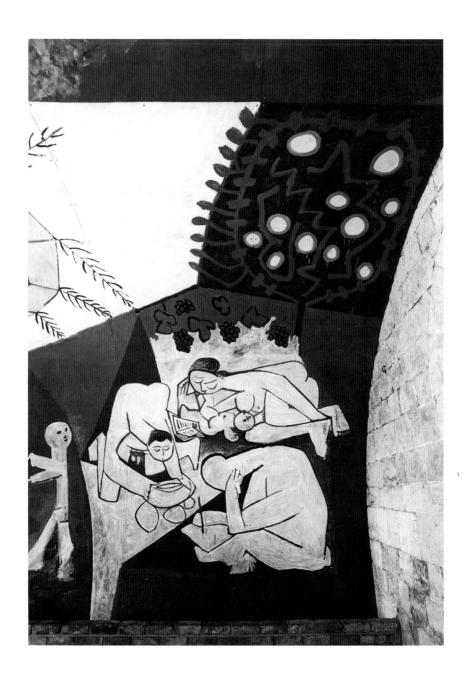

THIS BUCOLIC SCENE FROM THE PANEL DEVOTED TO PEACE PORTRAYS A SERIES OF FIGURES ENGAGED IN ACTIVITIES OF FREEDOM AND PLEASURE. LE MUSÉE NATIONAL PICASSO "LA GUERRE ET LA PAIX." PHOTO: MICHEL DE LORENZO

Picasso, Françoise Gilot (Picasso's companion from the mid-40s to the mid-50s) describes Picasso's unsuccessful efforts to persuade Matisse to abandon his project. Picasso pointed out that, from time to time, Matisse had expressed a lack of sympathy for organized religion, but was obsessed with the challenge of designing a "total environment." Picasso had goaded his old friend to design a marketplace—Nice was renowned for them—rather than a church building, but Matisse had insisted on going forward with his project. Picasso finally told Matisse that the brilliantly colored priests' vestments that he had designed could serve as bullfighter capes!

The Chapelle de la Guerre et la Paix—a monument to the horrors of war and the joys of peace—differs in a number of important ways from other artist-decorated chapels. Rather than painting directly on the crumbling, flaking walls of the old chapel, Picasso painted on huge plywood boards, similar to those he had used in his studio at the Château Grimaldi in Antibes to paint the mythological *Antipolis Suite* series.

The boards were cut to the exact dimensions of the vaulted chapel and, once completed, were mounted inside. Working in his normal, driven fashion, Picasso completed the two panels between 1952 and 1954. The work began with a series of sketches and drawings, some 250 in all, in addition to others which had preceded his conscious work on the chapel. Working in his studio (a former perfume distillery for jasmine and orange blossoms), he proceeded at a feverish pace.

The poet and sometime painter,

Jean Cocteau (see Chapters 2, 18, 19, and 20) occasionally visited Picasso and Françoise Gilot at their home. In his *Diaries* Cocteau notes his impressions of Picasso at work:

> Lunch at Picasso's at Vallauris. From two in the afternoon to ten at night he locks himself up with his fresco. No one disturbs him, not even Françoise. . . . Picasso is painting a hundred square meters (over 110 square yards) of fresco on composition board for the Chapel of Peace in Vallauris where the man with the sheep used to be. (His) studio—a huge room . . . is covered with construction board and lit by fluorescent light.

The "irradiating, burning force" that former curator of the chapel Sylvie Forestier describes as emanating from these "monumental panels, two opposite sides of the same reality" was obvious—even in their preparatory stages—when Picasso was working almost secretly in his studio on the panels for the chapel.

Cocteau also provides some idea of the impact of the work, even as it was still in progress:

> Lunch in Vallauris. Picasso was in the studio, where I went with Françoise to join him. He opens a locked door and we go into theroom where *War and Peace* —*La Guerre and La Paix*— is kept. The first sensation is of a nave in a church, and apparently everyone who comes in here takes off his hat. I take off mine. The work is of an incredible youthfulness and violence. A balance between

delirium and calm . . . no form is realistic, but everything is true . . . and when we come out of there, reality seems pale, color less stupid, inert, dead.

Today, in place in the chapel, the two immense panels that entirely cover the sides and vaulted ceiling create a dramatic impact. One is first struck by the horrors of war evoked by a shorthand of grotesque images. This, the *War* panel—to the left upon entering the chapel—is painted in sober shades of green, black, gray, and white, its silhouetted human figures frozen in successive acts of brutal destruction. Towering over them—enveloped in atomic-like clouds—is the central warrior, bearing a sword dripping in blood as he is borne on a tank drawn by emaciated horses. Below them, the parched earth is a blood bath of red as the warriors confront the Guardian of Peace bearing the shield of the white dove.

To the right, the panel devoted to Peace is equally powerful in capturing the joys of tranquillity. Painted almost entirely in blue and white, its figures are engaged in acts of freedom and pleasure: women dancing, children at play with pet birds and fish, flute-playing fauns, and Pegasus, the winged horse. One corner of the fresco is devoted to a series of figures at rest, tenderly engaged in pastimes associated with peace: figures reading and writing, women nursing children, or preparing the hearth. The bucolic scene is set in a pasture of verdant green enhanced by a tree in full bloom and warmed by a vibrant sun which illuminates the entire fresco.

At the far end of the room is a subsequently painted mural. It presents four figures in black, yellow, red, and white, symbolizing the different races, holding a globe on which is emblazoned the famous symbol of the dove of peace. The mural is actually the first thing seen by the visitor after passing through the vaulted antechamber whose niches and display cases hold original and limited edition examples of Picasso's ceramics.

Picasso expressed—again to his friend, Claude Roy—his desire that visitors should experience their visit to the chapel as if in the depths of some prehistoric sanctuary, candles in hand, discovering, little by little, what he had painted. The feeling created by the dimly lit chapel evokes precisely what Picasso had hoped for—a powerful response to the artist's personal statement concerning the atrocities, brutality, and mutilations of war, and the sweetness and joys of love and tenderness found in peace.

At the time that Picasso worked on this Temple, he was living happily in his beloved little village of Vallauris, inspired by the joys of his newfound family life with Françoise Gilot and their two young children. Picasso's attachment to Vallauris was manifested both in the gift of his bronze sculpture, *L'homme au mouton*, to the village (it stands today in the main square of Vallauris) and his gift to the French government of the frescoes for the chapel, which became a national museum in 1959.

PICASSO USED A SHORTHAND OF GROTESQUE IMAGES, SUCH AS THESE SILHOUETTED HUMAN FIGURES FROZEN IN ACTS OF
BRUTAL DESTRUCTION, TO EVOKE THE HORRORS OF WAR. LE MUSÉE NATIONAL PICASSO "LA GUERRE ET LA PAIX."
PHOTO: MICHEL DE LORENZO

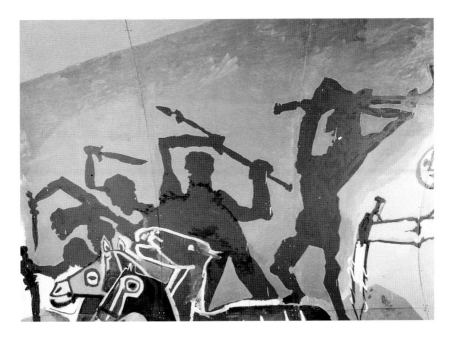

L'ESPACE DE L'ART CONCRET
THE SPACE FOR CONCRETE ART

Château de Mouans, 06370 Mouans-Sartoux
Tel: 04–93–75–71–50

Open Wednesday to Monday from 11:00 A.M. to 7:00 P.M.
June through September;
from 11:00 A.M. to 6:00 P.M. October through May.
Also open by appointment.
Closed Tuesday.

OTHER THAN THE FACT that L'Espace de l'Art Concret inhabits a jewel of an ancient structure situated on three acres of beautifully planted grounds—as do numerous other museums on the Riviera—this center for contemporary art has little in common with other museums in the area. In fact, its very name, "L'Espace," which has no equivalent definition in English other than the general concept of exhibition space, suggests that something very special is taking place here.

L'Espace de l'Art Concret is the result of a joint endeavor between a very singular private collector, Sybil Albers-Barrier, with her companion and partner in this venture, the celebrated Concrete artist Gottfried Honegger, and the town of Mouans-Sartoux—the municipal owner of the Château de Mouans.

In 1989, Albers-Barrier, whose family had lived in Mouans-Sartoux (a small village located midway between Cannes and Grasse) learned that the town had recently purchased the three-towered, triangular-shaped sixteenth-century château. In exchange for use of the château, she offered to lend her personal collection

of contemporary art for display there. An agreement was reached that provided not merely space to exhibit her collection of paintings, drawings, sculpture, and collages by world-renowned Minimal, Concrete, and Conceptual artists, but also use of the building as a center for education, research, and experimentation in the arts. With Albers-Barrier's collection as the underpinning, L'Espace de l'Art Concret was opened in 1990.

The unusually shaped 500-year-old château, set just off a traditionally charming French square, is one of the few bastions of avant-garde art on the Riviera. As such, it provides a unique opportunity to explore various aspects of Conceptual Art and the associated trends of Minimal and Concrete Art. The work on display at L'Espace represents exemplary expressions of the tenets of each of these movements.

Concrete Art, the term coined in 1930 by art theoretician Theo van Doesburg, describes a specific type of "non-figurative painting and sculpture . . . which emphasizes the intellectual aspect of art . . . opposed to art which is inspired by sensuality, sentimentality or other lyrical expressions." Van Doesburg goes on to describe Concrete Art as ". . . constructed entirely from purely plastic elements, that is to say planes and colors." As is evident in exploring the exhibits organized by L'Espace, Concrete Art is loosely associated with twentieth-century Minimal Art, characterized as it is by the use of monochromatic colors, three-dimensional geometric forms, industrial materials, and related

ULRICH RÜCKRIEM'S SCULPTURE, *BLACK AFRICA*, WHICH CREATES A SHALLOW POOL OF REFLECTING WATER, IS SET IN THE ENTRANCE COURTYARD OF THIS SIXTEENTH-CENTURY CHÂTEAU. L'ESPACE DE L'ART CONCRET. PHOTO: MICHEL DE LORENZO

THIS FIVE-HUNDRED-YEAR-OLD CHÂTEAU, DISTINGUISHED BY ITS THREE TOWERS, HOUSES A COLLECTION OF WORK BY CONCRETE, CONCEPTUAL, AND MINIMAL ARTISTS. L'ESPACE DE L'ART CONCRET. PHOTO: MICHEL DE LORENZO

expressions of modern technology, often arranged in serial form.

Albers-Barrier and Honegger have conceived a project distinct from that of traditional museums. In opposition to the notion of a museum as a site to display and preserve art for a public that comes to view it passively, they have created a "space" in which a rotating exhibit of Albers-Barrier's 400-piece collection serves to provoke, instruct, challenge, and encourage a new relationship between individual works of art and those who view them. The mission they have developed for L'Espace de l'Art Concret is consistent with art historian Jane Turner's interpretation of Conceptual Art as a type of artistic expression that "ascribes more impor-

tance to communicating an idea than to producing a permanent object."

Odile Biec, director of L'Espace de l'Art Concret, explains that one of its goals is to "establish a contact between the works of art and the visitors," emphasizing that "participation of a visitor is one of the conditions of the existence of a work of art." The pieces are constantly being exchanged, intermingled, transferred, and juxtaposed to create a new dimension, to spark a new interaction, an altered relationship, a new way of affecting and engaging the viewer.

In the course of each year, the Center sponsors a minimum of three major exhibitions. The works of art that constitute each exhibit consist

of pieces in the permanent collection, often complemented with additional work by the same or other artists held by another museum or private collector.

Each of the exhibits is organized around a specific theme that invites the visitor to examine any work of art—not merely as an aesthetic creation, but for its meaning in relationship to the viewer, to other art, and to society in general. The themes that are selected encourage visitors to consider works of art in relationship to the space in which they are exhibited, to contemplate oppositions of light and darkness, to consider the role of color in contemporary art, and to contemplate the interaction of music and the plastic arts—each of these subjects having been reflected in past exhibits.

Because there is a continually changing display of pieces in the collection, it is impossible to describe for the visitor, in advance, just which piece of art will be found at any one time in any particular place. However, it is possible to see work by some of the most acclaimed international Concrete artists and the most recent work by Minimal and Conceptual artists.

For example, in one exhibition, *Vue du collectionneur (Collector's View)*, wherein Albers-Barrier examined the subjectivity of her own collection, one was able to find juxtaposed, Cécile Bart's *Vitres (noir) (Black Glass Panes)*, a thoroughly Minimalist construction of three huge black-framed glass panes, standing side by side, in sharp contrast to *Tableau-espace R 1209 (Space Painting R 1209)*, Gottfried Honegger's simple, vibrant, green acrylic construction on a wood bar

that hung on the wall nearby. The space shared by these two pieces eloquently led the visitor to consider the relationship of these two pieces in their shared environment, and in Albers-Barrier's collection itself. Similarly contrasted in this same show were Adrian Schiess's *Travail plat (Flat Work)*, a long, rectangularly shaped aluminum form, painted with pink automobile lacquer, which rested just off the floor, and shared space with an elevated display of a tightly rolled turquoise-blue, conical-shaped form, *Acrylfarbe (Acrylic Color)* by Stefan Gritsch.

On another occasion, such as the show *Espace libéré (Liberated Space)*, visitors were able to consider one of Dan Flavin's electric light constructions. *Sans titre (To Caroline) (Untitled—To Caroline)* was an assemblage of six, alternately spaced fluorescent light bulbs, tightly grouped but hung at varying levels against a deep brown background. The exhibit was described by Flavin himself, who wrote, "One might say that in making both space and the spectator visible, light, in itself, 'creates' them." In this same exhibit, Michel Verjux's *Duo sous les voûtes (Duet under the Arches)* challenged viewers to consider the effect created by the presence of Verjux's two geometric, sconce-like shapes on the natural space beneath the arches of the old château.

While the majority of the collection is constantly being rearranged in response to the theme of an individual exhibit, an isolated number of pieces are on permanent view. The entrance court is graced by the elegant simplicity of Ulrich Rückriem's sculpture, *Africa nero (Black Africa)*—four, roughly-cut

slabs of granite that create a shallow pool of reflecting water. This piece rests on the rough cobblestones of the old courtyard and echoes their shape and that of the entrance door. Similarly, Gottfried Honegger's carved granite geometric perpendicular sculptures, *Division 13* and *Division 10*, stand on the grounds, silhouetted against one of the château's three towers.

The mission of L'Espace de l'Art Concret is passionately communicated by Gottfried Honegger: "We would prefer not to be regarded as a museum but as an alternative to what happens elsewhere. Our goal is didactic and political: to teach visitors how to see, help them learn how to learn." Consequently, he and Sybil Albers-Barrier have assumed a largely educational objective for L'Espace, attempting to engage the public in part by posting ever-changing provocative questions on the walls of the château, by challenging visitors to develop a critical sense of the meaning of the work exhibited. In addition, a devoted group of staff members make a point of greeting visitors, often accompanying them personally through an exhibit and engaging them in a dialogue about the space, the work, and the meaning of the art.

In keeping with the expressed philosophical mission of those who are responsible for L'Espace de l'Art Concret, the environment is visitor-friendly, providing a satisfying aesthetic and intellectual experience in a warm and inviting setting. As Françoise Chatel, director of the Côte d'Azur/Provence Regional Center for Art and Culture, suggests, "This is a unique setting in which to consider art of the late twentieth century as an echo of all the artistic activity that has occurred here in the past."

THE EVER-CHANGING EXHIBITS AT THE SPACE FOR CONCRETE ART ARE ALWAYS DESIGNED AROUND A SPECIFIC THEME. IN A "MUSEUM IMAGINED BY ARTISTS," NOTED CONCRETE ARTIST GOTTFRIED HONEGGER EXHIBITS TWO OF HIS WORKS, *SPACE PAINTING R 1209* AND *P 860*. L'ESPACE DE L'ART CONCRET. PHOTO: MICHEL DE LORENZO

LE MUSÉE NATIONAL FERNAND LÉGER
THE NATIONAL FERNAND LÉGER MUSEUM

Chemin du Val-de-Pôme, 06410 Biot
Tel: 04–92–91–50–30

Open Wednesday to Monday from 10:00 A.M. to 12:30 P.M.
and 2:00 P.M. to 5:30 P.M. October through April;
from 10:00 A.M. to 12:30 P.M. and 2:00 P.M. to 6:00 P.M.
May through September.
Closed Tuesday and holidays.

THE MULTICOLORED CERAMIC *CHILDREN'S GARDEN* DEMONSTRATES LÉGER'S PASSIONATE INTEREST IN INTEGRATING THE CONTRASTING TECHNIQUES OF CERAMICS AND SCULPTURE. LE MUSÉE NATIONAL FERNAND LÉGER. PHOTO: MICHEL DE LORENZO

U NLIKE THE VAST majority of artists who chose to spend important periods of their lives on the Riviera, Fernand Léger (1881–1955) was resolute in his preference for cooler climes. Born in the heart of Normandy in the town of Argentan, Léger liked neither the sun nor the heat and was relatively impervious to the charms of the Mediterranean light and landscape. In fact, it wasn't until several years

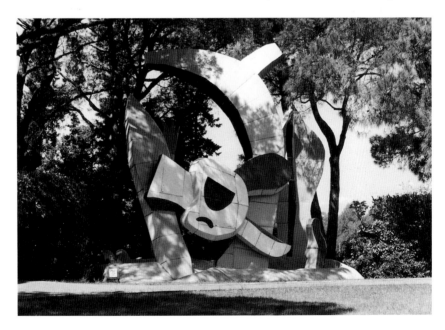

before his death that Léger began to spend regular periods of time in Southern France.

Léger was attracted to the Riviera by his former student, the ceramist Roland Brice. Brice had come to Biot, the charming little glassblowers' village situated five miles inland from Antibes, in 1949 with the intention of pursuing work in ceramics. This was the period during which a revival of this traditional art form was taking place in nearby Vallauris, the celebrated potters' town (see Chapter 5). The innovative work of a talented young group of ceramists had revived interest in the medium in the early 1940s. This was followed, in 1948, by the dramatic impact of Picasso's presence in Vallauris, which brought unprecedented attention to the ceramic arts. Other major twentieth-century artists who lived in the Mediterranean area—Chagall and Matisse in particular—were also creating new work in this age-old craft. Brice, too, began to experiment in novel forms, reminiscent of those he saw being developed around him.

In the early years of the 1950s, Léger joined Brice in Biot. Léger, however, couldn't have been less interested in the innovatively molded and whimsically decorated plates, vases, and other utilitarian ceramic pieces that were being produced in the area. Léger had been presented by Brice with plates and platters decorated with Léger's own motifs, adapted from work on which they had previously collaborated, but Léger had his own ideas about the type of ceramic work he wished to pursue. Léger's goal was to explore the possibility of developing large-scale architectural ceramic murals,

similar in many ways to the monumental painted murals for which he had become well known.

Léger's reputation as a muralist and painter had been long established. Arriving in Paris in 1900 at the age of nineteen, after having worked as an architect's assistant in Normandy, he soon discovered the canvases of Cézanne, which had a profound influence on him, as did the work of the Parisian avant-garde. It wasn't long until he was living and working in the same area of Paris as Chagall, Delaunay, and Soutine— together with the poets Blaise Cendrars and Guillaume Apollinaire. By 1910, he knew Picasso and Braque. The effects of the emerging Cubist movement, that was born of their collaboration became visible in his own work, which was to become a variation on Cubism, as the brightly painted objects in his paintings assumed the shapes of spheres, cones, and cylinders.

Léger's most distinctive work emerged in the years following his experience at the front during World War I. Admitting that his "contact with machines and a violent and crude reality" during the war might account for his preoccupation with mechanical forms and objects, his painting began to reveal the predominant themes with which he is identified. Believing that "in a mechanical age, art should take on a mechanical character," Léger's style and subject matter emphasized the machine-driven nature of highly industrialized societies: gears, pistons, building girders, railway wheels and cogs. The figures in his paintings, at work or at play, assumed massive proportions and were portrayed as impersonal automatons, symbols of

LE MUSÉE NATIONAL FERNAND LÉGER

mechanized life in modern urban centers. Even when he turned to the theme of leisure in several major paintings, the same use of vivid primary colors and a strident mechanized style dominated his work.

The influence of Léger's several trips to the United States—including the five years he spent there during World War II—reinforced his fascination with the objects and frenzy of modern life.

The forms of Léger's work took many shapes and were realized in a variety of media. Like other major artists of his era, Léger illustrated books, designed stage sets and costumes for ballet and opera, including the Swedish Ballet's *Skating Rink* with music by Arthur Honegger, and *La Création du Monde (The Creation of the World)* with music by Darius Milhaud, followed later by Prokofiev's *Le Pas d'Acier*, and Jules Supervielle's opera *Bolivar* with music by Milhaud. He directed his own film, *Le Ballet Mécanique*, the first without a scenario. Not limited to easel painting in oils, he executed works in stained glass, tapestry, mosaic, three-dimensional sculpture and, most significantly, designed huge polychrome murals. These decorative works, in which he strived to separate color from form, brought him great acclaim. It was his passionate interest in developing architectural-style ceramic sculpture and murals that brought him to Biot. And that led, ultimately, to the creation of a national museum in his name.

Striking in appearance, the architecturally modern Musée National Fernand Léger is home to an impressive collection of Léger's work. The museum is situated on a luxuri-

antly planted site on the very grounds that Léger had purchased, only a month before his death in August 1955, with the intention of building a studio and workshop. After his death, his second wife and former student, Nadia Khodossievitch Léger, in collaboration with Georges Bauquier, another loyal student from his Paris studio, undertook the construction of a museum in his honor. The structure was designed by Nice architect André Svetchine. Subsequent to its inauguration in 1960, Nadia Léger and Georges Bauquier donated the museum's collection to the French nation, an act which resulted in its being elevated to the prestigious status of a national museum. In 1990, the museum underwent major renovations and expansion so that it could accommodate the additional works in monumental dimensions that the original donors wished to bequeath to the museum.

Built on a slight elevation with five brilliantly colored mosaic murals on several sides, the museum can be seen from afar, its walls "bursting with life," as Léger had described the impact achieved by applying "blocks of pure color in a dynamic fashion." The most important of its exterior murals is located on the entrance façade. This massive, multicolored composition, executed in glazed enamel mosaic, was originally intended for a sports stadium in Hannover, Germany.

The museum's exterior is further enlivened by the presence of several of Léger's three-dimensional sculptures. The most dramatic is *Le Jardin d'Enfants (The Children's Garden)*, a huge polychrome ceramic structure with individually sculpted forms

84

THE ENTRANCE FAÇADE OF THE LÉGER MUSEUM IS ENLIVENED BY THE SPARKLE OF A MONUMENTAL, GLAZED-ENAMEL MOSAIC THAT WAS ORIGINALLY DESIGNED FOR A SPORTS STADIUM IN HANNOVER, GERMANY. LE MUSÉE NATIONAL FERNAND LÉGER. PHOTO: MICHEL DE LORENZO

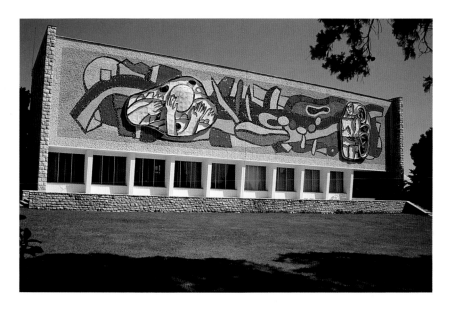

which were assembled directly on the museum's grounds after Léger's death. This important work demonstrates Léger's passionate interest in integrating the contrasting techniques of ceramics and sculpture. The presence of the mosaics, which sparkle in the sunlight, combined with the vividly colored ceramic sculpture, create a sense of enthusiastic anticipation upon arriving at the museum's entrance.

The museum's collection, comprised of more than 350 individual works, serves a biographic role as it traces Léger's artistic production throughout his lifetime. These works —drawing, oils, tapestry, stained glass, and ceramic—represent the themes and technical challenges that preoccupied Léger throughout his career.

The spacious entrance hall, with its simple white walls, is illuminated by a huge stained-glass window, *La Branche (The Branch)*, and adorned with two tapestries—*Les Baigneuses (The Bathers)*, and hanging at the top of the steps is *La Cocarde*, the official French tricolor rosette.

The first of two entrance-level galleries is devoted to drawings, gouaches, ceramics, bas-reliefs, sketches, and numerous preparatory studies for some of Léger's major ceramic constructions. Located at the far end of this gallery is one of several studies—this one in black-and-white—for *Les Femmes au Perroquet (Women with a Parrot)*, the lavishly colored mosaic mural that Léger designed for the terrace garden of La Colombe d'Or, the famous museum-like inn in Saint-Paul-de-

Vence. To the left of the mosaic and just in front of a window is a small study for the enormous *Jardin d'Enfant* sculpture, which stands, greater than life-size, just behind it in the garden.

In describing the work of Léger's "Biot Period," Nelly Maillard, the museum's archivist, emphasizes the role of preparatory studies for his ceramics. "Each of Léger's sculptural ceramics begins with sketches, drawings, and various models that permit us to study the transitions and development of the work as he translates them into the volume that ceramics permit."

A full gallery wall is covered with studies for bas-relief ceramic sculptures such as: *Les Femmes au Perroquet au fond rouge (Women with a Parrot on a Red Background)*, *Composition à l'oiseau (Composition with Bird)*, and *L'enfant à l'oiseau (Child and Bird)*. Glass display cases exhibit sketches and gouache studies for several works in the museum, including the entrance hall's tapestry and small models for some of his larger ceramic sculptures, such as his famous *La Fleur qui marche (Walking Flower)*.

The second of the first-floor galleries offers an opportunity to gather a full perspective on Léger's work, primarily in painting, from his first canvases to those completed in the last years of his life. Included are his earliest, almost Impressionist paintings, *Jardin de ma mère (My*

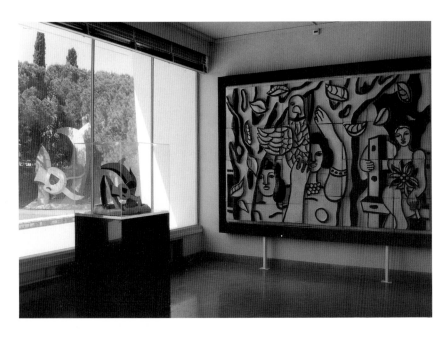

THE FIRST-FLOOR EXHIBIT GALLERY OFFERS AN OPPORTUNITY TO APPRECIATE THE EVOLUTION OF LÉGER'S WORK. THE SMALL MODEL IN THE DISPLAY CASE IS A STUDY FOR THE *CHILDREN'S GARDEN*, A HUGE, POLYCHROME CERAMIC STRUCTURE THAT STANDS OUTSIDE ON THE MUSEUM'S GROUNDS. THE BLACK-AND-WHITE *WOMEN WITH A PARROT* IS ONE OF SEVERAL STUDIES FOR THE LAVISHLY COLORED FINAL MOSAIC MURAL THAT ENHANCES THE TERRACE OF LA COLOMBE D'OR. LE MUSÉE NATIONAL FERNAND LÉGER. PHOTO: MICHEL DE LORENZO

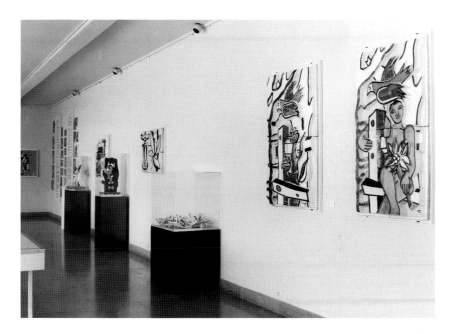

A FULL GALLERY WALL AND ADJACENT DISPLAY CASES PRESENT STUDIES FOR A NUMBER OF LÉGER'S BAS-RELIEF CERAMIC SCULPTURES, SUCH AS *THE CHILD WITH BIRD.* LE MUSÉE NATIONAL FERNAND LÉGER. PHOTO: MICHEL DE LORENZO

Mother's Garden) and *Portrait de l'oncle (My Uncle),* both done in 1905, as well as representative works completed during the next decades.

Between 1912 and 1914 Léger produced several important canvases. He describes one of them, *Étude pour la femme en bleu (Study for the Woman in Blue),* as "a battle of liberation from Cézanne. His grip was so strong that to get free of it, I had to go as far as abstraction." In *Contrastes de Formes (Contrasting Shapes)* and *Le 14 Juillet (The 14th of July)* Léger continued to work in a form of Cubism which was distinct from the formal analytic Cubism that preoccupied Picasso and Braque. In these paintings, Léger's signature bold shapes, painted in primary colors with sharp black outlines, become apparent.

The vast second-floor exhibition gallery displays many of Léger's

important later works. Léger was gassed and hospitalized during World War I. Returning to painting after these experiences, his work changed dramatically. Later in life, he reminisced about the war, recalling, "I left Paris in a period of abstraction, of pictorial liberation. Without any transition, I found myself shoulder to shoulder with the entire French nation. . . . That is just what it took to make me forget the abstract art of 1912–13." Léger's work of the 1920s reveals two general themes. The first—as demonstrated in the geometric proportions of *Le Grand Remorqueur (The Great Tug)*—is his obsession with the mechanistic aspects of everyday modern life. Second is his great preoccupation with integrating painting and architecture, as revealed in *Peinture murale (Mural Painting).* It was during this period that Léger

produced his first mural for the architect, Le Corbusier.

Of the museum's masterpieces, *La Joconde aux clefs (Mona Lisa with Keys)*, completed in 1930, is one of many paintings that fall into the series he called *"objets dans l'espace"* (objects in space). In this painting, which Léger considered "the riskiest painting from the point of view of objects contrasted," he daringly juxtaposed a simple key ring, a can of sardines, and a portrait of the *Mona Lisa.*

His account of his motivation for this diverse assemblage of objects is both amusing and informative: "In 1928 or 1930, I found a drawing . . . of a bunch of keys. I was very interested, at this point, in contrasting objects in space. I asked myself the question: What object is most opposed to a bunch of keys? I thought: The face of a woman, the body of a woman. I went out, and in a window saw a postcard of the *Mona Lisa.* I said to myself: This is it! But is it possible? In opposing a bunch of keys and, at the top of the canvas, a can of sardines, I composed the final painting from the point of view of juxtaposing objects. For me, the *Mona Lisa* is merely an object like any other."

Nelly Maillard explains that "Léger's research on the juxtaposition of planes served as a starting point for works he often called 'compositions.' For Léger, everything was an object, even the human body was an object for him. He never wanted to be sentimental."

His former student, Georges Bauquier, provides further insight into the construction of his work: "The painting itself was an object for Léger. He rejected all reminiscences of Impressionism, stripped his painting of any sentimentality, of all romanticism, rejecting all prettiness, the 'seductions of the trade' as he called them." Bauquier quoted Léger as saying, "A painter shouldn't try to reproduce a beautiful object but should work so that his painting itself is a beautiful object."

The next two decades were to witness the execution of many of his greatest paintings, several of them initiated during his wartime exile in the United States, where he became fascinated with the speed, vitality, and contrasts inherent in life in America. Two canvases, *Les Plongeurs (Divers*—1942) and *Les Quatre Cyclistes (The Four Bicyclists* —1942–46) subjects which he repeated in a variety of canvases, date from this period.

Several years later, back in France at the age of sixty-five, Léger undertook some of his largest work, murals in which the human figure predominates and in which he focused on the contrasting pursuits of modern life: work and diversion. *Les Constructeurs (The Builders)* of 1950 overflows with the images from the building trade: rivets, bolts, ironwork, steel girders, ladders, and muscled construction workers. It is painted in the same primary colors—red, blue, yellow, white, and black—that had become totally identified with Léger's paintings. By contrast are the great murals devoted to leisure: *Les Loisirs sur fond rouge (Leisure*—1948), *La Grande Parade sur fond rouge (The Great Parade*—1953), and *Le Campeur (The Camper*—1954). Even in these canvases, which capture the joy of relaxation, Léger is intent on communicating the impact of the modern world. In describing this era,

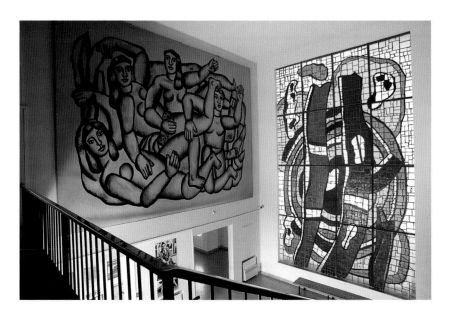

A HUGE STAINED-GLASS WINDOW, *THE BRANCH*, ILLUMINATES THE LÉGER MUSEUM'S VAST ENTRANCE HALL. IT IS FURTHER ADORNED BY THE *BATHERS*, ONE OF SEVERAL IMPORTANT TAPESTRIES IN THE MUSEUM. LE MUSÉE NATIONAL FERNAND LÉGER. PHOTO: MICHEL DE LORENZO

he wrote: ". . . an epoch of contrasts, a life of fragments. Our countrysides, which were once melodious, are bursting with metallic geometry which rises everywhere to hold the clouds. The multicolored billboard of the gray village, the tiny travelers lost in the maze of iron architecture. Our paintings are real if they represent this visual evolution."

Léger's last years were devoted to his monumental murals and his incessant efforts to establish a vital relationship between architecture and modern art. He—like Bonnard, Braque, Chagall, Matisse, and Rouault—took on ecclesiastic projects, contributing to the decoration of the Church of Notre-Dame-de-Toute-Grâce in the Savoie. He designed the mosaic mural for the façade of the Church of Audincourt, a panel for the major meeting room

of the United Nations in New York, made a model for a ceramic mosaic for Gaz de France, designed the decoration of the concert hall of the Opera of Sao Paulo, Brazil, as well as stained-glass windows for l'Eglise de Courfaivre in Switzerland and the University of Caracas in Venezuela.

This "cathedral of modern art," as the Léger Museum has sometimes been called, was the first museum in the world built exclusively for the work of a single artist. Conceived and financed by his wife and Georges Bauquier, the museum's original honorary board consisted of Léger's colleagues Braque, Chagall, and Picasso. The museum celebrates Léger's stay in Biot, which, although brief, was where he undertook some of the most important work of his career.

AS RENOIR'S HEALTH DECLINED, HE WAS CARRIED IN THIS PORTABLE CHAIR FROM HIS BEDROOM TO THIS SMALL STUDIO, WHICH WAS SOMETIMES USED IN THE WINTER BECAUSE IT WAS EASY TO HEAT. LE MUSÉE RENOIR. PHOTO: MICHEL DE LORENZO

LE MUSÉE RENOIR
THE RENOIR MUSEUM

Le Domaine des Collettes, Avenue des Collettes, 06800 Cagnes-sur-Mer
Tel: 04–93–20–61–07

Open Wednesday through Monday from 10:30 A.M. to 12:30 P.M. and
1:30 P.M. to 6:00 P.M. May through September;
from 10:00 A.M. to Noon and 2:00 P.M. to 5:00 P.M. October through April.
Closed Tuesday, holidays, and three weeks in October–November.

IN 1903, when Auguste Renoir (1841–1919) was at the height of his fame, he settled in what was then the charming and tranquil little town of Cagnes-sur-Mer. He rented an apartment in a building that also housed the town's post office and moved in with his wife and the youngest of their three sons, Claude. This building, still affectionately known as "La Maison de la Poste," has since been converted into Cagnes' Town Hall. But during his residence, from his apartment windows Renoir could revel in the views of nearby orange and olive orchards, as well as the meadows filled with jasmine, mimosa, lavender, carnations, and roses that supplied the perfume distilleries in Grasse (and would become the subjects for many of his paintings).

Together with many artists before and after him, Renoir was attached to this region and its riches. He was captivated by the luxurious landscapes, the soft luminosity of the light, and the radiance of the colors. He had traveled to the south on many prior occasions. Moving as the "nomad" that his son Claude called him, he visited Cézanne in Aix-en-Provence in the early 1880s, traveled

RENOIR BUILT A LARGE HOME AT LES COLLETTES, BUT HE WAS PARTICULARLY ATTACHED TO THIS SIMPLE PROVENCAL FARMHOUSE, SURROUNDED BY HIS BELOVED OLIVE TREES, WHICH STOOD ON THE PROPERTY WHEN HE PURCHASED IT. LE MUSÉE RENOIR. PHOTO: MICHEL DE LORENZO

with Monet to Italy during the same period, and—in the early years of the twentieth century—rented houses in a variety of nearby spots including Grasse, Magagnosc, and Le Cannet. But now in his early sixties, Renoir, who had suffered for years from a variety of debilitating ailments, including chronic rheumatism, bronchitis, arthritis, partial facial paralysis, bouts with influenza and pneumonia, moved more or less permanently to Cagnes, seeking relief for his crippled, aching body from the warm sun of the south.

Renoir was seduced by Cagnes. As another son, Jean (who was to become a famous film-maker), recalls it, "The story of Cagnes and Renoir is a love story," and from the time the artist moved into the Maison de la Poste until his death some sixteen

years later, he was to spend the better part of every year there, leaving only at the height of summer for Essoyes in the Champagne country or for brief visits to Paris. With the first chill, he would return to the warmth of Cagnes, "exalting," as his son, Jean, recalls, "in the profusion, variety and sumptuousness of the Mediterranean landscape (that) . . . he seemed to discover anew with each painting. . . ."

In 1907, in part to save a rambling grove of beloved olive trees threatened with destruction by developers, in part to please his wife who sought a permanent "proper home," Renoir purchased a nearby country property, Le Domaine des Collettes. Renoir had fallen under the spell of the site, with its acres of knotty and robust olive trees, groves

THE COUNTRYSIDE SURROUNDING CAGNES—RICH WITH OLIVE TREES, PINES, AND CYPRESSES—WAS THE SUBJECT OF MANY
OF RENOIR'S WORKS. PENCIL AND CHARCOAL SKETCH BY MAURICE FREED, 1960–61.

of orange trees, meadows of clover and uncultivated rosebushes, and had often painted there. While the property included a small and simple Provençal farmhouse to which Renoir was particularly attached, he capitulated to his wife's desires and built a large bourgeois-style house on the grounds, which provided both the comfort his health required and the setting for a life-style his wife craved.

By the time Renoir moved to Cagnes and had initiated this building project, he had achieved great fame and its accompanying fortune. His early paintings, filled with shimmering, color-drenched light that reflects from every surface, had been exhibited in a series of shows organized by *"Les Peintres Impressionnistes"* ("The Impressionist Painters") beginning with their first

group show in 1874. It was at this exhibit that the term "Impressionist" was first used, initially as a derisive label to identify this group of artists, in a mocking reference to Claude Monet's painting, *Impression–Sunrise*. In these years, from the late 1860s—when, side by side with his friend Monet, he did a series of paintings of frog ponds—until 1882, Renoir was at the height of his Impressionist period and produced some of his most popular masterpieces: *Sailboats at Argenteuil, The Swing, La Moulin de la Galette,* and *The Luncheon of the Boating Party.*

But Renoir was not to remain identified with the Impressionists forever. By the mid-1880s, he had broken with them, believing that he no longer knew "how to paint or to draw." He was convinced that the

result of working in the open air and concentrating primarily on the transient effects of light had diminished his knowledge of pictorial composition and form. The next years—working in what he referred to as his "*manière aigre*" (alternately called his "harsh," "dry," or "tight" period)—were spent recultivating his ability to draw and compose. It was during this period that he produced one of his most famous paintings, *Les Grandes Baigneuses (The Women Bathers)*, a painting which displayed this revived concern for drawing, illustrated by the careful outlines of his classical figures juxtaposed with the lush background reminiscent of his earlier Impressionist period.

The last ten years of the nineteenth century—shortly before the move south because of his deteriorating health—witnessed the development of Renoir's mature style, which would characterize the paintings he produced during the rest of his life. These paintings, a few of which are preserved in the Musée Renoir, retain some of the shimmering effects of the earlier Impressionist paintings, but, more importantly, they possess a sculptural quality and a blossoming sensuality, infused with a radiance of deep, rich, almost palpable color that was not characteristic of his earlier work.

Visiting Les Collettes is a journey back in time. Far more than a museum, particularly since Renoir's greatest masterpieces hang in museums elsewhere, it is the atmosphere of his gardens, naturally transformed with the changing seasons, the unassuming *fermette* (little farmhouse)—now the site of the admission and documentation center—and the authenticity of his home and simple possessions that pervade the site. Frédérique Verlinden, the curator of the museums of Cagnes, speaks with reverence about the surroundings, emphasizing that "the essence of a visit here is [to experience] Renoir's communion with nature: his garden, the Domaine des Collettes and the countryside he loved to paint."

In his book, *Renoir, My Father,* Jean Renoir recalls that these were good years for Renoir. He pursued the passion of his life, painting daily—portraits, still lifes, and landscapes seen from his garden. He maintained his love for life, his gaiety and sensuality, despite the continuing decline of his body. He rejoiced in the grounds of Les Collettes, recognizing that "he needed his silver olive trees of Provence, just as thirty-five years earlier he had needed the blue-tinted undergrowth of Fontainebleau." He took pleasure in the visits of friends and colleagues who called on him, eager to see his work or to show their own. Among them were Henri Matisse, Aristide Maillol, Pierre Bonnard, Amedeo Modigliani, and his art-dealer, Ambroise Vollard.

All those who paid visits to Renoir considered him "*le maître,*" the great master, and accorded him the appropriate respect. Matisse, who moved to the Riviera in 1917 (see Chapter 16), visited Renoir almost immediately upon arriving in Nice. Matisse once described his relationship with Renoir, recalling to art historian Alfred Barr, "When I was young, I was very fond of Renoir's painting. Toward the end of the first World War, I found myself in the Midi. Renoir was still alive, but very old. I still admired him and I decided to call on him at Les Collettes, his place at Cagnes. He received me in a

very friendly fashion and so, after a few more visits, I brought him a few of my paintings, to find out what he thought of them. He looked them over with a somewhat disapproving air. Finally he said, 'Well, I must speak the truth. I must say I don't like what you do, for various reasons. I should almost like to say that you're not really a good painter, or even that you're a very bad painter. But there's one thing that prevents me from telling you that. When you put on some black, it stays right there on the canvas. All my life I have been saying that one can't any longer use black without making a hole in the canvas. It's not a color. Now you speak the language of color. Yet you put on black and you make it stick. . . . I suppose you are a painter after all.' "

Matisse admiringly said of Renoir, "His life was a long martyrdom; he suffered for twenty years from the worst form of rheumatism... but as his body dwindled, the soul in him seemed to grow ever stronger and to express itself with more radiant ease." Perhaps inspired by Renoir's example, Matisse, too, persevered with his art into old age, despite severe physical discomfort.

It seems that Renoir permitted himself to speak openly to Matisse about his life, and Matisse would later comment upon Renoir's "unabashed enthusiasm for female beauty" and "the women to whom he had made love."

Despite the fulfillment of the

Cagnes period, the debilitation of Renoir's body continued. He became thinner and thinner, ultimately relinquishing the use of his two canes and accepting confinement to a wheelchair. Daily, he was carried from his bedroom to one of his studios or transported in his light bamboo chair out to the gardens and fields surrounding his home. His hands became increasingly twisted and deformed, to the point that they had to be bandaged to prevent his tightly curled fingers from destroying the flesh of his palms. He was now limited to the use of a single brush, which was inserted between the bandages that protected his hands.

Exploring Les Collettes and its collection of lovingly preserved personal possessions, a small group of oils and sculpture offers a glimpse of his life there during the early years of this century. The most enriching visit to Les Collettes is preceded by a leisurely walk through his gardens where, as Frédérique Verlinden describes it, "every effort is being made to preserve the natural, untended look that he preferred." Renoir disliked the symmetry of formal French gardens, insisting on maintaining the spontaneous growth of violets, dandelions, clover, the roses that grew wild and unmowed lawns. It is these gardens and surroundings that capture Renoir's

spirit and provide insight into what inspired him.

Depending on the time of year, various aspects of the landscape greet the visitor. In the spring, the medieval village of Haut-de-Cagnes with its Château-Musée towering above, is visible through a screen of sweet-smelling orange blossoms. In the winter, it is the oranges themselves that frame the view. Year round, the olive trees—some of them centuries old and each with its own distinctive shape—are reminders of Renoir's passion for painting those trees again and again.

Standing prominently on the gravel path behind the house is the sculpture *Vénus Victrix (Venus Victorious)*, done in the last years of Renoir's life. Renoir didn't begin to sculpt until coming to Cagnes, initiating his first piece in 1907 with the encouragement of his friend, the sculptor Aristide Maillol. Unfortunately, because his hands were so crippled, he was able to complete only two pieces on his own. Both of these, *Buste de Coco (Head of Claude*—his youngest son, affectionately called Coco) and a small medallion, *Médaillon de Claude*, are displayed in the house. The stately *Vénus Victrix* is considered by Renoir scholar Paul Haesaerts, to be "the most complex and best" of Renoir's sculptures. It was done in 1915–16 with the assistance of Richard Guino, a young Spanish sculptor trained in Paris by Maillol. This piece, originally executed in clay from the property, was started in the basement of the house but was completed outdoors under the shade of the olive trees.

Over the next five years, Guino assisted Renoir with some twenty additional sculptures. Guino carried out Renoir's directions, communicated with a few words and the long stick Renoir used as an extension of his now incapable hands. Included among the sculpture to be found inside the house are the *Buste de Madame Renoir (Head of Madame Renoir)*, *Le Berger Pâris (The Shepherd Pâris)*, *Petit Jugement de Pâris (Small Judgment of Pâris)*, *L'eau et le feu (Water and Fire)*, *L'eau ou la Petite Laveuse accroupie (Water or Small Washerwoman Kneeling)*. In addition, there are two pieces done by Guino alone—*Buste de Renoir (Head of Renoir)*, and a small work *Renoir peignant (Renoir Painting)*.

Entering this large house from its surprisingly somber north entrance, one almost has the impression that Renoir still lives there. A simple bouquet of flowers, as Madame Renoir might have arranged it, serves as a welcome—as does the sculpted head of Madame Renoir. The main salon beyond the entrance hall displays seven of the original oil paintings that are in the possession of the Musée Renoir; four more original works are in the adjoining dining room.

This collection of landscapes, nudes, portraits, and still lifes, painted between 1895–1915, include several that are most characteristic of Renoir's last period. Three among them are particularly noteworthy. The most appealing is perhaps *Coco lisant (Coco Reading)*, the charming small portrait of Renoir's youngest son, with his long, blond hair still uncut in the style Renoir encouraged for his sons. This painting has all the characteristics of Renoir's great late paintings—the radiant glow of peach, crimson, and rose that pervades the

polished surface of the painting and the tender soft contours of the cherubic face and young body.

Les Grandes Baigneuses (The Women Bathers) is a repetition of the famous *Les Grandes Baigneuses* painted in 1887, four or five years earlier. The original version, which Jean Renoir claims his father considered "the culmination of his life's work," now hangs in the Philadelphia Museum of Art. This second version, with its luscious fluid bathers, overflows with the warmth of the red palette that infused his later paintings.

Les Canéphores, also called *Les Cariatides (Caryatids)*, brings to fruition the sculpted dimension of Renoir's later paintings. His sensuous rendition of the *canéphores*, young women who carried offerings to the temples in ancient Greece, displays all of the opalescent, almost translucent quality that distinguished so many of Renoir's greatest works. Other paintings include *Portrait de Madame Pichon*, *Portrait de Colonna Romano*, *La Jeune Femme au Puits (Young Woman at the Well)*, *La Nature Morte aux Pommes et aux Amandes (Still Life with Apples and Almonds)*, and *Paysage (Landscape)*.

To the left of the salon is the dining room, the heart of the Renoir home. Although Renoir had two studios on the second floor, he often chose to paint in this room, which is flooded with afternoon sunlight. The dining room has been preserved with the same stark simplicity that Renoir preferred. The room has little ornamentation other than its marble fireplace, its wainscoted walls, and its furnishings—essentially limited to the large white breakfront and a solid wood dining table surrounded by the same Thonet-style caned chairs that appear elsewhere in the house.

The second floor of the house contains the four family bedrooms: one each for Renoir, Madame Renoir, and their youngest son, Coco, and a fourth shared by the older sons, Jean and Pierre, when they visited Les Collettes. The one bathroom—unusually well-equipped for the period—has a humorous and delightful personal touch in the hand-decorated and badly drawn ceramic tile of a nude on a bidet. The tile, attributed by Georges Dussaule (former curator of the museum), to young Claude is discreetly placed low on the wall to the right of the bathtub.

Most important of the second-floor rooms are, of course, Renoir's studios. The larger of the two, at the top of the steps, conveys a sense that Renoir might still be alive and at work. Open and ready for use is his paint box, tubes of paint, scrupulously clean square palette, jars holding an assortment of brushes, and his paint rags. The easel holds a facsimile of a work in progress and the wheelchair his shawl. Scattered throughout the room are various props—a straw hat, a bouquet of roses, stores of canvases, a day bed, and ornaments for his models. Anecdotally, the large northern-exposed window is covered with chicken wire, a protection against a repetition of the tennis ball that came flying through the window one day, splattering vermilion paint all over the jacket of art-dealer Vollard.

On the other side of the second floor, next to Jean and Pierre's room, is the smaller "winter" studio, which was easier to heat and was bathed in light from the east and west, as

RENOIR DIDN'T BEGIN TO SCULPT UNTIL HE CAME TO CAGNES. *VÉNUS VICTORIOUS*—COMPLETED WITH THE HELP OF HIS ASSISTANT, RICHARD GUINO—WAS EXECUTED IN THE LAST YEARS OF RENOIR'S LIFE. LE MUSÉE RENOIR. PHOTO: MICHEL DE LORENZO

THIS *HEAD OF COCO*, AS RENOIR'S SON CLAUDE WAS AFFECTIONATELY CALLED, IS ONE OF THE ONLY TWO PIECES OF SCULPTURE THAT THE ENFEEBLED RENOIR WAS ABLE TO COMPLETE ON HIS OWN. LE MUSÉE RENOIR. PHOTO: MICHEL DE LORENZO

well as the north. The room, a
reminder of Renoir's precarious state
of health in later years, holds the
folding chair in which he was often
carried, as well as his collapsible
easel.

Throughout the house are display
cases with a variety of Renoir's
personal objects. In his bedroom are
his favorite fine brown-and-white
tweed jacket and a lavender-and-
white scarf. Elsewhere is the small
porcelain palette that permitted
him to judge the transparency of
colors, the bell he used to call for the
servants, the cup-and-ball game
(bilboquet) that he used to help
maintain some strength in his hands,
several canes, and numerous
photographs.

More than anything else in the
house, these photographs are
poignant reminders of the deteriora-
tion of Renoir's body and his personal
determination to continue working,
bringing to life his son Jean's
statement, "the more he suffered, the
more he painted."

Of all the artist-named museums
on the Riviera, the Musée Renoir
provides a special intimacy born of
the fact that this is where he painted,
lived, raised the youngest of his
three sons, lost the wife who had
protected him throughout the years,
and ended his days.

After Renoir's death in 1919 his sons
maintained the property until it
was purchased by the town in 1960
and turned into a museum. While
Cagnes-sur-Mer has become a
bustling little town today, deprived of
the orange groves and fields of
flowers Renoir loved, his property
retains the tranquillity, simplicity, and
authenticity that characterized his

life. In the gardens, his beloved olive
trees stand as a living memento to
Renoir, representing the challenge
that led him to say: "The olive tree,
what a swift pain . . . if you can
imagine the difficulties it poses . . .
how those little leaves have made me
sweat. . . . One gust of wind and the
whole tree changes color. The color
isn't in the leaves but in the empty
spaces."

LE CHÂTEAU-MUSÉE

THE CHÂTEAU MUSEUM

Haut-de-Cagnes, 9 Place Grimaldi, 06800 Cagnes-sur-Mer
Tel: 04–93–20–85–57

Open Wednesday to Monday from 10:30 A.M. to 12:30 P.M. and
1:30 P.M. to 6:00 P.M. May through September;
from 10:00 A.M. to Noon and 2:30 P.M. to 5:00 P.M. October through April.
Closed Tuesday, holidays, and four weeks in October–November.

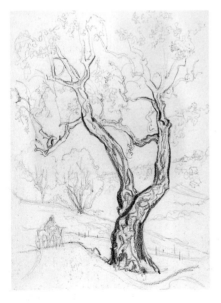

STATELY OLIVE TREES, CONSIDERED PRIZED POSSESSIONS
IN TRADITIONAL PROVENÇAL LIFE, ARE CELEBRATED BY MANY
ARTISTS WHO MADE THE RIVIERA THEIR HOME. CHARCOAL
SKETCH BY MAURICE FREED, 1960–61.

THE LOVELY VILLAGE of Haut-de-Cagnes, with its steeply sloping streets and ancient, vaulted passages, is an enduring vestige of the Middle Ages. Perched high above the relatively modern seaside town of Cagnes-sur-Mer that lies sprawled out below it, Haut-de-Cagnes is dominated by its imposing fourteenth-century Château, which rises above the entire village. Originally a fortified Provençal castle built by the Grimaldi family, who reigned in nearby Monaco and over much of the surrounding region, the structure was transformed in the early seventeenth century into a sumptuously decorated private palace by a descendant of the original Grimaldi lords. It remained a residence until the Grimaldis fled the area during the French Revolution.

Some hundred years later, this castle—which had retained the baronial double staircase at its entrance and a very grand interior Renaissance courtyard surrounded by two-story columned galleries—was restored to much of its original splendor. In 1936 it was purchased by the municipality of Cagnes for the purpose of creating a museum devoted to local history and to the olive tree—an important

THE OPEN, FIRST-FLOOR RENAISSANCE COURTYARD, SURROUNDED BY TWO-STORY COLUMNED GALLERIES, HAS BEEN RESTORED
TO ITS ORIGINAL SPLENDOR. LE CHÂTEAU-MUSÉE. PHOTO. MICHEL DE LORENZO

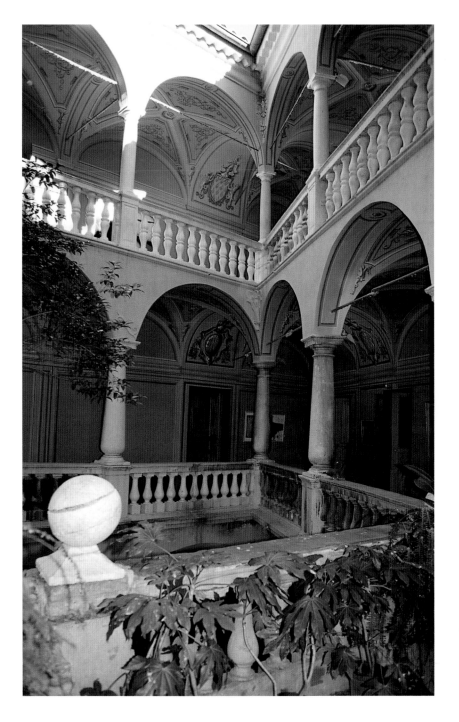

agricultural commodity in the region. Today, classified as an historic monument, the Château can be seen from afar, proudly waving the colorful flags that beckon the curious to come and discover the diverse collection housed within its ancient walls.

The imposing, if somber, entrance to the museum in no way prepares the visitor for the delightful surprise of the interior patio that is open to the sky and filled with flowering potted plants. Occasional birds swoop in and out of the greenery, often resting on a 200-year-old pepper tree that reaches high above the three stories of the museum. Part of the pleasure of visiting this museum is the unanticipated opportunity to enjoy spectacular views over the rooftops of the ancient village and the surrounding countryside.

The Château-Musée's permanent collection—actually organized as a series of mini-museums—is displayed in small, vaulted chambers that open onto the first-floor courtyard, as well as in more spacious rooms on the upper two stories. The collection itself consists of a curious blend of modern art, combined with objects of local and historical interest.

Several of the eight rooms on the first floor are reserved for the Musée de l'Olivier (Museum of the Olive Tree), a unique ethnographic collection devoted to the olive trees that are abundant throughout the area. Frédérique Verlinden, the curator of the museums of Cagnes, speaks eloquently of "this remarkable, majestic

THE OLIVE TREE MUSEUM, ONE OF THE MINI-MUSEUMS CONTAINED WITHIN THE CHÂTEAU-MUSÉE, IS AN ETHNOGRAPHIC COLLECTION DEVOTED TO THESE TREES, ABUNDANT THROUGHOUT THE AREA. LE CHÂTEAU-MUSÉE. PHOTO: MICHEL DE LORENZO

A 200-YEAR-OLD PEPPER TREE REACHES HIGH ABOVE THE THREE STORIES OF THE MUSEUM. LE CHÂTEAU-MUSÉE.
PHOTO: MICHEL DE LORENZO

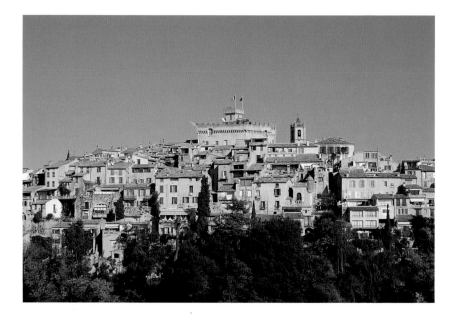

THE PERCHED VILLAGE OF HAUT-DE-CAGNES, AN ENDURING VESTIGE OF THE MIDDLE AGES, IS DOMINATED BY ITS FOURTEENTH-CENTURY CHÂTEAU. NOW CLASSIFIED AS AN HISTORIC MONUMENT, IT WAS CONVERTED INTO A MUSEUM IN 1936. LE CHÂTEAU-MUSÉE. PHOTO: MICHEL DE LORENZO

tree," explaining that evidence of wild olive trees in the area pre-dates the arrival of the Greeks, who brought their techniques of cultivation with them.

Referring to the paintings of olive trees in the museum, Ms. Verlinden emphasizes that this "eternal and robust tree," each with its own distinctive character, has been memorialized in the works of many artists, noting, in particular, that Renoir, who lived in Cagnes-sur-Mer, was so enamored of these olive trees that he purchased the estate that was to become his final home to preserve an olive grove from destruction (see Chapter 9).

The museum's unusual display examines various aspects of a rich local industry—the historical production and cultivation of olive trees. The exhibit includes a venerable olive oil mill and man-made objects associated with these age-old trees and their fruit: baskets, hemp filters, olivewood utensils, and earthenware Provençal jugs, known as *jarres*, in which olive oil traditionally was—and still is—stored. Particularly informative for olive aficionados is a description of forty-some varieties of olives, many of which are for sale in the local open-air markets.

Additional first-floor galleries deal with the history of Cagnes, and include several pieces of Roman sculpture uncovered in the area, as well as a descriptive mural that depicts the changes in the village over the centuries.

Much of the rest of the museum is devoted to modern art as part of the Château's Musée d'Art Méditerranéen Moderne (Museum of Modern Mediterranean Art). This rotating collection—partially displayed in the former banquet hall on the second floor and smaller rooms on the third floor—includes works by modern and contemporary painters who are either Mediterranean-born or who have lived and worked in the area. Included among them are Raoul Dufy and Marc Chagall, who painted in Vence, Francis Picabia, who lived in Mougins, Jean Cocteau, who spent various periods in Villefranche and Saint-Jean-Cap-Ferrat, and Théo Tobiasse, who lives today in the neighboring village of Saint-Paul.

A major exception to this modern art is the Grimaldi-commissioned *trompe-l'oeil* fresco on the ceiling of the banquet hall where the seventeenth-century Genovese artists, Jean Baptiste Carlone and Giulio Benso, painted (with astounding perspective) *La Chute de Phaéton (The Fall of Phaeton)*. Phaeton, in Greek mythology, borrowed the fiery, horse-drawn chariot of his father, the Sun, but was frightened by the sight of the animals of the Zodiac and lost control of it. Zeus feared the destruction of the Universe, since the chariot threatened to ignite the four corners of the earth, and so struck down Phaeton. Permanently preserved in the Marquise de Grimaldi's former boudoir is a gallery of portraits donated by Suzy Solidor, the celebrated singer who starred in Parisian cabarets between the two world wars. Solidor spent the last twenty-five years of her life in Haut-de-Cagnes where, as a friend

of many local artists, she amassed a collection of some 224 portraits of herself. Prior to her death in 1985 at the age of eighty-five, she donated forty of these portraits to the Château-Musée, including works by Cocteau, Raoul Dufy, Moïse Kisling, Marie Laurencin, Kees Van Dongen, Yves Brayer, and Foujita. These diverse portraits, all of the same woman but painted by some of this century's most important artists, offer an unusual way of considering not only different aspects of the subject, but also each artist's individual style.

Throughout most of the year, the museum's permanent collection is on display, but every summer—from the end of June until the end of September—it hosts the International Painting Exhibit, for which it has become particularly famous. This mixed-media, juried show overflows into almost every nook and cranny of the museum, renewing its ancient role as the center of local life and building a bridge from the modern town of Cagnes below to the medieval perched village above.

THE VAULTED ARCADES AND
NARROW SLOPING STREETS
OF THE ANCIENT VILLAGE OF
HAUT-DE-CAGNES ARE
CHARACTERISTIC OF THE
RIVIERA'S PERCHED VILLAGES.
CHARCOAL SKETCH BY MAURICE
FREED, 1960–61.

LA FONDATION MARGUERITE ET AIMÉ MAEGHT
THE MARGUERITE AND AIMÉ MAEGHT FOUNDATION

06570 Saint-Paul-de-Vence
Tel: 04-93-32-81-63

Open every day from 10:00 A.M. to 7:00 P.M. July through September;
from 10:00 A.M. to 12:30 P.M. and 2:30 P.M. to 6:00 P.M.
October through June.

LA FONDATION MAEGHT, situated in an incomparable hillside setting in Saint-Paul-de-Vence, is home to the extraordinary collection of modern art amassed by its donors, Aimé and Marguerite Maeght. It is further enchanced by artwork designed specifically for the site by the Maeghts' many artist friends. These works, including major paintings, sculpture, and mosaics by Georges Braque, Alexander Calder, Marc Chagall, Eduardo Chillida, Alberto and Diego Giacometti, Fernand Léger, Joan Miró, Pierre Tal-Coat, and Raoul Ubac, among many others, reside in a setting that is unique in the world of art.

When the Foundation was dedicated by André Malraux on the evening of June 28, 1964, it was the first modern art museum to be built in France since the opening of the Museum of Modern Art in Paris in 1936. However, the donors and all those associated with the Foundation have remained steadfast in their insistence that the building and grounds do not constitute a "museum" in any traditional sense of the word, but rather a space that welcomes all forms of contemporary art.

As a private institution, the Foundation has fulfilled Aimé Maeght's desire that it be "something that belonged to the community and . . . an independent enterprise that would have the power to act." The Foundation has thus maintained complete autonomy over its daring architectural design, its acquisitions, exhibitions, and multifaceted cultural activities, remaining free of the ordinary constraints to which French government-supervised regional and national cultural institutions are subject.

The story of the Fondation's evolution is a tale that traces a talented young couple's enthusiastic interest in contemporary art, and their transformation of a personal tragedy—the death of their son—into one of the most successful memorials of its kind in the modern art world.

Although Aimé Maeght was born in Belgium, he spent most of his childhood near the town of Nîmes in Southern France. Trained as a lithographer-draftsman, Maeght moved to Cannes where Marguerite Devaye, his wife-to-be, had been born. As an ambitious young man, Maeght worked in a printing company, but he also opened his own printing shop,

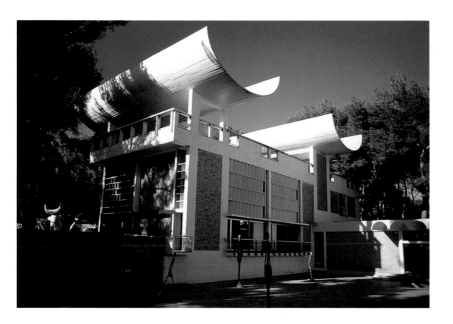

LA FONDATION MARGUERITE ET AIMÉ MAEGHT, DESIGNED BY JOSEP LLUIS SERT, REFLECTS HIS CONCERN FOR PRESERVING THE SURROUNDING NATURAL LANDSCAPE AND A DESIRE TO UTILIZE NATURAL RESOURCES. IN ADDITION TO HIDDEN LIGHT TRAPS ON THE ROOF, HE DESIGNED ROOFTOP WATER BASINS, PATTERNED AFTER ANCIENT ROMAN ARCHITECTURE, TO COLLECT RAINWATER THAT IS RECHANNELED INTO THE FOUNDATION'S FOUNTAINS. LA FONDATION MARGUERITE ET AIMÉ MAEGHT. PHOTO: MICHEL DE LORENZO

as well as an electrical supply shop. At the rear of this store, which Marguerite decorated with paintings, Maeght pursued his own lithographic work. By 1936, this shop had become their first art gallery. Then, early in his career, a significant opportunity occurred when Pierre Bonnard, living close by in Le Cannet, asked Maeght to print a color poster for him. Bonnard's appreciation for the technical quality of Maeght's work led not only to a close personal friendship, and an introduction to Matisse, who was then living in Vence (see Chapters 16 and 17), but also, with Bonnard's encouragement, the Maeghts' eventual move to Paris. During the next decade, Maeght was to become a celebrated lithographer, acclaimed publisher of art books and reviews, art dealer and agent for some of the century's most important artists, and owner of one of the most prestigious art galleries in the world. In the process, he and his wife not only acquired their own impressive art collection, but developed a long and lasting friendship with many of the artists whom they represented.

In the early 1950s the Maeghts purchased several acres of land in Saint-Paul-de-Vence. In an area known as the Gardettes Hills, close to the very area where Marc Chagall would move in 1966 (see Chapter 12), they built a Provençal *mas*, as homes in Southern France are often called. And then disaster struck.

In the fall of 1953, the youngest of their two sons, the eleven-year-old Bernard, died of leukemia. Everything they had achieved paled in the face of this tragedy.

Plunged into great despair, the Maeghts soon renamed their home "Mas Bernard." At this sad time in their lives, many of their artist friends came to their rescue. When they discovered, as if by fate, that a dilapidated old chapel near their home had been devoted to Saint-Bernard, Georges Braque suggested to the Maeghts that they restore the little chapel in memory of their son. As Aimé Maeght recalled the period, "Georges Braque urged me into an undertaking that would help me overcome my grief, a place devoted to modern art right near the spot where we live, amid the thyme and rosemary. . . . And Fernand Léger said to

me, 'If you do it, I'll bring my daubings. I'll even paint the rocks.' "

Shortly thereafter, in response to the encouragement of Léger, who had already made several trips to America (see Chapter 8), the Maeghts left for the United States. They took with them the germ of an idea to "bring together (their) entire collection and provide (their) artist friends with a place . . . to work and exchange ideas." While in America, they met Josep Lluis Sert, the famous Catalan architect who was then at Harvard University. From the preliminary discussions that took place at this time, emerged the plans that would result, ten years later, in the creation of La Fondation Maeght.

In the planning process, Sert—as the architect—in close collaboration with the Maeghts, involved many of the artists who were the couple's close

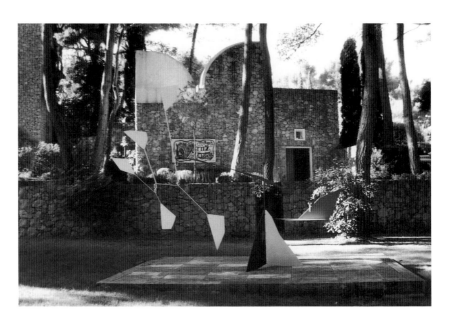

CALDER'S MOBILE, *FEATHERING*, STANDS IN THE FRONT OF THE RESTORED SAINT-BERNARD CHAPEL, WHICH IS DEDICATED TO THE MAEGHTS' SON. LA FONDATION MARGUERITE ET AIMÉ MAEGHT. PHOTO: MICHEL DE LORENZO

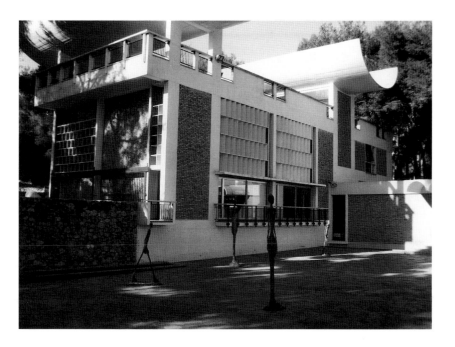

THE REAR TERRACE—KNOWN AS THE GIACOMETTI COURTYARD—IS POPULATED WITH A NUMBER OF THE SCULPTOR'S TOWERING, ELONGATED BODIES OF MEN AND WOMEN, INCLUDING *WALKING MAN* AND *TALL STANDING WOMEN*. LA FONDATION MARGUERITE ET AIMÉ MAEGHT. PHOTO: MICHEL DE LORENZO

friends, and whose work was to become an integral part of the basic plan for the Foundation's architecture. The building Sert created reflects his, and the Maeghts', abiding concern for the natural setting—not only the preservation of the surrounding luxuriant pines, cypresses, rosemary, and lavender, but the beauty of the uneven slope of the grounds. Sert was sensitive to the intense quality of the natural light and intent on subduing it so that it could be used to illuminate the interior of the Foundation. He studied the height and direction of the sun's rays and designed a series of "light traps" on the roof that permit light rays, reflecting off the ground and walls, to fall on the paintings at forty-five-degree angles. Equally aware of the

need to conserve water and make use of normal rainfall, he designed two enormous *impluviums*, which provide one of the distinctive architectural features of the overall design. These huge white rooftop curvilinear water basins, patterned after ancient Roman architecture, serve to collect the rainwater that is rechanneled into the Foundation's many fountains. Sert was also eager to create a characteristically Mediterranean feeling and chose warm, pinkish-brown hand-made bricks for the exterior walls of the buildings. The artists, for their part, were intent on integrating their works into the site as naturally as possible. Miró, for example, erected huge plywood models of sculpture in progress to be certain (as Chagall wrote) that they would be

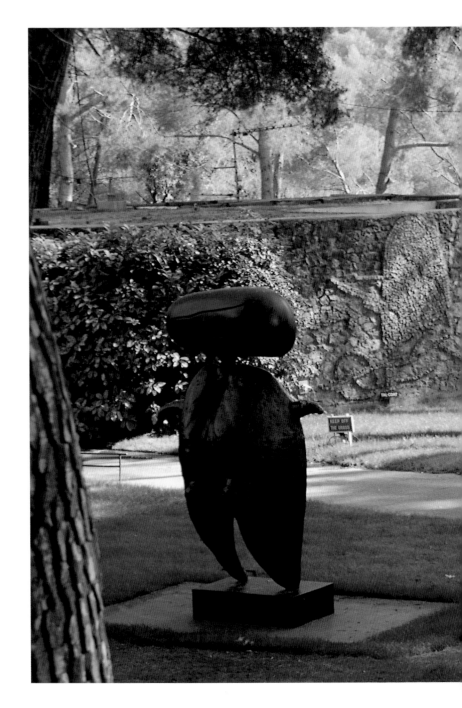

THE FOUNDATION'S FRONT SCULPTURE GARDEN, ONE OF THE MOST IMPRESSIVE IN EUROPE, INCLUDES A ROTATING COLLECTION OF MAJOR PIECES, SUCH AS MIRÓ'S HUGE *BIRD* AND *MONUMENT*. LA FONDATION MARGUERITE ET AIMÉ MAEGHT. PHOTO: MICHEL DE LORENZO

"in harmony with nature, an extension of nature."

Working collectively they accomplished what they had hoped to achieve. Today, as when it opened in 1964, the Fondation Maeght is a joy to the senses. The visually dazzling structure blends perfectly into the rich grandeur of its natural setting. Entering the grounds, endless surprises await the visitor, from the soft murmur of the many artist-designed pools and fountains, to the fragrance of evergreens that pervades the outer courtyards, the contrast of smoothly rounded and roughly hewn shapes and textures, the contrasting moods in the sculpture gardens' humorous and serious pieces, and the pervasive peacefulness that inspires reflection in this setting of subtle spirituality.

And, in response to Braque's original suggestion, the restored Saint-Bernard Chapel, a memorial to their son Bernard, has been smoothly integrated into the architectural layout of the Foundation. It stands unobtrusively to the right, just behind the Foundation's gate, with a sober statue of *Saint-Bernard* by Eugène Dodeigne at its entrance. Its front wall is graced by a small Léger mosaic, its interior illuminated by the soft glow of Braque's mauve-and-white dove in his *Oiseau (Bird)* and Ubac's *La Croix et le Rosaire (The Cross and the Rosary)* stained-glass windows.

The front sculpture garden, one of the most impressive in Europe, serves to welcome the visitor to the Foundation's collection. While some of the pieces are moved periodically, others—such as Calder's enormous stabile, *Les Renforts (The Reinforcements)*, Jean Arp's *Pépin géant (Large Seed)*, Barbara

Hepworth's *Figure*, Joan Miró's huge *Monument*, Ossip Zadkine's *Statue pour un jardin (Statue for a Garden)*, and Chillida's cut-granite sculpture *Iru Burni*—are likely to be on display. Serving as a backdrop to all this, on the low protective stone wall to the left is Tal-Coat's "stone painting," an enormously elongated earth-colored mosaic that blends almost imperceptibly into the wall and its surroundings.

The Fondation Maeght's interior is laid out in a series of multileveled wings positioned around a central courtyard. The entrance proper—enhanced by the thick glass doors with handsome bronze door handles handcrafted by metal artist Diego Giacometti—is constructed of the same warm terra-cotta tiles that cover the floors throughout the Foundation. To the left are five exhibit rooms, all windowless but bathed in the natural light provided by Sert's intricately designed "light traps," which are concealed overhead. Each of the five rooms is dedicated to one of the Foundation's major artists: Alberto Giacometti, Wassily Kandinsky, Marc Chagall, Joan Miró, and Georges Braque. These rooms, of varying sizes and ceiling heights, are frequently used for special exhibits on the work of a specific artist or subject.

Up a half-flight of steps to the right of the bright entrance hall is a large exhibit gallery that is usually reserved for a rotating selection of the approximately 6,000 works of art comprising the Foundation's permanent collection. Given the size of the Foundation's holdings, it is not possible to say with certainty exactly which pieces will be displayed at any one time. Among the paintings

usually on view is Chagall's celebrated *La Vie (My Life)*, which he created for the Foundation. This autobiographical, large-format canvas, filled with the familiar images of Chagall's painting, traces his birth in the Russian town of Vitebsk, his sojourn in Paris, and his celebration of the world of music, dance, flowers, and love. Elsewhere is Léger's *La Partie de campagne (Country Outing)*, one of several paintings in which he portrayed the theme of leisure within the context of an industrialized society (see Chapter 8), and Miró's colorful *Femme oiseau (Woman Bird)*. A prized Bonnard, *L'été (Summer)*, is one of the artist's early paintings in which he celebrates the glorious light of Southern France. A small example of other twentieth-century artists associated with the region are Braque's *Atelier VI (Studio VI)*, Matisse's *Le Lierre (Ivy)*, Tal-Coat's *Grand Tracé II (Large Line)*, Jean-Paul Riopelle's *Sans Titre (Untitled)*, Pierre Soulage's *Sans Titre (Untitled)*, Jean Bazaine's *La Terre et Le Ciel (Heaven and Earth)*, and Hans Hartung's *T 71-H 1*.

Directly opposite the Foundation's entrance hall is the Giacometti Courtyard, which is home to one of the two largest collections of Alberto Giacometti's work in Europe. Surrounded by the ever-present

POL BURY'S STAINLESS STEEL CYLINDER *FOUNTAIN* PROPELS STREAMS OF WATER INTO THE POOL BELOW AT IRREGULAR INTERVALS. LA FONDATION MARGUERITE ET AIMÉ MAEGHT. PHOTO: MICHEL DE LORENZO

THE *MIRÓ LABYRINTH* IS POPULATED WITH A SPECTACULAR COLLECTION OF AMUSINGLY STRANGE WORKS SUCH AS *SOLAR BIRD*, MANY DESIGNED SPECIFICALLY FOR THIS SETTING. LA FONDATION MARGUERITE ET AIMÉ MAEGHT. PHOTO: MICHEL DE LORENZO

fragrance of cypresses and pine trees, the courtyard—visible from many of the interior rooms—is populated with the sculptor's towering, elongated bodies of men and women. Among these is *L'Homme qui marche (Walking Man)*, this monumental figure is contrasted to *Grandes Femmes debout (Tall Standing Women)*, smaller figures of women nearby. As with other works in the collection, the Giacometti pieces are rotated periodically, but the visitor will always find a selection of Giacometti bronze sculptures which might include *Grande Tête I (Large Head I)*, a painted bronze bust of his brother, Diego, *Les Femmes de Venise (Women of Venice)*, *La Forêt (The Forest)*, *Le Chien (Dog)*, and *Le Chat (Cat)*.

Catalan artist Joan Miró is even more extensively represented. The Foundation counts among its many treasures the Miró Labyrinth, an extended series of terraces and paths that display a spectacular collection of amusingly strange works designed specifically for this setting by Miró. Situated on a variety of levels, reachable from numerous locations in and outside the main building, Miró has created what Jean-Louis Prat, the long-time director of the Foundation, describes as "a sculpted world of dreams in marble, ceramic, cement and bronze." These fantasy creatures were executed in collaboration with Josep Llorens Artigas, the renowned Spanish potter.

The most monumental of Miró's sculptures is *Le Grand Arc (Large*

Arch), a huge concrete mass carved in the shape of an unidentifiable prehistoric form that stands between two terraces as though standing guard over the grounds. During the construction phase, Miró erected models of *Le Grand Arc* and the ceramic sculpture of *La Déesse (Goddess)* directly on the grounds to assure the proper integration of his work into the landscape and building's structure.

Further below are the most amazing of Miró's creatures. *L'Oiseau solaire (Sun Bird)*, carved in white Carrara marble, is perched on a rough stone and looks as if it might take off at any moment. A figure of almost life-size proportions is the startling *L'Oiseau lunaire (Lunar Bird)*, also in white marble, which appears as if it may have just arrived from outer space. These two strange figures, both humorous and grotesque with the rounded curves of their protruding horns, when viewed from a certain angle, reflect the shape of the inverted arcs on the roof of the Foundation. Not far away, high on a rough stone, *Le Lézard (The Lizard)*, seems to creep along as though it might climb over the top. Further evidence of Miró at work are groups of masks and gargoyles, some of which playfully spit streams of water into basins below.

Standing at some remove, silhouetted against the landscape and distant Alps is the iron-and-bronze Miró piece, *La Fourche (Pitchfork)*, that seems to serve as a type of landmark. Close by is his multicolored ceramic

Cadran solaire (Sundial). Miró considered the multifaceted pieces that make up this "labyrinth" among the best-executed and integrated of his projects. These works, along with others owned by the Foundation, represent one of the most important Miró collections in the world.

Wandering peacefully through the grounds and the interior galleries, new discoveries can be made at every turn. Chagall's first work in mosaic, *Les Amoureux (The Lovers)*, protects one of the walls of the Foundation's bookstore, while Pol Bury's stainless steel cylinder *Fountain* propels streams of water at irregular intervals into a pool below. While the gallery walls have no windows, at unanticipated locations glass bays offer views of the grounds or isolated works of art that were created specifically for the Foundation. In one such location is Calder's stabile-mobile, *Humptulips*, which stands in a pool of clear water. Elsewhere is Braque's mosaic fountain basin, *Les Poissons (The Fish)*. And still more surprises await the visitor.

In an effort to capture the spirit that pervades the Foundation, director Jean-Louis Prat renders eloquent homage to the generosity and vision of its founders: "A poetry has been created here by the rare personal engagement and passionate commitment of Aimé and Marguerite Maeght in interaction with the friendship they shared with their artists and the natural beauty of this spot. It is a magical site."

In the vicinity:

Marc Chagall's grave: Chagall was buried in the century-old cemetery at the far end of the old village. His wife, Vava, is buried next to him.

Marc Chagall's mosaic on the front of Saint-Paul's public school.

La Colombe d'Or: A charming inn and restaurant with a celebrated collection of works by many international twentieth-century artists (see Introduction).

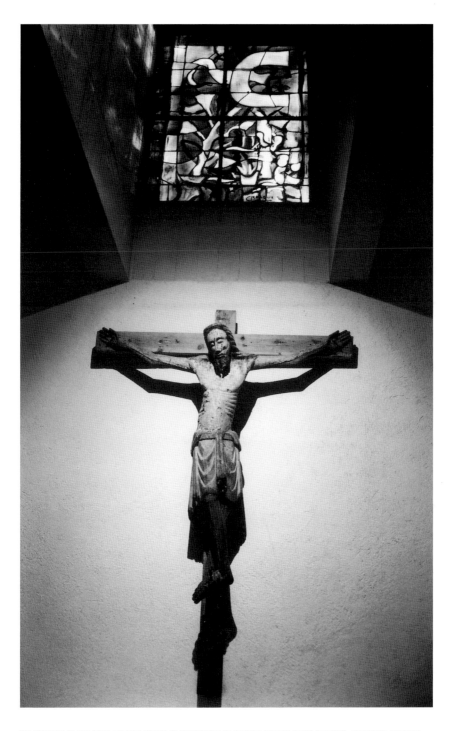

THE INTERIOR OF THE SAINT-BERNARD CHAPEL IS ILLUMINATED BY SEVERAL STAINED-GLASS WINDOWS, INCLUDING BRAQUE'S *MAUVE-AND-WHITE BIRD*. BELOW THE WINDOW IS A FIFTEENTH-CENTURY SPANISH CRUCIFIX. LA FONDATION MARGUERITE ET AIMÉ MAEGHT. PHOTO: MICHEL DE LORENZO

LE MUSÉE NATIONAL MESSAGE BIBLIQUE MARC CHAGALL
THE NATIONAL MARC CHAGALL BIBLICAL MESSAGE MUSEUM

Avenue du Docteur Ménard, 06000 Nice
Tel: 04–93–53–87–20

Open Wednesday to Monday from 10:00 A.M. to 5:50 P.M.
July through September;
from 10:00 A.M. to 4:50 P.M. October through June.
Closed Tuesday and holidays.

THIS MUSEUM, WHICH OWNS THE LARGEST PUBLIC COLLECTION OF CHAGALL'S WORK, IS BUILT OF WHITE STONE FROM THE VILLAGE OF LA TURBIE, AND SET IN A TRANQUIL TREE-SHADED SPOT. LE MUSÉE NATIONAL MESSAGE BIBLIQUE MARC CHAGALL. PHOTO: MICHEL DE LORENZO

66 FEEL I'VE SEEN the world through a bouquet of flowers." These were the rapturous terms in which Tériade (Efstratios Eleftheriades), Marc Chagall's publisher and close friend, described Chagall's new work after the artist's first trip to Southern France in the mid-1920s. Tériade's enthusiasm proved to be prophetic.

By the time Chagall (1887–1985) moved permanently to the Riviera twenty-five years later, he had achieved international acclaim. His

reputation was based on the innovative and uniquely individual paintings he created with fantasized images of his Russian childhood—brightened with the palette he developed in France. During the years between his departure from his native Russia in 1910 and his permanent arrival on the shores of the Mediterranean in 1949, Chagall was to become one of the world's most beloved artists for the tenderly joyous images he created in a full range of media—extending from large public murals and massive oils to delicately colored drawings and engravings.

Born, as he described it, "between heaven and earth," the sensitive young Chagall absorbed all that went on around him in the Jewish shtetl of Vitebsk. A poet in words as well as in images, he included in his autobiography, *My Life*, many of those colorful recollections of his childhood, which were to become the iconography of his art.

"I had only to open my bedroom window, and blue air, love and flowers entered with her [my fiancée]. Dressed all in white or all in black, she seemed to float over my canvases for a long time, guiding my art." Elsewhere he wrote, "All over the neighborhood, goats burst into tears." He wrote, too, of his three aunts: "On the wings of angels they flew across the market, over baskets of berries, pears and currants. People look at them and ask, 'Who is flying like that?' " And of his uncles: "I have also had half a dozen or more uncles. Every Saturday, Uncle Neuch put on a *tallis* [prayer shawl], and read the Bible aloud. He played the violin like a cobbler. Grandfather listened to him dreamily. . . ."

These were the images that Chagall carried with him when he left Russia for Paris at the age of twenty-three. "I came to Paris," Chagall wrote, "because I was looking for its light, its freedom. In Russia my pictures were without light, everything in Russia is dark, brown, gray. Paris illuminated my dark work like a sun. But in seeing the light . . . I did not forget the world where I was born. On the contrary, I saw it more clearly."

In Paris, Chagall met the artistic avant-garde of the period, and, with the support of writer and critic Guillaume Apollinaire, he quickly established his reputation, based on the vitality and originality of his paintings. While surrounded by the Fauves and Cubists and, later, the Surrealists who courted him, Chagall rejected what he called all the "isms." He refused to join any group, stating, "I want an art of the earth and not merely an art of the head."

During this first four-year sojourn in Paris, Chagall produced what many critics considered some of the best work of his career: *A la Russie, aux ânes et aux autres (To Russia, Donkeys and Others)*, *Le Poète ou Half Past Three (The Poet or Half Past Three)*, *Hommage à Apollinaire (Homage to Apollinaire)*, *Moi et le Village (Me and My Village)*, *L'autoportrait (Self Portrait)*, and *Le Musicien (The Fiddler)*. In these first, great masterpieces, Chagall portrayed the rich fabric of fantastic images for which he would become famous: green-headed violinists, horses standing on their rear hooves, couples floating in the air, and everyday scenes of provincial Russian life.

In 1914, Chagall left Paris for what was intended to be a short return trip to Russia, but events lead-

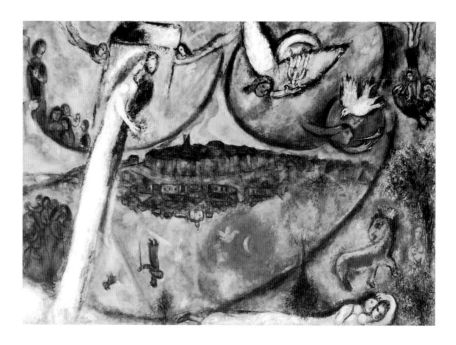

TO ILLUSTRATE THE *SONG OF SONGS,* CHAGALL PAINTED A FLOATING BRIDAL COUPLE WHO—AMID HIS SIGNATURE IMAGES OF BIRDS, FLOWERS, AND ANIMALS—SOAR ABOVE THE TWO TOWNS THAT HE LOVED MOST: VENCE AND JERUSALEM. LE MUSÉE NATIONAL MESSAGE BIBLIQUE MARC CHAGALL. PHOTO: MICHEL DE LORENZO

ing to World War I trapped him there; he remained through the early years of the Russian Revolution. When he returned to Paris in 1923, he was accompanied by his childhood sweetheart, Bella, now his wife, and their young daughter, Ida. Back in Paris he continued to paint, producing several important, large compositions, which were influenced by the political turmoil of the era. These included *Révolution, La Crucifixion blanche (White Crucifixion),* and *Le Martyr.* During these years, he also received three major commissions for book illustrations from the art dealer and publisher, Ambroise Vollard. The first was for Gogol's *Dead Souls,* followed several years later by an illustrated edition of *The Fables* of La Fontaine.

The third, the illustration of a special edition of the *Bible,* was to prove the most significant of all, as it served as a precursor to the monumental canvases in Chagall's *Biblical Message Cycle.*

This second period in Paris came to a conclusion with the outbreak of World War II, when Chagall and his family left Paris for the south of France. Shortly thereafter, an invitation was extended by the Museum of Modern Art in New York to Chagall—as well as to Dufy, Ernst, Matisse, Masson, Picasso, and Rouault—to seek refuge from the war in the United States. For many reasons, Chagall was reluctant to accept the invitation, asking, "Are there trees and cows in America, too?" However,

the political climate, especially for Jews after the fall of France—and the traumatizing personal experience of being arrested during a raid in Marseille—created a sense of urgency for Chagall. From 1941 until 1947, Chagall lived in the haven of New York, establishing contact with other exiles from the war, traveling, and enduring the tragedy of the death of his beloved Bella. While in the United States, Chagall completed the important canvas of *La Chute de l'Ange (Falling Angel)* that he had been working on since 1923 and produced a series of major canvases, several of which—*L'Obsession, Crucifixion en jaune (Yellow Crucifixion), La Guerre (The War)*—were motivated by the war. He also began his first color

lithographs as illustrations for an edition of the *Arabian Nights* and undertook ballet sets and costumes for Léonide Massine's production of *Aleko,* and later for Stravinsky's *Firebird.*

Three years after the end of the war, Chagall returned to France and settled on the Riviera. He lived first in Saint-Jean-Cap-Ferrat, later in the perched village of Saint-Jeannet, finally settling in 1950 in the small medieval hill town of Vence. Two years later, at the age of sixty-five, Chagall married Valentina Brodsky, known as "Vava," who became the second great source of love in his life. Inspired by his second marriage and imbued with the light of the Mediterranean, Chagall discovered a

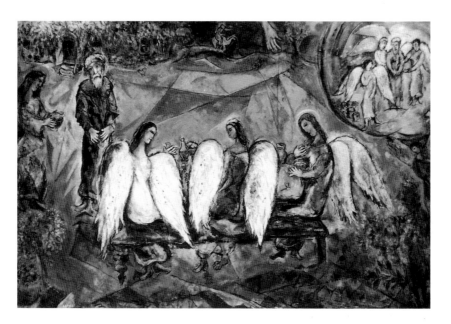

CHAGALL'S PAINTING, *ABRAHAM AND THE THREE ANGELS,* WHICH DEPICTS THE BIBLICAL EPISODE WHEREIN THE AGED ABRAHAM AND SARAH ARE INFORMED THAT SHE WILL GIVE BIRTH TO ISAAC, IS ONE OF THE MOST GLORIOUS OF THE TWELVE GREAT PAINTINGS THAT COMPRISE THE *BIBLICAL MESSAGE CYCLE.* LE MUSÉE NATIONAL MESSAGE BIBLIQUE MARC CHAGALL. PHOTO: MICHEL DE LORENZO

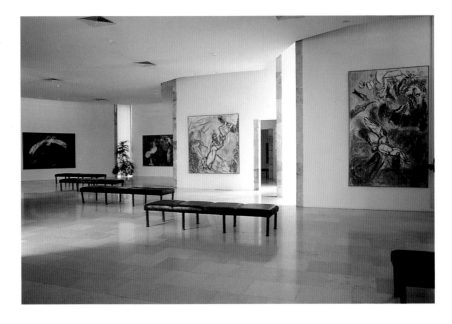

THE TWELVE, BIBLICALLY BASED CANVASES DEPICTING SCENES FROM *GENESIS* AND *EXODUS* ARE DISPLAYED SO THAT THE ENTIRE GROUP OF PAINTINGS MAY BE VIEWED AT THE SAME TIME, WHILE SIMULTANEOUSLY SHOWCASING EACH SEPARATELY ON ITS OWN WALL. LE MUSÉE NATIONAL MESSAGE BIBLIQUE MARC CHAGALL. PHOTO: MICHEL DE LORENZO

new *joie de vivre*. With an impressive career already behind him, Chagall embarked on new creative adventures, expanding his media to include mosaics, sculpture, ceramics, and stained glass. He also undertook a momentous new project that, in many respects, represented the culmination of his life's work.

By the time Chagall made the Riviera his home, numerous artists had already been attracted to the glory of its light, while others had made it their land of exile during the war. When Chagall, an important personage in his own right, settled in Vence he was in the towering presence of Matisse—who had returned to his apartments in Nice after spending the war years in Vence—and Picasso, who lived nearby in Vallauris.

Matisse's Chapelle du Rosaire in Vence (see Chapter 17) was nearing completion, and Picasso had begun painting the panels that would be installed in his Chapelle de la Guerre et la Paix in Vallauris (see Chapter 6). Chagall, too, was preoccupied with religious themes, particularly those of the Bible, which had been a source of inspiration to him for many years. He was later to declare, "The Bible has fascinated me since my earliest childhood. I have always considered it as the most extraordinary source of poetic inspiration imaginable. That is what I care about most, in both life and in art."

Chagall soon set to work in his home in Vence, "Les Collines," on an integrated cycle of large scale paintings

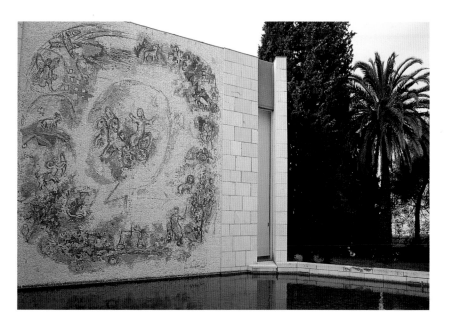

CHAGALL'S WORK IN MOSAICS DIDN'T BEGIN UNTIL THE MID-1950S. THIS MOSAIC OF THE PROPHET ELIJAH, DESIGNED FOR THE MUSEUM, SPARKLES IN THE SUNLIGHT, CASTING ITS REFLECTION IN A POOL OF WATER LILIES BELOW. LE MUSÉE NATIONAL MESSAGE BIBLIQUE MARC CHAGALL. PHOTO: MICHEL DE LORENZO

that dealt with episodes from the *Old Testament*. Coincidental to his initiating this project, Chagall became intrigued by the discovery in Vence of a series of deconsecrated chapels known as Les Chapelles du Calvaire (see Chapter 22). Chagall believed that the largest of these chapels would provide the spiritual setting he envisioned for his Biblical Cycle Paintings. Despite promising preliminary discussions with the town of Vence, the projected plans never came to fruition. However, the grandeur of the original canvases so impressed writer André Malraux, Chagall's friend and Minister of Culture during the De Gaulle years, that he proposed building a new museum specifically to display this work. In 1966, Chagall and his wife made a formal gift to the French nation of the seventeen paintings that constitute the Biblical Message Cycle.

The cornerstone for the new building was laid in 1969. Four years later, on July 7th, 1973, Chagall's eighty-sixth birthday, Le Musée National Message Biblique was dedicated. The intentionally unassuming building is located in the hills of Cimiez high above the city of Nice. Designed by noted architect André Hermant, in consultation with Chagall, the museum houses the largest public collection of the artist's work. It is built of white stone from the nearby medieval village of La Turbie, and set in a tranquil spot surrounded by beds of flowers, umbrella pines, cypress and olive trees. No setting could better capture

THE MUSEUM'S COLLECTION INCLUDES SEVERAL EXAMPLES OF CHAGALL'S RELATIVELY UNKNOWN WORK IN SCULPTURE. THESE THREE PIECES, *KING DAVID*, *MOSES*, AND *CHRIST ON THE CROSS*, CARVED IN SOFT STONE, WERE EXECUTED IN THE EARLY 1950S. LE MUSÉE NATIONAL MESSAGE BIBLIQUE MARC CHAGALL. PHOTO: MICHEL DE LORENZO

THE MUSEUM'S COLLECTION INCLUDES SEVERAL EXAMPLES OF CHAGALL'S RELATIVELY UNKNOWN WORK IN SCULPTURE. THESE THREE PIECES, *KING DAVID*, *MOSES*, AND *CHRIST ON THE CROSS*, CARVED IN SOFT STONE, WERE EXECUTED IN THE EARLY 1950S. LE MUSÉE NATIONAL MESSAGE BIBLIQUE MARC CHAGALL. PHOTO: MICHEL DE LORENZO

the spirituality that Chagall envisioned, a building that he hoped would be experienced neither as a museum nor a chapel, but as a place of personal dreams and reflection for all humanity.

Entering the building, one is initially struck by its utter simplicity. Chagall's *Tapisserie pour l'entrée (Entrance Hall Tapestry)*, extends a welcome with its sunlight-filled evocation of a Mediterranean landscape that unites the images of two cities dear to the artist—Jerusalem on the right and Vence on the left. Concealed behind the entrance hall are the major exhibit rooms, ingeniously designed in an orthogonal shape so that, in one sweep, the visitor's view can embrace the entire group of paintings at the same time that each painting is showcased on its own individual wall. The paintings of the *Biblical Message Cycle* are divided into two groups—the Biblical stories of *Genesis* and *Exodus* and the *Song of Songs*—and are hung in two separate rooms.

In the museum's lovely, large central hall hang the twelve great canvases from *Genesis* and *Exodus*. Each canvas dramatically portrays an incident from the Old Testament, depicted in the majesty of Chagall's unique style. These canvases overflow with symbols and images from Chagall's universe: flying fish, embracing couples, bouquets of flowers, colorful birds and animals, supportless ladders, floating angels, heavily-cloaked rabbis, the scrolls of the Ten Commandments, and his cherished cities of Vence and Vitebsk.

Following Chagall's explicit wishes, the paintings are not organized following their actual sequence in the Bible, but rather, according to the complementarity of their colors. Therefore the visitor will find incidents such as *La Création de l'Homme (The Creation of Man)* and *Le Sacrifice d'Isaac*, related at some distance in the Bible, paired to highlight the balance of their chromatic organization of blues, pale greens, yellow, bursts of red, and patches of white. *Le Paradis (The Garden of Eden)* and *Adam et Eve chassés du Paradis (Adam and Eve Driven from Paradise)* are powerfully coupled to emphasize the richness of their emerald greens and cobalt blues emblazoned with massive floral bouquets. Chagall perceived a similar balance in the brilliant reds of *Abraham et les Trois Anges (Abraham and the Angels)* as contrasted with deep blues and greens of *L'Arche de Noé (Noah and the Rainbow)*, which hang facing each other at opposite ends of the room.

Displayed in a small adjacent room, which leads to the second series of the Biblical Cycle paintings, are several examples of Chagall's

relatively unknown work in sculpture. The five pieces—three stone sculptures of *King David*, *Moses*, and *Christ* and two white marble bas-reliefs of *Sarah and Rebecca*, and *Rachel and Leah*—were among the new media in which Chagall began to work when he returned to France after World War II. These were completed between 1950 and 1954 in Vallauris.

The adjoining, hexagonally shaped room glows with the radiance of the five grand *Cantique des Cantiques (Song of Songs)* canvases. Painted on paper glued to canvas, these Biblical images are composed in shades of red that vary from the deepest crimson to the palest pink.

They are tenderly dedicated "To Vava, my wife, my joy, my delight." No ode to joy could better convey the rapture that Chagall expresses in these paintings

Ensconced in a courtyard outside the museum, but visible only from a small room just off the major exhibit halls, is one of Chagall's most successful mosaics. Chagall became enamored of this ancient art form after a trip to Italy in the mid-1950s and undertook his first mosaic in 1964. The mosaic of *Le Prophète Elie (The Prophet Elijah)*, seated on his chariot of fire and surrounded by signs of the Zodiac, was actually executed by Lino Melano, a master mosaicist from the famous School of

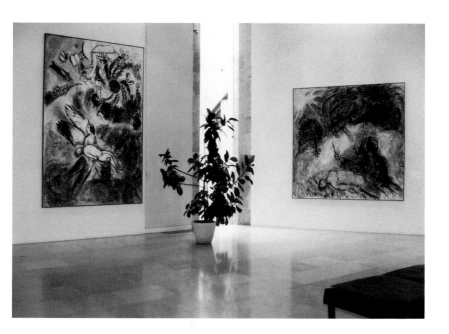

IN ACCORDANCE WITH CHAGALL'S WISHES, THE PAINTINGS IN THE BIBLICAL MESSAGE CYCLE ARE NOT ORGANIZED ACCORDING TO THEIR SEQUENCE IN THE BIBLE, BUT RATHER, ACCORDING TO THE COMPLEMENTARITY OF THEIR COLORS. *THE CREATION OF MAN* AND *THE SACRIFICE OF ISAAC* ARE PAIRED TO HIGHLIGHT THE BALANCE OF THEIR CHROMATIC ORGANIZATION OF BLUES, PALE GREENS, YELLOW, BURSTS OF RED, AND PATCHES OF WHITE. LE MUSÉE NATIONAL MESSAGE BIBLIQUE MARC CHAGALL. PHOTO: MICHEL DE LORENZO

Ravenna in Italy. The large mosaic, composed of tiny glass stones, sparkles in the sunlight, casting its reflection in a pool below where water lilies echo the subtle colors of the delicate mosaic.

In addition to the luxurious expanse of wall space designed to display the Biblical Message paintings, a spacious and comfortable concert hall supplements the museum's gallery space. It is adorned with three spectacular stained-glass windows, an art form Chagall first embraced during his early years in the South of France in the 1950s. The luminous windows, executed by master stained-glass artist Charles Marq, illustrate the Creation of the World. The ambiance created by the color and light of these windows, composed of harmonies of blue against which the events of the seven days of creation are illustrated, evokes the sense of spirituality and sacredness that Chagall desired.

In its totality, Le Musée National Message Biblique captures Chagall's conviction that "these pictures express a dream that belongs not to a single tribe but to all mankind." The enduring inspiration of the Biblical episodes in Chagall's career is underscored by the Museum's extensive collection of additional works that relate to biblical themes. These include the 200 preparatory studies in crayon, ink, pastel and oil for the Biblical Message Cycle, as well as 39 gouaches from 1931, which he did to illustrate a special edition of the Bible. These are accompanied by 105 etchings and 75 lithographs from other volumes he had illustrated.

While Chagall was obsessed with this project for close to twelve years, his creative production during this period was not limited to the Biblical Message Cycle. He also completed some of his most celebrated and dazzling work, which would reside in international centers throughout the world. Included among the major commissions he completed during these years are the ceiling of the Paris Opera House, murals for the Metropolitan Opera House in Lincoln Center, stained-glass windows for cathedrals in Metz, Corrèze, and Rheims in France, Chichester and Kent in England, in Zurich, and the Hadassah Medical Center Synagogue in Jerusalem. In addition, he designed tapestries and mosaics for the parliament building in Jerusalem and the United Nations in New York.

Closer to home, Chagall's legacy is visible in a variety of locations on the Riviera. His very first mosaic is prominently displayed at the Fondation Maeght in Saint-Paul-de-Vence (see Chapter 11). Elsewhere in Saint-Paul, there is a small mosaic he created for the front of the public school, and his paintings at the celebrated inn, La Colombe d'Or. Although Chagall moved from Vence to Saint-Paul in 1966, Chagall made a gift of a mosaic, *Moses Saved from the Water* to the tenth-century Cathedral of Vence. For the Law School at the University of Nice, he designed a mosaic entitled *The Message of Ulysses*. Elsewhere, in the small village of Les Arcs, a mosaic was designed to recount *The Angels' Meal* (see Chapter 3).

In bestowing the extraordinary collection displayed in the Biblical Message Museum to the French nation, Chagall expressed the sentiment of having been born a second time in France. The radiance of the

THE FINAL FIVE PAINTINGS OF THE BIBLICAL MESSAGE CYCLE ILLUMINATE THE WALLS OF A SEPARATE HEXAGONALLY SHAPED ROOM WITH A GLOW OF PINK, RED, AND CRIMSON. THIS CANVAS FROM THE SERIES PORTRAYS THE BRIDAL COUPLE IN KING SOLOMON'S *SONG OF SONGS*, ASTRIDE A FLYING HORSE AMIDST TYPICAL CHAGALLIAN IMAGES. LE MUSÉE NATIONAL MESSAGE BIBLIQUE MARC CHAGALL. PHOTO: MICHEL DE LORENZO

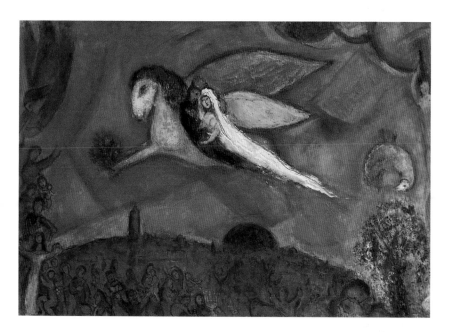

work created in his adopted country emerged from the joint influence of Southern France's color, light and landscapes blended with the deeply-embedded recollections of life in the Russian village of Vitebsk. Their joint imagery made a profound impression upon him, and through his art, upon the world.

Chagall spent the final years of his life working quietly in Saint-Paul-de-Vence. He died shortly before his ninety-eighth birthday at his home, close to the Fondation Maeght. He is buried near the entrance to the small cemetery at the southern end of the village, which overlooks the valley he so loved.

LE MUSÉE INTERNATIONAL D'ART NAÏF ANATOLE JAKOVSKY
THE ANATOLE JAKOVSKY INTERNATIONAL MUSEUM OF NAÏVE ART

Château Sainte Hélène, Avenue Val Marie, 06200 Nice
Tel: 04–93–71–78–33

Open Wednesday to Monday from 10:00 A.M. to Noon and 2:00 P.M. to 6:00 P.M.
Closed Tuesday and holidays.

THE STRAWBERRY-PINK Château Sainte Hélène, which houses the unique collection of Naïve Art assembled by Anatole Jakovsky during his lifetime, provides exactly the dream-like setting it deserves. An elegant two-story villa, built in the late nineteenth century by the founder of the Monte Carlo casino, the château had a succession of owners until it was purchased in 1922 by the famous perfumer, François Coty. Coty redesigned the palm-and-pine-tree park that surrounds the villa, adding the fragrant gardens of sweet-smelling wisteria, lavender, and orange blossoms still scenting the air.

In the late 1960s, after the death of Coty's widow, the city of Nice purchased the site, seeking to preserve not only its lovely grounds on the hill of Fabron, but also the feeling of the former Coty home itself, including its distinctive exterior color, the harmonious flow of its rooms, and the style of the Belle Époque furniture in the villa. This purchase turned out to be serendipitous several years later when Anatole Jakovsky (1909–1983) and his wife, Renée, expressed their desire to bestow their prestigious collection of Naïve Art on the city of Nice.

Jakovsky, a Romanian art critic, writer, and collector, came to France in 1932. While his early interest had been in abstract art, he soon became fascinated with the relatively unappreciated genre of Naïve Art, and immersed himself in learning more about its history and expression throughout the world. He devoted his life to championing Naïve Art, writing a first book on the topic in 1949 and publishing the first worldwide dictionary of Naïve painters *(Dictionnaire des Peintres Naïfs)* in 1967, followed in 1976 by a second edition that included the biographies of more than 1,000 Naïve artists.

As becomes clear in exploring the many treasures displayed in this airy, light-filled space, Naïve Art is characterized by spontaneity and freshness in its depictions of everyday life. While some Naïve artists indulge in fantasy, sometimes bordering on the surrealistic, most of their paintings offer colorfully precise details of the commonplace. The charm of this work results, in part, from the fact that many, but not all, Naïve artists have worked in isolation, free

PAINTINGS BY FRENCH NAÏVE ARTISTS—VIVIN, BAUCHANT, AND DE SENLIS—PART OF A LONG-TERM LOAN FROM THE POMPIDOU CENTER, ENRICH JAKOVSKY'S COLLECTION OF APPROXIMATELY 600 WORKS BY NAÏVE ARTISTS FROM AROUND THE WORLD. LE MUSÉE INTERNATIONAL D'ART NAÏF ANATOLE JAKOVSKY. PHOTO: MICHEL DE LORENZO

from the constraints of a specific artistic tradition and unfettered by classical rules of perspective.

The term "Primitive" is sometimes used as a synonym for "Naive," although such use is both misleading and inappropriate. As a rule, the term "Primitive Art" is reserved (as art historian Harold Osborne carefully points out) for describing either the "early phases within the historical development of painting or sculpture in the various European countries (e.g. Italian Primitives)," or the art of those who work "outside the direct influence of the great centers of civilization . . . as in the art products of Africans . . . Eskimos . . . and the inhabitants of the Pacific islands." This is distinct from the work pro-

duced by "Naïve" artists, who often work within sophisticated societies.

Prior to Jakovsky's pioneering critical studies, knowledge of the works of Naïve artists had been relatively limited. At the turn of the century, French collector Georges Courteline had organized a small collection of their work but it remained for the German critic, art dealer, and collector, Willhelm Uhde, to bring the art world's attention to the genre, leading the way by championing the painting of customs-officer turned-painter Henri (Douanier) Rousseau (1844–1910) and his meticulous, dream-like paintings. This led, in the 1920s and 1930s, to interest in a small group of French Naïve artists including André

THE STRAWBERRY-PINK VILLA THAT HOUSES ANATOLE JAKOVSKY'S UNIQUE COLLECTION OF NAÏVE ART WAS BUILT IN THE LATE NINETEENTH CENTURY BY THE FOUNDER OF THE MONTE CARLO CASINO. LE MUSÉE INTERNATIONAL D'ART NAÏF ANATOLE JAKOVSKY. PHOTO: MICHEL DE LORENZO

Bauchant, Emile Blondel, Jean Eve, Louis Vivin, René Rimbert, Séraphine de Senlis, and Camille Bombois, each of whose work is represented in the museum's collection.

In the course of his life, Jakovsky amassed a huge collection that traces the history of Naïve Art (paintings, sketches, works on paper, and sculpture) from the eighteenth century to the present by some 200 artists from twenty-seven countries. His collection, comprised of 600 works along with his considerable archives, bequeathed to the museum, serves not only to present the work of an international group of Naïve artists but also to present a visual definition of the style.

The lover of the genre will be enchanted by the discoveries that a visit to this museum offers. Among them will be an American painter, Gertrude O'Brady, whom Jakovsky met in Paris in 1938, when both were living in the Latin Quarter, and whom he promoted for many years. Jakovsky considered her work to be second in importance only to that of Rousseau. In her painting she portrays her desire to immortalize the daily events and everyday objects that she said "we will never see again; these little notions stores that sell lollipops and two-cent post cards . . . the butcher's family, posing, all dressed up, in front of the sumptuous background of slabs of beef and

strings of sausage . . . the blocks of sculpted butter . . . and the electric organs and fireworks from country fairs."

One of the most representative examples of O'Brady's work hangs in a room with eight other portraits of Jakovsky by various Naïve painters. In this painting, *Anatole et Minou (Anatole and the Pussy Cat)*, she portrays Jakovsky, beloved pipe in hand, in his Saint-Germain apartment, surrounded by his personal possessions: a Mondrian painting, Calder mobile, a Chéret poster of a can-can dancer, along with representations of her own paintings, *Le Tandem (Bicycle Built for Two)* and several of her paintings of airplanes. This minutely detailed canvas captures the dream-like universe and richness of color for which she became known. Other O'Brady pieces in the museum include her stylized *Portrait d'Anatole Jakovsky*, in which he is wearing a prized checkered shirt, a gift to him from his friend, Alexander Calder, well known for his own checkered shirts; and her most famous *Le Moulin de Sannois (The Sannois Mill)*, in which she evokes one of her favorite nostalgic themes of "times long past," in a scene from the Belle Époque. Seeing these canvases makes it easy to understand why Anne Devroye-Stilz, the museum's curator, describes O'Brady's paintings as "unknown to most Americans but possessing a magic quality that makes her work much richer than that of the better-known Grandma Moses."

Hanging together in another room are many of the collection's rich examples of Naïve Art by Central European artists, particularly those from the former Yugoslavia,

recognized as the country that has produced the largest number of outstanding Naïve artists. Among the famous Yugoslavian pieces in the collection are two that demonstrate an unusual technique of painting with oil on glass. The first is Ivan Generalic's painting *Le Vacher (The Cowherd)*, a particularly evocative rendition of the cowherd and his animals executed in a combination of bold colors that are balanced by soft nuances in the background. Ivan Lackovic, one of the most prolific and best of the modern Naïve artists, is represented by *Le Village sous La Neige (The Village in the Snow)*. The charm of this typical village scene with its shawled women, a child with a sled, and a lone, red fox is achieved through the effect of the soft blankets of snow covering the church steeple and surrounding village homes.

As Anne Devroye-Stilz explains, "these paintings on glass, often executed with the assistance of a mirror, were painted from the front to the back," with the artists filling in the small details of the foreground before tackling the background.

Prominent French Naïve artists are well represented in the Jakovsky collection. Bauchant, whose subjects included mythology, flora, portraits, and landscapes is particularly worthy of attention for his *La Servante et les Chèvres (The Servant and the Goats)*, which is a perfect example of the comparatively old-fashioned aspect of his work. It is perhaps this quality and the diversity of his work that led Serge Diaghilev to commission him, in 1928, to provide the decoration for the ballet *Apollon Musagète*. Rimbert, "the postman who paints," as he described himself to the poet Max Jacob, offers in perfect harmony, a

typical, quiet, provincial street corner where the butcher, a housewife, a child, and retirees gather in front of the local café. By contrast, Blondel's *Ma Vie (My Life)* is a totally autobiographical portrayal of various moments in the artist's life. In a composition which has a mosaic-like quality, he traces his travels from his hometown of Le Havre—which he left to become a ship's boy—to his years as a docker, then an agricultural worker, as well as to his days as a bus driver in Paris. These paintings, like most in the museum, display the Naïve artist's talent in transforming and poetically elevating everyday experiences.

The gay and spacious rooms on the museum's second floor are hung with paintings by seventeenth-to nineteenth-century Naïve artists from countries as diverse as Abyssinia,

Bali, Brazil, Haiti, Italy, the Philippines, Poland, Spain, and the former Yugoslavia. In addition, there is a whimsical collection of diverse folk-art-like pieces.

Beyond Jakovsky's own collection, the museum has recently been enriched by a long-term loan from the Musée National d'Art Moderne Centre Pompidou in Paris. This group of paintings includes several major examples by artists already in the museum, as well as important works by celebrated Naïve artists not owned by Jakovsky. Prominent among these are *L'Arbre Mort (The Dead Tree)* by the American, Grandma Moses, a typical bucolic country scene in soft dreamy colors realized in a semi-stylized form, *Grenades (Pomegranates)* by the well-known French Naïve artist

THE TOP SHELF OF THE GLASS CASE AT THE MUSUEM'S ENTRANCE CONTAINS SEVERAL PHOTOGRAPHS, INCLUDING TWO OF FAMOUS NAÏVE ARTIST HENRI ROUSSEAU, WHILE THE BOTTOM SHELF EXHIBITS PERSONAL MEMORABILIA OF THE POLISH NAÏVE ARTIST ANDRZEJ WOJTCZAK. THE SECOND SHELF EXHIBITS A WOODEN SCULPTURE BY WOJTCZAK TO THE LEFT, A DRUM BY AN ANONYMOUS ECUADORIAN ARTIST IN THE CENTER AND, TO THE RIGHT, A *PAPIER-MÂCHÉ* SCULPTURE BY BRAZILIAN ARTIST LUIZ CARLOS FIGUEIREDO. TWO PAINTINGS OF JAKOVSKY'S HOME IN PARIS BY SWISS ARTIST ALFRED ERNEST PETER OCCUPY THE THIRD SHELF. LE MUSÉE INTERNATIONAL D'ART NAÏF ANATOLE JAKOVSKY. PHOTO: MICHEL DE LORENZO

Séraphine de Senlis, and *Les Moissonneurs (The Harvesters)* by the equally well-known André Bauchant.

Although the museum's large and varied collection consists of work by Naïve artists from around the world, it retains a very personal, almost biographical, feeling. This sense of intimacy is enhanced by the numerous photographs of Jakovsky and his wife and the many portraits of Jakovsky scattered throughout the museum. In addition, several glass cases display examples of his prized possessions, exemplifying the broad range of his personal interests—his collection of little robots, of canes, even models of the Eiffel tower. Not to be missed is the original copy of *La Clé du Pavé (The Cobblestone Key)*, a book of Jakovsky's poetry illustrated by his close friend, the artist Robert Delaunay, and his work on the history of tobacco (a subject he explored in two important books).

It is easy to see why Jakovsky became known as *"Le Pape des Naïfs"* (The Pope of Naïve Painters). The collection is imbued with his passion and commitment to these artists and their works. With obvious pride, curator Devroye-Stilz summarizes, "Ours is the only museum to present a total perspective, both geographic and chronologic, of Naïve Art—with rare, worldwide examples."

One might also wonder, along with Jakovsky—who was sentimentally attached to the city of Nice and wrote in the preface to the museum's catalogue—"Where, if not in Nice, on the shore of the Bay of Angels, in this best and only haven of peace, would the Naïve artists, so long misunderstood and rejected, be finally reunited?"

AMERICAN ARTIST GERTRUDE O'BRADY'S COLORFUL PAINTING, *ANATOLE AND THE PUSSY CAT,* DOMINATES THIS ROOM IN WHICH EIGHT PORTRAITS OF JAKOVSKY BY VARIOUS NAÏVE ARTISTS ARE DISPLAYED. LE MUSÉE INTERNATIONAL D'ART NAÏF ANATOLE JAKOVSKY. PHOTO: MICHEL DE LORENZO

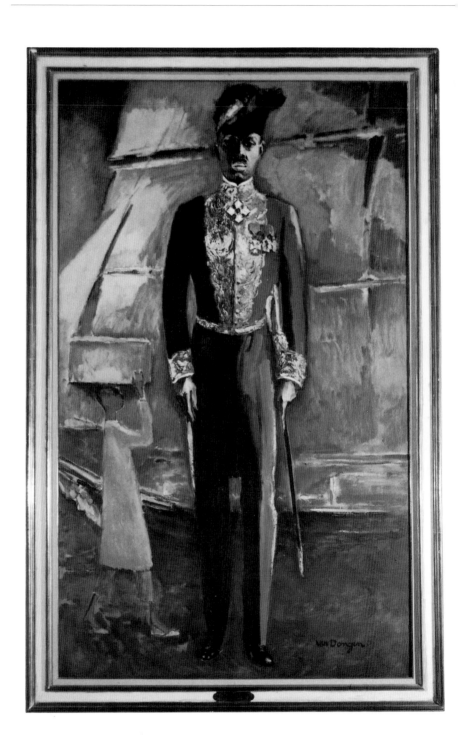

AMONG THE WORK BY VAN DONGEN IS THIS PORTRAIT, *AUGUSTE CASSEUS, HAITIAN AMBASSADOR*. LE MUSÉE DES BEAUX-ARTS
PHOTO: MICHEL DE LORENZO

LE MUSÉE DES BEAUX-ARTS (JULES CHÉRET)
THE MUSEUM OF FINE ARTS (JULES CHÉRET)

33 Avenue des Baumettes, 06000 Nice
Tel: 04–92–15–28–28

Open Tuesday to Sunday from 10:00 A.M. to Noon and 2:00 P.M. to 6:00 P.M.
from May 2 through September;
from 10:00 A.M. to Noon and 2:00 P.M. to 5:00 P.M. October through April.
Closed Monday, holidays, and two weeks in November.

THE MUSÉE DES BEAUX-ARTS is a palace fit for a princess. And with good reason: this splendid villa was commissioned in 1878 by the Ukrainian Princess Elisabeth Vassilievna Kotschoubey and built on the Baumette Hill of Nice, close to the area where many members of Nice's important Russian colony then lived. The building's exterior reflects both the Genovese Mannerist-style architecture of its original architect and the even more luxurious influence of its subsequent owner, James Thompson, a fabulously wealthy American.

Situated on close to two-and-a-half acres of luxuriantly planted grounds, the two-storied apricot-and-cream-colored Belle Époque building—complete with decorative friezes and ornate cornices—was acquired in 1925 by the city of Nice, which had plans to transform it into a museum. The new museum inherited a diverse assemblage of collections, including the one held by Nice's first fine arts museum, established just after the County of Nice was annexed to France in 1860. Among other treasures, this included works by Fragonard, Hubert Robert, and the Vanloo painters, a selection of

Impressionist paintings, and an extensive donation of work by Jules Chéret, creator of modern poster art. Since its inauguration in 1928 as the Musée des Beaux-Arts, the museum has continued to receive generous donations from private donors and the French state.

The museum's vast collection today undeniably focuses on the nineteenth century, although its acquisitions include early work from the Italian School, Flemish tapestries, numerous engravings (including a series of Goya "Caprices"), sculpture by Carpeau and Rodin, and a small but specialized concentration of twentieth-century art.

Entering the museum, one is struck by its grandeur, the height of the ceilings, the sculpture-filled winter garden, and the monumental staircase, which leads to a bay of enormous windows crowned by a zinc dome. Here—on this mezzanine-like landing with amazing acoustics— musicians once played for the pleasure of guests. This lovely light-filled area ushers in the world of Jules Chéret and leads to adjoining rooms on the second floor, where the museum's concentration of twentieth-century work is located.

Chéret (1836–1932), originally a lithographer, preceded Toulouse-Lautrec in the development of poster art. As Jean Forneris, curator of the

THE APRICOT-AND-CREAM-COLORED BELLE ÉPOQUE BUILDING, WHICH WAS ONCE THE HOME OF A UKRAINIAN PRINCESS, WAS TRANSFORMED INTO NICE'S MUSEUM OF FINE ARTS IN 1928. LE MUSÉE DES BEAUX-ARTS. PHOTO: MICHEL DE LORENZO

Musée des Beaux-Arts describes him, "Chéret turned color lithography into an art . . . theaters, dance halls, concerts and circuses could not do without him . . . he made advertising an enchantment." Quoting the critic C. Mauclair's description of Chéret's posters, Forneris explains, "Paris, dazzled, watched its walls singing. Soon, the central character was famous: a little blonde with a tip-tilted nose, dancing in a short skirt, who seemed to proclaim her joy in a world of Pierrots and Harlequins." It is just this world that is created on the walls surrounding the upper staircase where Chéret's cheerful oils *La Danseuse au tambour basque (Dancer with Tambourine)*, *L'Orchestre*, *Le Printemps (Springtime)*, *L'Air*, and *La Femme à L'éventail (Woman with a Fan)* are hung. In addition to these oils, which capture the essence of Chéret's posters, the museum holds a major collection of these posters, some 500 in all.

Although Chéret is famous for his posters, he also enjoyed working in pastels. A full room on the second floor is devoted to his pastel work, which further demonstrates the joy he created with his airy style. *La Pantomime* is an exuberant burst of color wherein his delightful trade-mark feminine figure, who became known as "la Chérette," dressed in a flouncy yellow confection, is surrounded by masked, costumed figures. *Étude pour le rideau du théâtre du Musée Grévin (Study for the Curtain of the Grévin Museum Theater)* is recognized as one of Chéret's masterpieces. This pastel on canvas once again presents this delightful feminine figure as a pied piper of merriment, lightheartedly

leading a group of colorfully masked characters.

Chéret's diversity is demonstrated in the collection of portraits. Among those in the collections are portraits of *Le Baron Joseph Vitta* and *La Baronne Vitta*. The Vittas, major collectors of Chéret's work, bequeathed this collection to the museum that was to bear his name.

One of this museum's highlights is an important collection of work by Kees Van Dongen (1877–1968), the Dutch artist who moved to Paris and joined the group of avant-garde artists working in Montmartre. Van Dongen, whose early work was identified with that of the Fauves, was later to move in a different direction as he became a society painter. In the years following World War I, he painted important political and cultural leaders including the Aga Khan, Anatole France, Maurice Chevalier, and Léopold III of Belgium. Preserved in this collection are two of his notable portraits, *Auguste Casseus, Ambassadeur d'Haïti* and *Madame Jenny*, an important personality in Parisian Haute Couture circles. Among the eighteen major pieces by Van Dongen in the museum's possession are the early *Chimère pie (Piebald)*, and the famous *Tango de l'Archange (Archangel's Tango)*, which demonstrate the strength of his composition.

The display cases in the same room with the Van Dongen collection exhibit ceramic and glass works by two twentieth-century artists. Pablo Picasso is represented by a small display of clay pieces he executed during the years he worked in Vallauris (see Chapters 4, 5, and 6), Maurice Marinot by several of his

large Art Deco-style glass vases.

The museum is also the proud possessor of one of the largest and most diverse collections of work by Raoul Dufy (1877–1953). Dufy, like many artists before him, was captivated by the Mediterranean light and landscape, both of which had a major impact on his work. He made many visits to the south and on three separate occasions lived in the nearby hill town of Vence. While considered a Fauve because of the brillant colors of his palette, Dufy's work evolved in a totally original manner, characterized by a gaiety and lightness that was distinct from that of the recognized Fauve masters. As a talented draftsman, he developed a charming graphic shorthand that he applied to

his watercolors and oils, as well as to the lesser-known fabrics he developed in association with couturier Paul Poiret.

While only a portion of this rich collection of drawings, oils, watercolors, tapestries, and ceramics is available for display at any one time, several of the Dufy masterpieces are almost always on view. Included among them are *Le Casino à la jetée, promenade aux deux calèches (Casino on the Pier, Rides in Horse-drawn Carriages)*, and *Feu d'artifice à Nice (Fireworks in Nice)*, both of which celebrate a frequent theme in his work, *La Grande Jetée*, the large, Belle Époque steel pier in Nice, which—until its destruction in 1944 —was the center of Niçois social life.

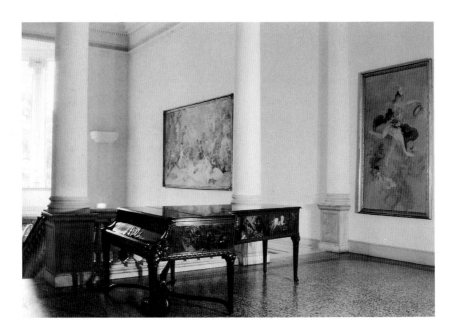

THE FIRST LANDING OF THE MUSEUM'S GRAND STAIRCASE IS CROWNED BY A ZINC DOME, WHICH PROVIDED EXCELLENT ACOUSTICS FOR THE MUSICIANS WHO ONCE PLAYED HERE. IT IS SURROUNDED BY DELIGHTFUL WORKS BY JULES CHÉRET, THE CREATOR OF MODERN POSTER ART, TOGETHER WITH HIS DECORATED PIANO. LE MUSÉE DES BEAUX-ARTS. PHOTO: MICHEL DE LORENZO

These paintings capture his interest in the festive activities at the Jetée-Promenade on the palm-studded Promenade des Anglais and his fascination with the curious construction of its Moorish-style buildings with their minarets and cupolas. The two canvases, done twenty years apart, reveal the continuity of his rich color sense, counterbalanced by the seeming rapidity of his almost calligraphic brushstrokes, which add an effervescent sense of movement to the prancing horses, the costumed Carnival revelers, and the fireworks themselves.

Another festive occasion is the subject of *Le Mai à Nice (May in Nice)*, which celebrates the ancient tradition of dancing around a flower-decorated tree to commemorate the arrival of springtime. This tradition —celebrated for many years in individual sections of Nice with open-air balls and games—was the inspiration for this depiction of *Le Vieux-Nice* (the old section of Nice, which has changed little over the years) with its festooned balconies and gaily waving flags. Even greater charm is evident in the deceptively spontaneous execution of *Le Grand Concert (Concert)*. This painting, done late in Dufy's career, overflows with the warmth of its pink, red, and amber tones and the script-like overlay figures—members of the orchestra and the balconied audience.

Portrait de Madame Raoul Dufy is described by Jean Forneris, as "an

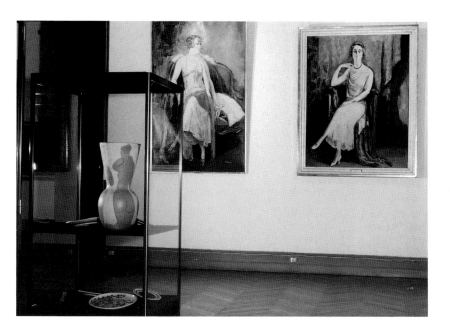

CORNELIUS (KEES) VAN DONGEN, RECOGNIZED FIRST AS A FAUVE AND LATER AS A SOCIETY PAINTER, WAS WELL KNOWN FOR HIS PORTRAITS, SUCH AS THESE OF *LADY JENNY* AND *WOMAN WITH JEWELS*. ALSO DISPLAYED IN THIS ROOM DEVOTED MOSTLY TO VAN DONGEN IS CERAMIC WORK BY PICASSO. LE MUSÉE DES BEAUX-ARTS. PHOTO: MICHEL DE LORENZO

homage to Matisse." The strength of
this bold portrait, with the flatness of
the deep-blue background contrasting
with the intricacy of the patterned
dress and tablecloth materials, is
reminiscent of Dufy's imprinting tech-
nique for fabric design.

Elsewhere in the museum, hung in
the same room with a series of
landscapes—including a few late
Impressionist pieces by Claude
Monet, Eugène Boudin, and Alfred
Sisley—is one of the museum's
twentieth-century masterpieces:
Pierre Bonnard's *Fenêtre ouverte sur
la Seine à Vernonnet (Window
opening onto the Seine at Vernonnet)*.
This gloriously warm painting of a
verdant landscape visible beyond
open windows, was completed before
Bonnard had moved south to
the Riviera. It is perfectly placed,
between two windows overlooking
the museum's garden.

The museum also pays tribute
to two Nice artists, Alexis and
Gustav-Adolf Mossa, who served
sequentially as its first two curators.
Their work may be seen either in
the Musée des Beaux-Arts proper
or in its extension, the Galérie-Musée
Mossa on the Quai des États-Unis.

Alexis Mossa's (1844–1926)
celebrity as an artist was relatively
minor. The majority of his work
consisted of local landscapes, painted
primarily in watercolor. His great
fame, however, was as the initiator of
the pageant-filled Nice Carnival,
for which he designed numerous
imaginative models for glorious floats.
His son, Gustav-Adolf Mossa
(1883–1971), achieved a transitory
reputation as an artist whose work
was related to the Symbolist
movement. Much of his work is

adapted from biblical and/or classical
mythological themes as evoked in
paintings such as *Salomon (King
Solomon)* and *David et Bethsabée
(David and Bathsheba)*. Many
of these paintings appear almost as
miniatures with their exacting details
and colors reminiscent of those
used by the Austrian Symbolist artist,
Gustav Klimt—a translucent range of
sparkling pinks, deep violets,
and turquoise greens applied in a
collage-like style with golds and
brocades and the sparkling presence
of jewels. In contrast to these works,
are the fantasies he created, following
in his father's footsteps, for the
Carnival festivities in Nice. Many of
these works—models, sketches, and
drawings—based on Greek and
Roman chariots driven by assorted
gods and kings, were often translated
for the Nice Carnival into the figure
of His Majesty, the King of the
Carnival. In the spring, before and
during the Carnival season, the
museum sometimes mounts a special
exhibition of sketches, models,
and drafts of Alexis Mossa's wildly
imaginative floats, along with
similarly spectacular fantasies created
by his son.

These two aspects of the Mossas'
work offer an interesting vision of
these very specialized artists, who
have been described as "the
guardians of the traditions of Nice."

ONE OF DUFY'S FAVORITE SUBJECTS WAS THE LARGE BELLE ÉPOQUE STEEL PIER IN NICE KNOWN AS *LA GRANDE JETÉE* WHICH,
WITH ITS MOORISH-STYLE THEATERS AND CASINO, ONCE SERVED AS A CENTER OF NIÇOIS LIFE. LE MUSÉE DES BEAUX-ARTS.
PHOTO: MICHEL DE LORENZO

LE MUSÉE D'ART MODERNE ET D'ART CONTEMPORAIN
THE MUSEUM OF MODERN AND CONTEMPORARY ART

Promenade des Arts, 06300 Nice
Tel: 04–93–62–61–62

Open Wednesday to Monday from 11:00 A.M. to 6:00 P.M.,
except Friday from 11:00 A.M. to 10:00 P.M.
Closed Tuesday and holidays.

THE MOST CONTEMPORARY museum on the Riviera is Nice's Museum of Modern and Contemporary Art, which was inaugurated in June of 1990. This museum, designed by architect Yves Bayard, is an imposing structure consisting of four marble-faced towers that contain the museum's three levels of exhibition space and its

AMERICAN POP ART, WHICH EMERGED IN THE UNITED STATES AT THE SAME TIME THAT THE IMPACT OF THE NEW REALISTS WAS BEING FELT IN FRANCE, IS REPRESENTED BY THE WORK OF WESSELMANN, LICHTENSTEIN, AND WARHOL, AMONG OTHERS. LE MUSÉE D'ART MODERNE ET D'ART CONTEMPORAIN. PHOTO: MICHEL DE LORENZO

rooftop terraces. The towers are connected by foot-bridges surrounded by enormous, gracefully arched windows. From the exterior, the transparent foot-bridges—framed by inverted arches of glass and steel—provide a visually harmonious transition connecting the solid mass of the towers. From the inside, they permit dramatic views over the rooftops of Nice, out to the sea in one direction, and toward the distant Alps in another.

The museum sits at the edge of Nice's old quarter and the Cours Saleya, where Matisse lived during his years in that city (see Chapter 16). This striking building represents the Riviera's response to the modern era of French architecture, ushered in with the opening of the Georges Pompidou Center in Paris in 1977. This was followed during the years of François Mitterrand's presidency by an unprecedented explosion of spectacular new architecture throughout the capital, which included the Pyramide du Louvre and the Musée d'Orsay. With the opening of Nice's new museum and the contemporary artistic movements it celebrates, Nice attained a position of heightened importance as an artistic center in France.

MAMAC, as the museum is familiarly called, is not only a dazzling addition to the architectural scene in Nice, it is also a recognition and affirmation of the important artistic movements that flourished in Nice during the second half of this century. As Pierre Chaigneau, curator of the museum's collections, explains, "The Côte d'Azur, privileged by its climate and beauty, attracted numerous modern artists such as Renoir, Bonnard, Picasso, Léger, Matisse, Dufy, Magnelli, de Staël, and

THE MUSEUM OF MODERN AND CONTEMPORARY ART IS A STRIKING STRUCTURE CONSISTING OF FOUR MARBLE-FACED TOWERS CONNECTED BY GLASS-AND-STEEL-FRAMED FOOTBRIDGES THAT PERMIT SPECTACULAR VIEWS OF THE CITY OF NICE. LE MUSÉE D'ART MODERNE ET D'ART CONTEMPORAIN. PHOTO: MICHEL DE LORENZO

Chagall. Without knowing it, they were preparing a creative environment that would be amplified toward the end of the 1950s—and especially during the following decade."

It was during this period that the "School of Nice," and the various artistic movements that are associated with this general umbrella term, emerged. The museum's collections are, in very large part, devoted to the work of the internationally known artists who were—and remain—part of these artistic currents.

The term "School of Nice" first appeared in 1960 in an article by Claude Rivière. Initially, it referred to the work of a dynamic group of young artists known as *"Les Nouveaux Réalistes"* (New Realists).

The most famous of these artists—all in the museum's collection—Yves Klein, Martial Raysse, Niki de Saint-Phalle, Jean Tinguely, Raymond Hains, Daniel Spoerri, Jacques Villeglé, Arman, César, and Christo, were described by art historian and critic Pierre Restany as being "touched by modern times, industrialization, urbanity and the influence of the media." They shared a rejection of abstract art and a preference for a figurative style, embracing the aesthetic appeal they found in the everyday, utilitarian objects of consumer-oriented societies. Their work has been compared to that of their American counterparts of the 1960s, Pop artists such as Andy Warhol, Claes Oldenburg, Roy Lichtenstein, Robert Rauschenberg,

James Rosenquist, and Jim Dine (whose paintings are also displayed in the museum).

New Realism was the first and the best known of the various artistic currents that emerged in France during the second half of the twentieth century, but it is not the only movement associated with the "School of Nice." Included, as well, is work by artists associated with the "International Fluxus" movement—Ben (Vautier), Serge III, and Pierre Pinoncelli—whose creative expressions were related to performance art and "happenings," many of which took place in Nice and nearby Villefranche during these years. In the late 1960s and 1970s, new trends in the School of Nice began to appear, including the "Support-Surface" group whose work is represented in the museum by Bernard Pagès, Noël Dolla, and Claude Viallat among others. These artists, and those associated with artistic currents of the 1980s such as *La Figuration Libre* (Free Representation), also contribute to the comprehensive view of the times provided by the museum's collections. As a group, they broke with the tradition of the early members of the School of Nice, those preoccupied with representations of the "manufactured objects" of contemporary society, and returned to what Pierre Chaigneau has described as "painting for painting."

Access to the museum is via the high steps or escalators that lead to the vast terrace upon which sits Calder's *Stabile Mobile*. The interior exhibit space is divided among the three circular floors that rise above the large entrance area. The first floor is devoted to an ever-changing series of important temporary exhibits, while the second and third floors are reserved primarily for permanent acquisitions. The museum's more than 400 works of art are displayed on a rotating basis, in an effort to provide a balanced display of recent work by members of the School of Nice, as well as by those who were associated with its emergence in the middle of this century.

One of the most famous names associated with the period—and with the museum itself—is Yves Klein. A full room is devoted to this artist, whom curator Chaigneau considers "one of the two most important French artists of the second half of the twentieth century." The museum traces his short career with twenty of his paintings. Klein's work is dominated by his use of a deep, vibrant blue known as "I.K.B." In particular, Klein's blue is represented in the winged blue sculpture *Victoire de Samothrace bleue (Blue Victory of Samothrace)*, *Vénus bleue (Blue Venus)*, *Anthropométrie ANT 84*, *Portrait-relief de Martial Raysse*, *Arman et Claude Pascal* and the semi-formal *Tableau de mariage (Wedding Portrait)*, which is co-signed by Christo. In addition to his painting and sculpture, the panoramic terraces above the museum display two posthumous creations: *Grille de feu (Gate of Fire)* and *Jardin d'Éden (Garden of Eden)*, which were completed according to his instructions.

The New Realists are equally well represented by Martial Raysse's *L'arbre (Tree)*, a carefully-pruned standing sculpture composed of multicolored bottles and discarded

cans, and his painting-and-neon *Portrait de France Raysse*. Jacques Villeglé's *Affiche lacérée (Shredded Poster)* and *Boulevard Saint-Martin* are also illustrative of the work produced by the New Realists. Prominent other work by members of this group include Arman's *Clairobscur (Chiaroscuro)*, an assemblage of burned wood, violins, and cellos, and *The Birds 11*—an ingenious assemblage of pliers—and César's *Compression plate de voiture [Dauphine] (Flat Compression of a [Dauphine] Automobile)*, a mounted model of a crashed car. This piece, which caused a sensation when it was first exhibited, serves as an irreverent comment on the conspicuous consumption of contemporary society—a prominent theme of the movement. Christo's *Package on Luggage Rack*, one of his signature wrapped-sculptures, is one of the ten or so pieces tracing his work that are on display in the museum. As a group, these works illustrate the preoccupations of these artists, who were obsessed and dismayed by the materialist excesses they saw around them.

American Pop Art, a quasi-companion movement—which emerged in the United States at the same time that the impact of the New Realists was being felt in France—is represented by several major works. These include Tom Wesselmann's *Still Life*, a tripartite work incorporating an enormous rotary telephone, a light switch, and a burning cigarette, Oldenburg's *Shrimps on Fork*, Lichtenstein's *Figure with Banner*, James Rosenquist's *Big Bo*—a large red, cutout of a jazz musician—and Robert Rauschenberg's *Ruby Goose*, one of the several mixed-media works

by this artist in the museum's collection. Dine's *Hard Hearts*, is typical of the gaily patterned hearts that have become one of his trademark images, illustrated here by an oil paint-and-wood collage assembled on five large vertical panels. Warhol, one of the most celebrated of the American Pop Artists, is represented by his serigraphed *Dollar Sign*.

The work of the "Fluxus" artists Ben and Serge III is also an important part of the museum's collections. Ben, known for the contradictory titles of his works, is represented by his acrylic on canvas, *J'ai rien à vous montrer. Il-y-a tout à voir (I have nothing to show you. There is everything to see)*, as well as his assemblage *La Cabane de Ben (Ben's Hut)*, which is covered with his ironic and oppositional statements.

The "Support Surface" group, particularly representative of artists working in Nice starting in the late 1960s, includes Dolla's *Croix (Cross)* and Viallat's *Sans titre (Untitled)*, one of his richly patterned and textured canvases.

In addition to celebrating the creations of artists associated with specific groups, the museum's collections feature representations of well-known painters and sculptors who work in individual idioms, including Conceptual and Minimal art, and American abstract art. Some examples of these are Sasha Sosno's white marble *Tête au carré (Squared Head)*, Claude Gilli's painted wood *Coulée (Flow)*, Jean-Claude Farhi's *US N° 18*, and several pieces by Robert Malaval such as his *Rampe Schoeller, Fragments de corps féminin (Fragments of a Feminine Body)* and his large, encased sculpture, *Dormeuse (Sleeping Woman)*. This

work, along with that of numerous other local artists, has contributed to Nice's increasingly rich diversity of artistic expression and its reputation as a creative center.

In many respects, Nice's Museum of Modern and Contemporary Art owes a retrospective expression of gratitude to Henri Matisse. In the years before his death in Nice in 1954, Matisse lent his considerable prestige to championing the establishment of a permanent home for the exhibition of work by modern artists. With his help, a charming seafront structure on the Quai des États-Unis, a former arsenal for the Sardinian navy and subsequent market building for local fishermen, was inaugurated in 1950 under the name "La Galérie des Ponchettes." This delightful site, which has retained a charming evidence of its multifaceted past—an elegant Genovese-style arcaded exterior and an interior of Roman arches and individual stone pillars which bear the numbers of the boats that had been stored there—became a showcase for twentieth-century art. For several decades, the Galérie des Ponchettes served as a quasi-museum of modern art, and, from 1990 until late 1997, as the Galérie-Musée Raoul Dufy.

Almost forty years elapsed between the creation of the Galérie des Ponchettes and the formal opening of MAMAC. During this period, Nice was to assume an important role in challenging the dominance of Paris in contemporary art. Recognition of the vitality of artistic expression in the area was confirmed by Pontus Hulten, the former director of the Pompidou Center in his dedication to the Center's inaugural exhibit, "About Nice." Hulten wrote, "Contemporary art history would never have been the same were it not for the activities and events that took place in the region around Nice."

Nice's impressive Museum of Modern and Contemporary Art underscores and celebrates that sentiment.

WORK BY ARTISTS WHO ARE PART OF THE SCHOOL OF NICE CONSTITUTE A MAJOR PART OF THE MUSEUM'S COLLECTION. ONE OF THE MOST FAMOUS IS YVES KLEIN, WHOSE PAINTINGS (MANY DOMINATED BY HIS TRADEMARK VIBRANT BLUE PAINT), FILL AN ENTIRE ROOM. LE MUSÉF D'ART MODERNE ET D'ART CONTEMPORAIN. PHOTO: MICHEL DE LORENZO

THE WORK OF ARTISTS KNOWN AS THE NEW REALISTS FOCUSED ON UTILITARIAN OBJECTS, THE IMPACT OF THE MEDIA, AND THE CONSPICUOUS CONSUMPTION OF A CONSUMER-ORIENTED SOCIETY. REPRESENTATIVE OF THEIR WORK IS CÉSAR'S *FLAT COMPRESSION OF A (DAUPHINE) AUTOMOBILE,* A MOUNTED MODEL OF A CRASHED CAR, RAYSSE'S NEON *PORTRAIT OF FRANCE RAYSSE,* AND CHRISTO'S *PACKAGE ON LUGGAGE RACK.* LE MUSÉE D'ART MODERNE ET D'ART CONTEMPORAIN. PHOTO: MICHEL DE LORENZO

THE ENTRANCE FOYER OF THE FORMER VILLA CONTAINS FURNISHINGS FROM MATISSE'S APARTMENT-STUDIO AT THE HÔTEL RÉGINA—INCLUDING A STRIPED LOUIS XVI ARMCHAIR, A VENETIAN ARMCHAIR, VARIOUS TABLES, AND HIS PAINTING, *WINDOW IN TAHITI*. LE MUSÉE MATISSE. PHOTO: MICHEL DE LORENZO

LE MUSÉE MATISSE
THE MATISSE MUSEUM

164 Avenue des Arènes, 06110 Nice
Tel: 04–93–53–40–53 and 04–93–81–08–08

Open Wednesday to Monday from 10:00 A.M. to 5:00 P.M.
October through March;
from 10:00 A.M. to 6:00 P.M. April through September.
Closed Tuesday and holidays.

FOR THOSE HOPELESSLY in love with the work of Henri Matisse (1869–1954), visiting the Musée Matisse is something of a pilgrimage. The museum is located on the site of an ancient Roman arena on a hillside just above the center of Nice, but to retrace Matisse's Riviera career one must begin closer to the Mediterranean, where he spent the first twenty-odd years of his residence in that city.

A stroll by the Hôtel Beau Rivage on the Rue Saint-François-de-Paule just behind the Quai des États-Unis— the palm-studded seaside boulevard that borders the Mediterranean— passes the place where Matisse first lived when he came to Nice in 1917. A short walk leads directly into the old section of Nice and the Cours Saleya, the large, colorful open-air square with daily flower and food markets that supplied many of the props for his Nice Period paintings of the 1920s. The next stop is the charming yellow house at 1 Place Charles-Félix at the far end of the Cours Saleya. This Neoclassical building where Matisse lived from 1921–1938 still stands (but without any sort of biographical plaque), brightly painted, as though in

homage to his palette.

From there, it is a pleasant drive of a few short, though winding, miles up to the Musée Matisse in Cimiez, the residential section of Nice located in the hills overlooking the city. Just before reaching the museum, the ride on the Boulevard de Cimiez weaves past the imposing Hôtel Régina. The splendor of this formerly grand hotel-turned-apartment house has long since faded, but it is an important landmark in the Matisse story. With the exception of the war years—from mid-1943 when the threat of coastal bombings forced him to retreat inland to the village of Vence—until 1949, Matisse spent much of the last chapter of his life here and produced some of his most important work in his apartment-studios overlooking the city below.

Immersing oneself in these views—the turquoise blue of the sea, the rose glow of the sun as it seeps through the colored shutters of the Neoclassical apartments, the ornate balconies and stone balustrades over-looking the palms of the Promenade des Anglais, the transparent light shimmering as it reflects the sea and sky—is the best way of experiencing Nice as Matisse saw and captured it in his paintings.

At the age of 48, Matisse was already world-renowned when he came to the Riviera from Paris. In 1904, at the age of 34, he had had his first one-man show. The next year, at Paris's landmark painting exhibition, the Salon d'Automne, Matisse startled the artistic community with the first of what were to be called his Fauve paintings (see Chapter 1). These canvases, along with those of André Derain, Maurice de Vlaminck, and

Cornelius (Kees) Van Dongen, associated him with the avant-garde of the day. There was an ardent group of Russian collectors who had already deprived France of some of his early masterpieces. However, it was by coming to the Riviera—to Nice in particular—that he burst forth with an explosion of artistic activity that was to last until his death at the age of 84. Matisse exalted in the light of the Riviera: "When I realized that every morning I would see this light again, I couldn't believe my good fortune. . . . The richness and silvery clarity of the light in Nice seem to me to be quite unique and absolutely indispensable. Here, the light plays the leading role; color comes later."

In his considerable writings, he frequently commented about the impact the light had on his work: "Most people come here for the picturesque quality. As for me, what made me stay are the great colored reflections of January, the luminosity of the daylight." He was later to say, "If I had continued painting in the north, as I did thirty years ago, my paintings would have been different. There would have been browns, grays, fog, shadings with color through perspective." The truth of this statement becomes obvious once inside the Musée Matisse. The pre-Riviera era paintings there are puddled with dull colors. The Nice Period paintings suddenly seem to glow.

At first glance, the Musée Matisse itself is a shock of rich, warm colors. The core of the museum's permanent collection resides in a sienna-colored seventeenth-century villa, accented with contrasting green shutters and a *trompe l'oeil* stone

THE HEART OF THE MATISSE MUSEUM IS LOCATED IN THE SIENNA-COLORED SEVENTEENTH-CENTURY VILLA DES ARÈNES, SITUATED IN THE MIDST OF THE ARCHAEOLOGICAL REMAINS OF A ROMAN ARENA AND BATHS, WITHIN VIEW OF THE HÔTEL RÉGINA WHERE MATISSE LIVED FOR MANY YEARS. LE MUSÉE MATISSE. PHOTO: MICHEL DE LORENZO

façade. Known as the "Villa des Arènes" (because of its location in the midst of the archaeological remains of an ancient Roman arena and baths that preceded modern Nice), the villa initially housed both a modest Matisse collection and an archaeological museum. Successive major donations by the Matisse family, coupled with the discovery of additional archaeological treasures on the grounds, resulted in the separation of the two museums. The archaeological museum was eventually moved to its own structure nearby and the Matisse Museum was modernized and expanded. In 1993, after many complications and delays, the renovated museum, designed by Jean-François

Bodin, was opened. It now consists of the original seventeenth-century villa and a sleek and modern adjoining structure that is partially underground. The formal entrance to the museum is through the new addition that provides, via a connected passageway, a gracious transition to the older building.

The museum's collection is a celebration of Matisse's life and work. Xavier Girard, the longtime curator of the Musée Matisse, describes it as a "biographical museum," and it is just that. Displayed in its eighteen rooms on three floors, some shaded and intimate, others high-ceilinged and ablaze with the Mediterranean light that so enraptured Matisse,

are expressions of Matisse's life on the Riviera—a setting in which the personal and professional have become intermingled.

Those familiar with Matisse's work will delight in the presence of some of his most prized possessions: The famous rococo Venetian armchair that he so adored is there, right next to the painting of the *Fauteuil rocaille (Rococo Armchair*—1946), in which it figures prominently. Display cases on several floors contain the blue vases, ceramic fragments, various pitchers, the crystal jam-jar, snuff boxes, white porcelain cups, and pewter and Tabac Royal jugs that appear repeatedly in Matisse's paintings.

The entrance foyer of the Villa contains furnishings from his apartment-studio at the Hôtel Régina and lend a personal character to the collection: a striped Louis XVI armchair, another rococo (or Venetian) armchair, a little decorated table, and a larger marble table—appropriately enhanced with a huge philodendron.

These personal objects are not displayed as mere mementos. As Xavier Girard explains, "All of these objects are shown . . . with the intention of contributing to an understanding of a work and its internal organization." The way he translated a printed fabric into its painted counterpart showed how he distilled life into art.

A contemplative stroll through the museum permits one to reflect on the progression of Matisse's works. They span his career from his earliest painting—*Nature morte aux livres (Still Life with Books*—1890) done when he was 21—to the great paper cutouts of his final years. Matisse's genius is evident, not only in the individual masterpieces he produced in any one genre, but in the vast diversity of media within which he worked: oil, engravings, pen and ink, tapestry, glass, colored paper, sculpture, and ceramics. He designed ballet costumes and stage sets, as well as illustrated books, and created a totally new means of expression with his paper cutouts.

The art is not arranged in any particular chronological order. Following Matisse's very explicit belief that a museum is "more an instrument for study of an artist's work and its development than as a shrine to completed creations," the collection is displayed in a manner that permits comparisons of different techniques and the relationship between different media—paintings with sketches, sculpture with painting, cutouts with illustrations, and so forth. Thus the visitor will find Matisse's work organized in such a way that a single room will display drawings or paintings and sculpture of the same person; or cutouts inspired by prior sculptural forms.

Works on Paper:
The very first thing to be seen upon entering the museum is the monumental paper cutout, *Fleurs et Fruits (Flowers and Fruit*—1952–53). Matisse, enfeebled in his later years and unable to stand for long periods or wield a brush, turned to a technique developed thirty years earlier—cutting out shapes from colored papers and assembling them into a collage.

To get the papers in the exact coloration and patterning he wanted, he first mixed batches of gouache to the correct tone, then had assistants apply the colors onto squares of

THE COLORFUL PRIESTS' VESTMENTS THAT MATISSE DESIGNED FOR THE CHAPELLE DU ROSAIRE IN VENCE ARE AMONG THE MANY PREPARATORY STUDIES IN THE MUSEUM. LE MUSÉE MATISSE. PHOTO: MICHEL DE LORENZO

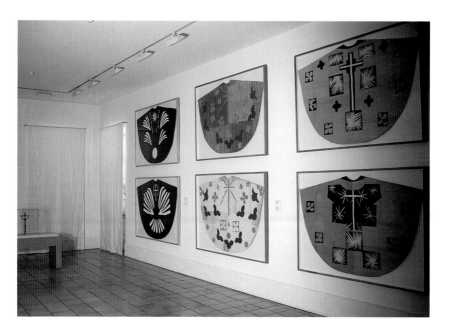

THE COLORFUL PRIESTS' VESTMENTS THAT MATISSE DESIGNED FOR THE CHAPELLE DU ROSAIRE IN VENCE ARE AMONG THE MANY PREPARATORY STUDIES IN THE MUSEUM. LE MUSÉE MATISSE. PHOTO: MICHEL DE LORENZO

paper in quick brushstrokes to ensure smooth swatches of single isolated colors. Once satisfied with his material, he would work on the design, then put preparatory drawings out of sight and cut directly into the vibrantly colored paper.

He first used this technique in 1920 when preparing the models for the costumes and sets for Diaghilev's ballet, *Le Chant du Rossignol (The Song of the Nightingale)*. He returned to it in 1930 when working on the models for the celebrated *Dance* mural for the Barnes Foundation in Merion, Pennsylvania. Later he expanded on the technique, using paper cutouts as a preparation for the twenty colorplates for the illustrated

volume, *Jazz*, published in 1947. An entire wall in the museum displays the *Jazz* colorplates. In the preface to this text, Matisse describes his cutouts as "drawing with scissors," adding that "cutting directly into color reminds me of a sculptor's carving into stone."

During the last years of his life, this was a medium that permitted the ailing artist to retain great creative freedom. Even while confined to his bed or a wheelchair, he continued tirelessly to create, using either a long bamboo stick to which a piece of charcoal was attached or a pair of scissors that served as a surrogate brush. He filled his rooms at the Régina with a world of brilliantly

colored cutouts—birds, flowers, fruits, dancers—some on the ceiling, others on the walls or on the floor. Some were of enormous dimensions and took on a life of their own as they were pinned lightly to the wall with transparent tacks. Matisse delighted in this technique, commenting that critics might say, "Old Matisse, nearing the end of life, is having fun cutting up paper. That won't make me happy, of course. Well, I had a lot of fun cutting up my paper, trying to rediscover through unusual technical means the lovely days of line and color."

The museum owns the most important collection of paper cutouts including—in addition to those mentioned above—studies for the chapel in Vence: *Les Chasubles (The Vestments*—1950–52) and *Les Abeilles (The Bees*—1948), *La Danseuse créole (The Creole Dancer*—1951), *Nu bleu IV (Blue Nude IV*—1952), *Baigneuse dans les roseaux (The Bather in the Rushes*—1952), and *La Vague (The Wave*—c. 1952).

The Painting Collection:
There is no denying that the Musée Matisse does not own many of Matisse's greatest paintings, especially the richly sensual, decoratively patterned odalisques with which his work in Nice has been associated. These exotic female studies were

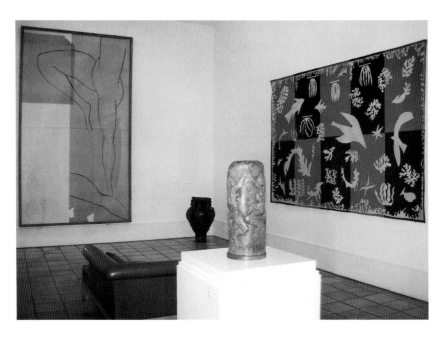

THE MUSEUM'S COLLECTION IS ORGANIZED SO AS TO PERMIT COMPARISONS OF DIFFERENT TECHNIQUES AND THE RELATIONSHIP BETWEEN DIFFERENT MEDIA, SUCH AS THIS STUDY FOR THE BARNES FOUNDATION'S *DANCE,* A TAPESTRY, *POLYNESIA, THE SEA,* A WOODEN SCULPTURE ALSO ENTITLED *THE DANCE,* AND HIS OWN ETRUSCAN VASE. LE MUSÉE MATISSE. PHOTO: MICHEL DE LORENZO

"grabbed up" by foreign collectors well before Matisse was sufficiently appreciated in France. Nonetheless, the painting collection here does span his lifetime.

It begins with the early dark paintings of the late 1890s, includes several important Fauve period works—*Jeune femme à l'ombrelle (Young Woman with a Parasol)* and *Portrait de Madame Matisse,* both from 1905)—and four works from the early Nice period: *Tempête à Nice (Storm in Nice), La Petite pianiste (The Little Pianist—1924), Interieur à l'Esclave (Interior with Slave)* and *Odalisque au coffret rouge (Odalisque with a Red Box—1926).* Paintings of his later period include *Fenêtre à*

Tahiti (Window in Tahiti—1935–36), La Nymphe dans la forêt (Nymph in the Forest—1935–43), Nu au fauteuil, plante verte (Nude in an Armchair with Foliage—1936–37), Liseuse à la table jaune (Woman Reading at a Yellow Table—1944), and the well-known masterpiece, one of his last easel paintings, *Nature morte aux grenades (Still Life with Pomegranates—1947).*

The Sculpture Collection:
The museum owns the majority of the original casts of the approximately seventy pieces of sculpture completed by Matisse. Sculpture was an important medium to him, one with which he experimented early in his

MOST OF THE ORIGINAL CASTS FOR THE APPROXIMATELY SEVENTY PIECES OF SCULPTURE MATISSE COMPLETED ARE OWNED BY THE MUSEUM. AMONG THEM ARE THE SERIES OF FIVE *JEANNETTE* HEADS. LE MUSÉE MATISSE. PHOTO: MICHEL DE LORENZO

career and returned to periodically throughout his life. Consistent with its goal of juxtaposing work in various media to permit comparisons of technique, the museum's sculpture collection is dispersed throughout the building. Prominent among the collection are early pieces such as *Le Serf* (1900–1903), the largest and among the most famous of his sculptures, a series of small sculpted heads of family members *(Pierre, Rosette, Marguerite, Jean)*, several *"petits têtes" (small heads)*, and various nudes—all more or less from the Fauve years. Several large pieces include the well-known *La Serpentine* (1909) and *Deux Négresses (Two Negresses—*1908).

Contemporaneous with painted portraits of one woman (Jeanne Vaderin), is the series of five *Jeannette* heads (1910–13). These five pieces, along with the three *Henriettes* (1925–29) and the series of *Dos (Backs)* done from 1909 to 1932, are among his most important sculptures. The *Dos* series represent an important aesthetic obsession, extending over a twenty-three-year period.

The Drawings:

Drawings occupied a premier place for Matisse, who considered them as important as many of his paintings. He once confided that he believed that "it is crucial to know how to draw. With that skill, one can draw anything at all, be it plants or furniture or the Virgin, the goal is to be able to feel that one has a vocabulary that can be applied to everything." Beyond the stated importance he attributed to it, his preoccupation with drawing often revealed itself unconsciously. Soeur Jacques-Marie,

who as a young nursing student had cared for Matisse after a major cancer operation, described how, in his sleep, Matisse would raise one hand to draw and then with his other hand attempt to rub out a line that didn't please him. Later, art critic Rosamond Bernier would describe how Matisse had confided to her his embarrassment in observing his hand movements on a documentary film of him at work. He noted that the film revealed that, as he raised his hand to draw, there was a prelude to the gesture—an observation that made him feel as though he had been seen in the nude.

The museum's collection of 236 drawings highlights the various roles that drawing played for Matisse. The wonderful line drawings and the shaded charcoal drawings, full of sensitivity and confidence of stroke, demonstrate how—with a single line—Matisse could bring an object to life.

The collection falls into several major groups. The first includes masterpieces from various stages of his career: *Portrait de Madame Matisse* (1915), *Géranium dans un vase (Geranium in a vase—*1916), *Tête, Bouddha (Buddha Head—* 1939), *Nu couché de dos (Reclining Nude Seen from Back)* and the india ink drawings *Platane (Plane Tree—* 1951) and *Grand Acrobate (Large Acrobat—*1952). A second group includes preparatory drawings that help trace the evolution of work in progress for several major projects. These include preliminary drawings for the Barnes Foundation's *Dance* mural (1930–32), and a collection of studies for various aspects of the chapel in Vence (1948–49). Finally, there are studies for several of his

IMPORTANT PERSONAL POSSESSIONS OF MATISSE'S, INCLUDING HIS PRIZED VENETIAN ARMCHAIR, A PORTRAIT OF MADAME MATISSE BY MARQUET, A PORTRAIT OF MATISSE BY DERAIN, AND A SELECTION OF MATISSE'S WORK IN DIFFERENT MEDIA FROM A VARIETY OF TIME PERIODS ARE INCLUDED IN THE MUSEUM'S COLLECTION. LE MUSÉE MATISSE. PHOTO: MICHEL DE LORENZO

illustrated books (*Poèmes* by Charles d'Orléans and Baudelaire's *Les fleurs du mal*).

Integrated Design:

The richness of the museum is crowned by its collection of the innumerable preparatory studies for La Chapelle du Rosaire, the small Dominican chapel in Vence which Matisse considered the "masterpiece" of his career. While the story of the chapel and Matisse's total absorption in every aspect of the project is told in Chapter 17, the museum's collection of preliminary studies for the chapel brings to life Matisse's artistic journey as he worked on the chapel. It is hung on the second floor of the museum.

This spectacular exhibit is displayed in a room specially lit to capture the chapel's spirit. A small area contains one of the several, colored glass models for the chapel's stained-glass windows, the only elements of architectural color in the structure. Even as models, they reveal the intensity and luminosity of the green, yellow, and blue glass that Matisse painstakingly sought. Elsewhere, the wall of gouache cutout studies for the chasubles (vestments worn by priests for important events) demonstrates the festivity Matisse hoped to evoke in the brilliant spectrum of colors he used, each loyal to the six liturgical colors required for various times of the year and for different church holidays.

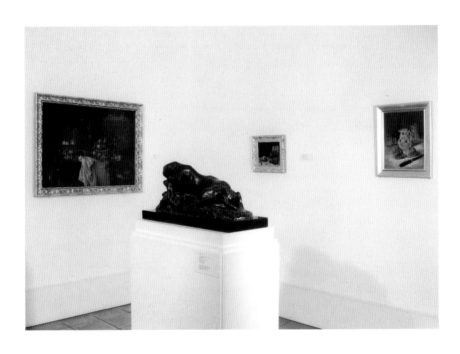

MATISSE'S ENTIRE CAREER IS SPANNED IN THE MUSEUM COLLECTION, WHICH INCLUDES SOME OF HIS EARLY "DARK" PAINTINGS AND SCULPTURE, DONE BEFORE HE MOVED TO THE SOUTH OF FRANCE. LE MUSÉE MATISSE. PHOTO: MICHEL DE LORENZO

Each vestment is decorated with the traditional cross enhanced by an assortment of typical Matissian leaves and stars, achieved with color-contrasting gouache cutouts. These studies are in sharp contrast to the simplicity, almost starkness of the charcoal studies for the monumental figure of *Saint Dominic* (which has been applied to a canvas backing after being removed from the wall of the Hôtel Régina upon which he had originally drawn it), the *Virgin and Child*, and the *Stations of the Cross* found in the chapel.

Studying the range and diversity of elements required for this chapel helps elucidate the motivation that led Matisse to undertake this major project during the last years of his life. It was, as he frequently explained in his writings, because he wanted to synthesize various aspects of his work—architecture, stained glass, large murals on ceramic—and, as he said "to integrate each of these elements, make them meld into a perfect unity."

Matisse's work on the Riviera changed and expanded during the nearly four decades he spent there. Although his choice of media and subjects varied, he was quoted as saying about his work a few years before his death, "From *Le Bonheur de vivre*—I was thirty-five then—to this cutout—I am now eighty-two—I have not changed . . . because all this time I have looked for the same things which I have perhaps realized by different means." This museum in his name is living testimony to this observation.

It is easy to understand why its curator, Xavier Girard, enthusiastically declares that Matisse would have liked his museum. Its organization exemplifies Matisse's belief that a museum should be laid out to encourage comparisons of techniques and the relationship between different media.

Equally important, it is located close to where he lived and worked for many years, high above Nice in a tranquil grove of olive trees. In addition, it is near the spot where he is buried—in a secluded and elegant setting behind the Franciscan monastery and close to the ancient Roman baths that, twenty centuries before, had existed on this timeless and immensely moving spot.

LA CHAPELLE DU ROSAIRE—LA CHAPELLE MATISSE
THE CHAPEL OF THE ROSARY—THE MATISSE CHAPEL

466 Avenue Henri Matisse, 06140 Vence
Tel: 04–93–58–03–26

Open Tuesday and Thursday from 10:00 A.M. to 11:30 A.M.
and 2:30 P.M. to 5:30 P.M.
During French school holidays open Wednesday, Friday, and Saturday
from 2:30 P.M. to 5:00 P.M.
Other days by appointment (24 hours in advance).
Apply to the Dominican Convent at the address above.

A S HE APPROACHED the age of eighty, Henri Matisse undertook the most ambitious artistic project of his life—that of designing and decorating a chapel (La Chapelle du Rosaire—The Chapel of the Rosary) in the small hill-town of Vence. In the course of four long years—from 1947 to 1951—his project became an all-consuming passion. Upon its completion, the eighty-two-year-old Matisse, often bedridden, was too weak to attend the consecration ceremony in person, but he sent the following message to the Bishop of Nice:

Your Excellency:
I present to you, in all humility, the Chapel of the Rosary of the Dominican Sisters of Vence. I beg you to excuse my inability to present this work in person since I am prevented by my state of health: the Reverend Father Couturier has been willing to do this for me. This work has taken me four years of exclusive and assiduous work and it represents the result of my entire

active life. I consider it—in spite of its imperfections—to be my masterpiece. May the future justify this judgment. . . .
—Henri Matisse

His opinion was to be confirmed time and time again as critics, art historians, and a loving religious as well as secular public have visited and marveled at the moving elegance of this chapel.

Matisse, of course, was not the first, nor the last major artist to decorate a house of worship. In a long history of artist-decorated chapels, from Giotto's fourteenth-century Arena Chapel in Padua, Italy, through the itinerant painter chapels in Southeast France and the modern art-filled Church of Notre-Dame-de-Toute-Grâce in Assy, which represented a renewal of interest in sacred art in France in the aftermath of World War II, along with the secular chapel of Picasso in Vallauris (see Chapter 5), the Fishermen's Chapel by Cocteau in Villefranche-sur-Mer (see Chapter 18), and Mark Rothko's chapel in Houston, Texas, there is nothing that

AS HE APPROACHED THE AGE OF 80, MATISSE UNDERTOOK THE MOST AMBITIOUS PROJECT OF HIS LIFE—DESIGNING AND DECORATING THE CHAPELLE DU ROSAIRE. LA CHAPELLE NOTRE-DAME DU ROSAIRE. PHOTO: MICHEL DE LORENZO

quite equals Matisse's achievement.

Matisse's enthusiasm for the project knew no bounds. It fulfilled his lifetime ambition to create a total environment—one in which he would be responsible for every element of design and decoration. He directed the architectural plan of the chapel, although a succession of architectural consultants was involved in one way or another. Then, using the stained-glass windows that had been his initial inspiration, he designed every decorative aspect of the chapel. He hand-sculpted the crucifix, designed the candelabra, the altar and altar cloth, the door to the confessional, the ceramic murals depicting the *Stations of the Cross*, the *Virgin and Child*, and *Saint Dominic*—the patron saint of the Dominican order

—the furniture and all the vestments worn by the priests.

No detail escaped his attention— the design of the wrought-iron spire and its bell, all external decoration, even the color and quality of the roof tiles. In other words, Matisse took the chapel over almost completely, contributing not only his creative genius, time and energy, but large sums of his own money for its completion.

Just how Matisse—who, though raised a Catholic, was not particularly observant—came to be involved in the chapel has been the subject of much investigation. What is clear is that events related to World War II brought him indirectly to this project.

Matisse had lived and painted in Nice for the better part of the previous twenty-six years. However,

IN 1943, AT THE HEIGHT OF WORLD WAR II, MATISSE MOVED FROM THE COASTAL CITY OF NICE INLAND TO THE MEDIEVAL HILLSIDE VILLAGE OF VENCE. PENCIL SKETCH BY MAURICE FREED, 1960–61.

in 1943, at the height of the war, he was forced to leave the coast. France was occupied by the German army and the German military situation had started to deteriorate. There was great fear that Nice would be bombed. Since Cimiez, the hillside residential section of Nice where Matisse lived, was considered a particularly dangerous target because of an arsenal nearby, Matisse was repeatedly urged to leave France. But, like Picasso, he refused to go, saying: "It would seem to me as if I would be deserting. If everyone who has any value leaves France, what remains of France?" Rather than leave, he retreated ten miles inland and upward to the village of Vence.

In Vence he moved to the Villa Le Rêve with Lydia Delectorskaya, his longtime secretary and assistant. From this peaceful, balconied villa (still standing today, surrounded by fruit and olive trees) Matisse continued to work—painting, drawing, completing the cutouts for his *Jazz* volume, an album of twenty circus-inspired colorplates with his own handwritten text—expanding the repertoire of his gouache-coated paper cutouts and enjoying the worldwide acclaim he was receiving.

Shortly after moving to Vence, Matisse began to receive periodic visits from Monique Bourgeois, the woman who became the source of much legend in the story of Matisse and the Chapelle du Rosaire. A few years earlier—in 1942—this young woman, while still in her teens, had been Matisse's devoted nurse and had cared for him briefly while he was recovering from his abdominal surgery for cancer.

She had secured this position after responding to a newspaper advertisement for a "young and pretty night nurse for the painter Henri Matisse." When she tended him during the long nights of his insomnia and discomfort in Nice, they had developed a close and affectionate relationship. Later she also posed for him. Interestingly enough, Monique Bourgeois, too, had an interest in art and had done some sketches, which she shared with Matisse.

Following the period during which Monique had been his nurse and, occasionally, his model, she left Vence. Several years later she was to become a Dominican nun, adopting the name of Soeur Jacques-Marie. By a happy coincidence, she was sent to the Dominican convent in Vence. The convent was on the Route de Saint-Jeannet, as chance would have it, just opposite the villa where Matisse was living. During Matisse's last years in Vence it was she who became the instrumental link between Matisse and the chapel.

In 1947, some nuns in the Dominican order in Vence dreamed of constructing a small oratory or chapel next to the convent where they lived. Attempts had been made in the past to build one, but had been abandoned, in part, because the Sisters feared that the building might deprive their living quarters of sunlight, since it would block the part of the convent that contained their rooms. As Soeur Jacques-Marie tells the story in her delightfully informative book, *Henri Matisse: La Chapelle de Vence*, the nuns used an old and leaking garage as a temporary chapel. Despite their dreams of a proper structure, funds were insufficient and there was no immediate project on the drawing board.

One night, Soeur Jacques-Marie

was inspired to do a watercolor of the Assumption, in the hope that it might become a stained-glass window for a future chapel. Not long afterward, she showed this picture to Matisse, who offered to help her bring this stained-glass window to fruition. He promised to help provide the necessary funds to make it become a reality.

At about the same time, a Dominican novice priest by the name of Frère Raysiguier was sent to nearby Saint-Paul-de-Vence for his health. He was interested in art and had something of a background in architecture. When visiting Vence, Frère Raysiguier made a point of meeting Matisse. From their discussions, and the eventual intervention and involvement of Père Couturier (the French priest who played a major role in integrating modern art into Catholic houses of worship), it wasn't long until Matisse's enthusiasm had drawn him into every aspect of the project. He worked on the chapel almost without interruption from late 1947 until 1951.

From its unassuming exterior today, the chapel could almost be overlooked, except perhaps for the soaring spire and decorative bell, which suggest that something very special might be inside. It is situated on a side street in Vence, now known as Avenue Henri Matisse. With an exterior of white stucco, like many of the area's surrounding villas, and the same concave shaped roof tiles, (albeit in blue and white in contrast to the typical terra-cotta tiles that cover most Provençal buildings), it blends peacefully into its setting.

Yet Matisse's touches, both small and grand, are to be seen everywhere. Upon entering the chapel—but before entering the sanctuary—a graceful blue-and-white holy water container opens like the petals of a flower in bloom. Once inside the building, the simplicity and power of the stark white setting is overpowering. The contrast and interplay between the towering black-and-white-tiled wall murals—highlighted by glints of color thrown off by the stained-glass windows—dazzle the eye. The harmonious balance that Matisse aspired to create between the glowing whiteness of the ceramic and marble and the bursts of color captured by the light radiating through the stained-glass windows envelops the visitor in its peacefulness.

The Windows:

Three sets of stained-glass windows are the only fixed sources of color in the chapel. The most glorious window of all is the central *Tree of Life*. Located on the west wall of the chapel, it permits the full intensity of the sun, transfigured by the colored glass, to illuminate the off-center stone altar.

The windows were Matisse's preoccupation for two full years. He was obsessed with both the design and the colors, completing numerous preliminary studies, as well as full models that he later rejected. He finally settled on a series of windows that reuse frequent themes in his work: the blue of the sea and sky, the yellow of the sun, and the verdant green abundant in the local vegetation.

The leaf shapes Matisse used assumed particular importance. Ultimately, for the *Tree of Life* window, he adopted the pattern of a local cactus—the prickly pear *(Figue de Barbarie)*—but without its thorns.

MATISSE WAS RESPONSIBLE FOR DESIGNING EVERY ASPECT OF THE CHAPEL THAT HE CONSIDERED HIS MASTERPIECE: THE STAINED-GLASS WINDOWS AND MURALS THAT ADORN THE WALLS, THE ALTAR, THE HAND-SCULPTED CRUCIFIX, THE CANDELABRA, THE PRIE-DIEU, AND THE ALTAR COVERING. LA CHAPELLE NOTRE-DAME DU ROSAIRE. PHOTO: MICHEL DE LORENZO

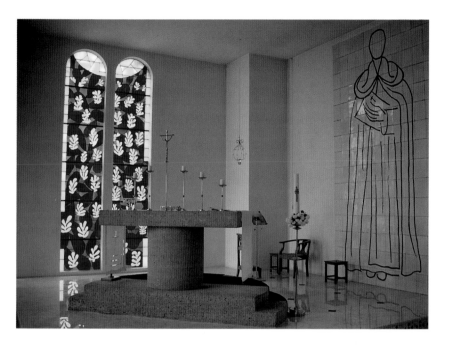

For Matisse, this plant, which flourishes in dry areas of Provence as in the desert, was symbolic of life and endurance. By contrast, variations on the palm leaf are the motif for the more transparent bays of side windows. One set serves as a backdrop for the section of the chapel reserved for the use of the Sisters of the Dominican community, the other set of side windows serves the worshipers. Together, they bathe the chapel in a warm, rich—perhaps unexpected—glow.

Once having decided on the leaf motif for the windows and the use of only blue, yellow, and green glass, Matisse tormented himself over the relationships of the color combinations and the colors they produced when reflected as an ensemble.

As always for Matisse, the role of light assumed major importance. He wrote: "For a long time I've had the sense of expressing myself by light, or rather through light, that appears to me as a crystal block through which something passes. It is only after having delighted for a long time in the light of the sun that I've tried to express myself through the light of the spirit."

In particular, Matisse labored over the precise shade of yellow glass to be used in the *Tree of Life* window. He insisted on an unpolished "lemon

THE CHAPEL IS SITUATED ON A SIDE STREET NOW NAMED AVENUE HENRI MATISSE. FROM ITS UNASSUMING EXTERIOR, IT COULD POSSIBLY BE OVERLOOKED, EXCEPT PERHAPS FOR THE SOARING SPIRE AND DECORATIVE BELL, WHICH SUGGEST THAT SOMETHING VERY SPECIAL MIGHT BE INSIDE. PENCIL AND PASTEL SKETCH BY MAURICE FREED, 1960–61.

yellow" glass that would cast the best shade of yellow onto the whiteness of the floor. In the end, the shade he wanted couldn't be found commercially and had to be specially sandblasted into the glass to provide the translucent quality he demanded.

Throughout the year, but particularly in winter, the stained-glass windows cast their reflections on the floor, on the white altar covering, and sometimes as far as the opposite wall, in varying shades of blue, in an ochre yellow, and—surprising even to Matisse—in mauve and purple despite the absence of these colors in the glass itself.

The Chasubles:

The only other objects of color associated with the chapel (but seen only rarely) are the startlingly colorful liturgical vestments Matisse designed for officiating priests. Envisaged by Matisse as additional elements to enrich the setting of a religious ceremony, they were carefully researched so that chasubles of the proper color, according to the designated liturgy of Catholic holidays at various times of the year, were designed for each holy period (for example, pink for Sundays between Advent and Lent, red for Pentecost, black for All Saints' Day and Good Friday). These vestments, along with numerous other preparatory sketches for the chapel, are displayed in a new gallery that

adjoins the chapel—as well as at the Musée Matisse in Nice (see Chapter 16).

The Murals:

Directly to the right of the stained-glass *Tree of Life* is the towering figure of *Saint Dominic* painted in black on white ceramic tiles. The utter simplicity of this faceless fifteen-foot-high figure reveals the strength and sureness of Matisse's hand. It is one of the three black-and-white ceramic murals in the chapel. To the right of *Saint Dominic* is a tile mural of the *Virgin and Child*, both again faceless but powerful in the elegance of their design.

The mural of the *Stations of the Cross* extends over the rear wall of the chapel. Unlike the usual detailed depiction of fourteen distinct stations, Matisse's mural offers a summarized story full of drama and torture, even in its abbreviated rendition. The only figure that is not faceless in the entire chapel is that which appears in the center of this mural, the face of Christ on Saint Veronica's veil. Of course, not accidentally, the shape of the veil is an almost perfect reflection of the design of the *Tree of Life* stained-glass window that faces it.

The luminosity of the white tiles in the murals is not due to the light of the sun alone. In her book, *Matisse and Picasso*, Françoise Gilot relates that "Matisse was a perfectionist in this as in all else. He would accept only perfectly even tiles of specified dimensions that had the right under-glow and that would be durable

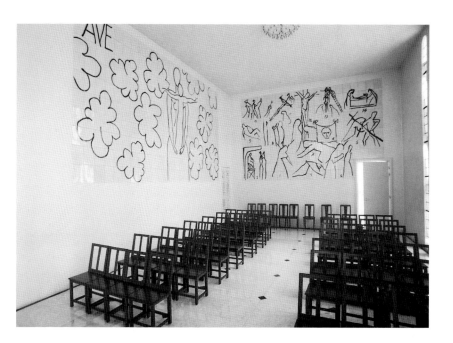

IN CONTRAST TO THE BRILLIANT COLOR OF THE STAINED-GLASS WINDOWS, THE CERAMIC MURALS AT THE REAR OF THE CHAPEL DEPICTING THE *STATIONS OF THE CROSS*, AND THOSE TO THE LEFT, OF THE *VIRGIN AND CHILD*, WERE EXECUTED IN BLACK-AND-WHITE. LA CHAPELLE NOTRE-DAME DU ROSAIRE. PHOTO: MICHEL DE LORENZO

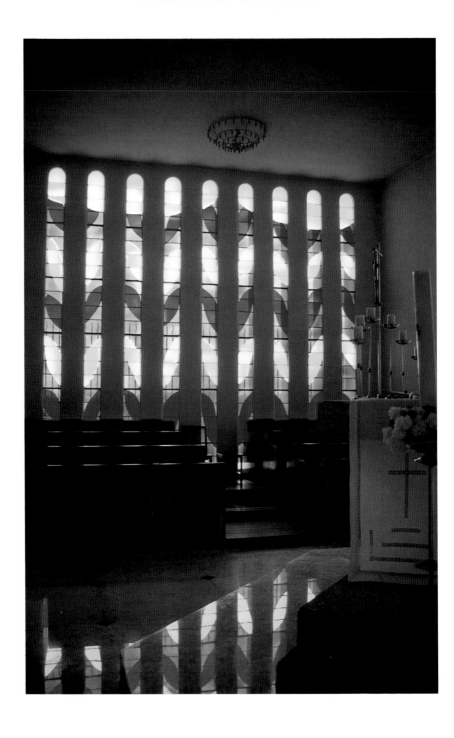

MATISSE LABORED OVER THE PRECISE SHADES OF BLUE, GREEN, AND YELLOW FOR THE STAINED-GLASS WINDOWS THAT CAST THEIR REFLECTIONS ON THE FLOOR AND SOMETIMES AS FAR AS THE OPPOSITE WALLS. LA CHAPELLE NOTRE-DAME DU ROSAIRE. PHOTO: MICHEL DE LORENZO

enough to sustain the second baking after Matisse sketched his design on them. The laborious process went something like this:

"The tiles were baked once; they were then sent to the Madoura Pottery (in Vallauris) where they were inspected. The tiles' upper sides and surfaces were then dipped in liquid enamel and set to dry. The tiles were next taken to Matisse's studio . . . and laid out on the floor in dimensions that paralleled the required dimensions of the finished panels in the church. Using a brush on a bamboo stick . . . Matisse drew directly on the tiles, basing his design on the many preparatory sketches he had done. The tiles (were then) carefully loaded and sent back to the Madoura factory . . . for a second baking in the electric kiln."

Gilot's intimate knowledge of Matisse's working style resulted from the fact that Picasso and Matisse saw each other with some regularity during this period. Picasso and Gilot were living in Vallauris, where Picasso was deeply involved in creating ceramics (see Chapters 4, 5, and 6). Although Picasso, an ideological atheist, strongly disapproved of Matisse's involvement in designing a house of worship, his respect and friendship for Matisse prompted him to assist in the tile-manufacturing process, something Gilot maintained that he would have done for no one else.

Liturgical Furnishings:
In contrast to the glow of the tiles and the luminosity of the stained glass, the stone altar—chosen for its similarity in visual texture to the bread of the Eucharist—is pleasing in its solidity. Set at what was then an unusual, asymmetrical angle to provide easy visibility to all in attendance, the altar is graced by a Matisse-designed cloth, candelabra, and hand-sculpted crucifix.

The total unity of the chapel is unique. Matisse's balance of space, decoration, color, and light seem to expand the relatively modest size of the chapel—which is roughly fifty feet in length and approximately thirty-three feet in width. In this small space Matisse managed to achieve his goal of creating such a feeling of space that the actual dimensions of the walls disappear. He wrote, "The goal is to give . . . with a very limited space the idea of immensity . . . the role of all decorative painting is to enlarge surface, to do it in such a way that one is no longer aware of the dimensions of the wall. . . . In the chapel, my chief aim was to balance a surface of light and color against a solid wall with black drawing on a white background."

In 1949, before the chapel was completed, Matisse left Vence and moved back to his apartment at the Regina in Cimiez, high above Nice. There he continued, at a distance, his passionate involvement in every aspect of the work on the chapel until its consecration in June 1951. In ill health, but filled with enthusiasm and motivation, he worked in his rooms—which, happily, approximated the size of the chapel.

While working on his designs for the chapel, Matisse continued to use the paper cutout technique that he had been evolving over a period of many years. Cutting pieces of brilliantly colored papers with a scissors, he designed the windows that were

his primary preoccupation in the chapel design. By this point, as the art lecturer Rosamond Bernier describes him, "he was an old, bedridden man who was saying, 'I'm going to make a church filled with gaiety, a place that will make people happy.' " His intention was amply realized. Speaking about the chapel, Père Couturier was to say, "At last, we shall have a cheerful church."

La Chapelle du Rosaire has been described by art historian Marcelin Pleynet as "one of the major works in the history of modern art." Certainly it has become a cherished part of the twentieth century's artistic creation on the Riviera. Matisse completed it with pride, considering it his culminating masterpiece. He continued to work as diligently during his final years as he had during his prime, receiving more and more critical attention and respect, producing some of his finest cutouts, all the while seeing friends and colleagues when time and his health permitted.

Matisse died on November 3rd, 1954. He was buried in a secluded spot overlooking the city of Nice in the decorative Franciscan Monastery beside the Matisse Museum, not far from the Hôtel Régina where he had spent the final years of his creative life.

THE DRAMATIC FIGURE OF *SAINT DOMINIC*, REFLECTED IN THE LUMINOSITY OF THE WHITE MARBLE FLOOR, IS OFTEN ILLUMINATED BY THE GLOW OF THE STAINED-GLASS WINDOWS. LA CHAPELLE NOTRE-DAME DU ROSAIRE. PHOTO: MICHEL DE LORENZO

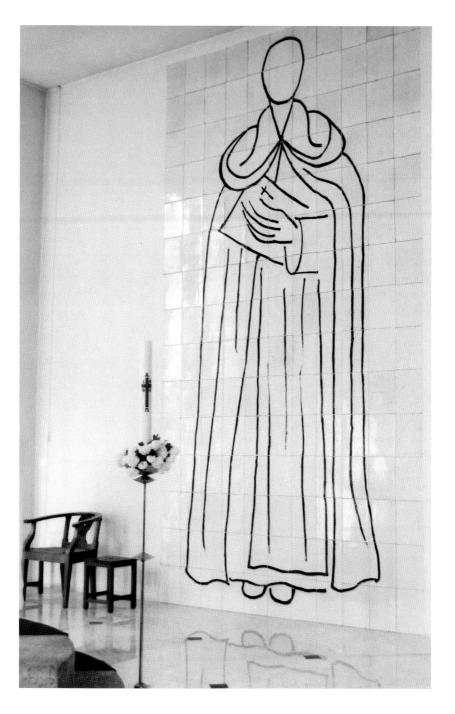

FROM THE OUTSIDE, THE CHAPEL APPEARS MUCH AS IT ALWAYS DID, WITH ITS ITALIAN-STYLE *TROMPE-L'OEIL* FACADE, ALTHOUGH COCTEAU ADDED TWO SMALL STAINED-GLASS WINDOWS AND DECORATED THE UPPER LEVEL WITH TWO HUGE PAINTED CANDELABRA WITH HIS SIGNATURE EYES. LA CHAPELLE SAINT-PIERRE. PHOTO: MICHEL DE LORENZO

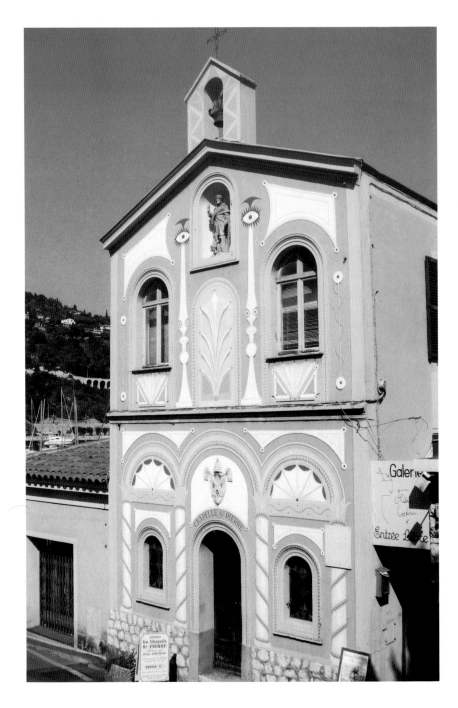

LA CHAPELLE SAINT-PIERRE (LA CHAPELLE COCTEAU)
SAINT PETER'S CHAPEL (THE COCTEAU CHAPEL)

Quai Courbet, Port de Villefranche, 06230 Villefranche-sur-Mer
Tel: 04–93–76–90–70

Open Tuesday to Sunday from 10:00 A.M. to Noon and 4:00 P.M. to 8:30 P.M.
June through September;
from 9:30 A.M. to Noon and 2:00 P.M. to 6:00 P.M., October through February;
from 9:30 A.M. to Noon and 3:00 P.M. to 7:00 P.M. March through May.
Closed Monday, the month of November, and December 25.

"THE PRINCE OF POETS," as Jean Cocteau was sometimes known, arrived in Villefranche-sur-Mer sometime during the summer of 1924, mourning the recent loss of Raymond Radiguet, the young novelist who had been his close companion. Although plagued by his ongoing battles with opium addiction, Cocteau soon fell in love with this little hamlet, nestled below Nice on the eastern side of the Riviera.

The narrow medieval streets of Villefranche, many of them arcaded, provided a setting that renewed and reinforced Cocteau's childhood fascination with the mazes and labyrinths of fairy tales and mythology. In Villefranche, he settled into the now-famous, but then relatively unknown, Hôtel Welcome.

His later description of the hotel evokes the place it then held in his affections: "The Hôtel Welcome was simply charming. Its rooms were enameled bright colors and a coat of yellow paint had been brushed over the Italianate *trompe-l'oeil* of its façade. I imagine that no Italian comic-opera set could more fittingly haunt the waking sleep of poets than

this theater of illusions for which the little town of Villefranche serves as backstage. . . . This hotel is a well-spring of myths, a place which youth . . . should convert into an altar and cover with flowers. Poets of every sort and every language have lived here and, by a simple mingling of fluids, made this extraordinary little town—a precipitous jumble ending at the water's edge—a center of fables and fabrications."

Such was his recollection of the setting in which he began the first of his two major periods on the Riviera. From approximately 1924 to 1929 Cocteau came and went frequently from Villefranche and the Hôtel Welcome.

This hotel still stands at the entrance to Villefranche's port, overlooking the harbor. It has assumed an air of respectability—in contrast to its raucous reputation in Cocteau's time, when Villefranche was primarily a fishing village and a port of call for ships of the British and American navies and their roistering crews. Today in the hotel's glass-enclosed dining room, one may dine on plates designed by Cocteau, gaze at the

port, and tranquilly admire the chapel Cocteau was to make famous.

But back in the 1920s the Hôtel Welcome was the scene of much wild activity, "outrageous public behavior," as Cocteau's friend, composer Ned Rorem, recalled it. Known as something of a druggy brothel, it was host to sailors and artists of all types. Albert Lorent, a close friend of Cocteau's, described those years: "Picasso, (Sasha) Guitry, Somerset Maugham, Blaise Cendars, Gérard Philipe, Mistinguett, Piaf, Greta Garbo, Max Jacob. They all came because of Cocteau. They liked him, he amused them and his enthusiasm was contagious. Villefranche was, for us, a wonderful Bohemia. . . ."

In these years of the mid-1920s, Cocteau lived at the Hôtel Welcome enjoying the sun, the beach, the fishermen, the fleet, as well as the company of the musicians, writers, and painters (including his on-again, off-again friend, Pablo Picasso) who lived and worked in the area. During this period, Cocteau pursued his career as a writer, producing some of his most important work—including his theatrical version of *Orphée*, based on the classical Greek legend of Orpheus, *La Lettre à Jacques Maritain* (the Catholic philosopher), in which Cocteau celebrates his return to Catholicism, and the libretto for Igor Stravinsky's oratorio, *Oedipus Rex*.

Most important, it was during this period that Cocteau first saw and was captivated by the tiny, ancient chapel on the waterfront, directly in front of the hotel. Despite the diversions at the Welcome, Cocteau was more fascinated with the view. Below his window lay a jewel of a building—a fourteenth-century

Romanesque chapel that had fallen into disrepair and was being used by the local fishermen to store their nets. Some thirty-odd years later, Cocteau would have the opportunity of fulfilling his dream to restore it.

In 1950, Cocteau began his second extensive stay on the Mediterranean coast. By now he was world-traveled and an established writer. During this period he expanded upon the artistic talents he had exhibited as a youth when he had been applauded for his facility at caricature using pencil and crayon, as well as pen and ink, for book and magazine illustrations, posters, and lithographs. Now, as a mature artist with a different perspective, he was to expand what critic Michael Brenson called his "particularly strong feeling for the potential drama of ink on paper." At the age of 61, Cocteau broadened his artistic range to include oil painting as he resumed a life on the coast he so loved. He renewed a sometimes strained relationship with Picasso as he settled in Saint-Jean-Cap-Ferrat in the platonic company of his benefactress, Francine Weisweiller, who offered him her house as a retreat in the sun. At Weisweiller's home, Villa Santo Sospir, Cocteau pursued his talent for drawing, covering many of the walls with murals and sketches—which he called "tattoos." He populated them with the Greek gods and mythological figures that were such a major subject of his literary and filmic output. They were soon to become the subject of his artistic work, as well.

Cocteau's return to the Riviera brought him new opportunities. The most important of these emanated from the structure on the waterfront

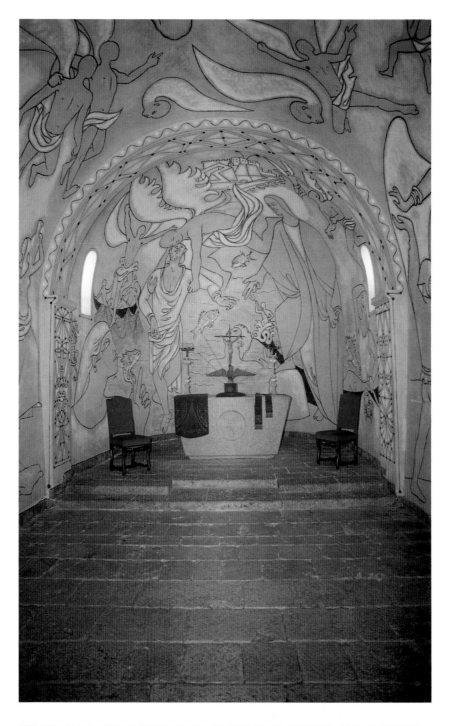

EVERY ASPECT OF THIS FOURTEENTH-CENTURY WATERFRONT CHAPEL WAS LOVINGLY DECORATED BY COCTEAU. IN ADDITION TO THE WALL FRESCOES PAINTED WITH SCENES FROM THE LIFE OF SAINT PETER, HE DESIGNED THE ALTARPIECE, THE CRUCIFIX, THE ALTAR COVERINGS, AND THE CANDELABRA. LA CHAPELLE SAINT-PIERRE. PHOTO: MICHEL DE LORENZO

A PAIR OF LARGE, GREEN COCTEAU-DECORATED CERAMIC CANDELABRA FLANK THE CHAPEL'S DUTCH DOUBLE DOORS. ABOVE THEM, COCTEAU HAS PLACED AN INSCRIPTION PARAPHRASING SAINT PETER: "ENTER THIS BUILDING AS IF IT WERE MADE OF LIVING STONE." LA CHAPELLE SAINT-PIERRE. PHOTO: MICHEL DE LORENZO

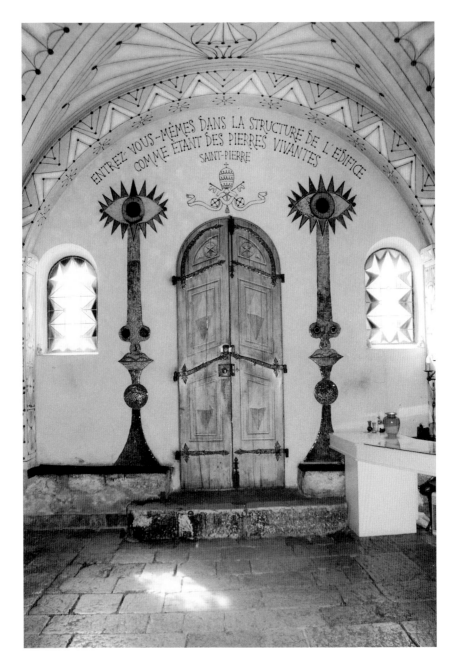

that had so enchanted him many years earlier: La Chapelle Saint-Pierre, the fishermen's chapel—named after Saint Peter, the fisherman turned Apostle, and founder of the Christian Church.

Surprisingly, Cocteau's desire to decorate the chapel in Villefranche was not welcomed enthusiastically by the local municipality, although neighboring Vence already had Matisse's chapel (see Chapter 17), and Vallauris had Picasso's Chapel of War and Peace (see Chapter 6). The dusty, abandoned structure in Villefranche had been a fixture at the port for 500 years and had long since been appropriated for storage by local fishermen. Cocteau became engaged in a protracted struggle to obtain official permission from the local authorities to restore the little building so that it might once again serve as a place of worship. At first, the fishermen who had appropriated the chapel were violently opposed to this possibility. While living in Weisweiller's home in Cap-Ferrat, Cocteau contacted an old friend, Albert Lorent, then head of French Tourism, in an effort to cut the French provincial bureaucracy's fabled red tape.

For a period of seven years, Lorent fought an on-going battle with Villefranche's City Hall, trying to convince the town's officials to let Cocteau renovate the chapel. Finally, Mayor Philippe Olmi informed Cocteau that the keys to the chapel were his. But the war wasn't over. When word of his victory spread, the fishermen—who wanted to keep the chapel for storage—stole his ladders to derail the project. But Cocteau won their good will by announcing that the receipts from entrance fees,

IN THE MID-1920S, COCTEAU SPENT CONSIDERABLE TIME IN THE FISHERMEN'S VILLAGE OF VILLEFRANCHE-SUR-MER. FROM HIS WINDOW COCTEAU WAS ABLE TO ENJOY THE VIEWS OF THE MEDITERRANEAN BELOW AND TO GAZE UPON THE ROMANESQUE CHAPEL WHICH HE WOULD DECORATE SOME THIRTY YEARS LATER. PENCIL SKETCH BY MAURICE FREED 1960–61.

postcards, and guidebooks would be donated to the Fishermen's Benevolent Fund.

In 1957, at the age of 68, Cocteau was finally able to begin working on the chapel. Like Matisse, who late in life tackled the Chapelle du Rosaire in Vence, Cocteau attacked this project with a fanatical zeal. With the help of assistants, he painted the structure inside and out, enthusiastically hoisting scaffolding into place, then climbing up and down day after day. In a delightfully written and illustrated small guidebook, prepared by Cocteau to introduce the renovated chapel, he describes some of his experiences while working on it: "For five months I lived in the little nave of Saint Peter, battling with the angles of the perspectives, bewitched by the arches, enchanted, even embalmed, I would say, as a pharaoh intent on painting his sarcophagus."

Every aspect of the chapel, save the structural architecture, was brought back to life by Cocteau. He painstakingly designed each of the chapel's decorative features. The altar, crafted by a local stonecutter, was carved in a single block from a rock found in the nearby village of La Turbie. The same craftsman was responsible for the lighting, hidden in the simple sculptural heads that Cocteau thought to be surprisingly medieval in feeling. Cocteau was equally responsible for the Eucharist Dove, the crucifix, the altar coverings, and the candelabra upon which he mounted a miniature pitchfork, representing the multipronged spear used in the past by local fishermen for night fishing. He painted the frescoes himself, combining many recurring themes: local life and color,

a lifelong fascination with legend and myth, mythological creatures, and the biblical stories themselves.

From the outside, the chapel appears much as it always did with its Italian-style *trompe-l'oeil* façade, freshened with frequent coats of paint in soft rose tones, accented by lemon-cream-tinted arches. But the building as a whole exudes the characteristic phantasmagorical Cocteau touch. The upper level of the façade is decorated with two huge painted candelabra with Cocteau's signature eyes, reflections of those that appear painted just inside the double Dutch doors. Below, at street level, are two small stained-glass windows.

A step within takes visitors further into this world. Flanking the doors are two huge green ceramic candelabra that Cocteau decorated with a visual paraphrase of the Apostle Peter's words: "And these candelabra had a human face. And the candelabra had a nose and a mouth. And these candelabra had an eye. And the eye looked over the lamb." Above the entrance is another paraphrased quote from Saint Peter, *"Entrez vous-mêmes dans la structure de l'édifice comme étant des pierres vivantes."* ("Enter this building as if it were made of living stone.")

Two decorative styles characterize the chapel: The first includes the dynamic figurative frescoes executed in Cocteau's distinctive line and accented with soft pastel colors. The second includes the rhythmic painted web of geometric designs covering many of the chapel's arches, and suggesting huge fishermen's nets.

On the wall murals to the left of the entrance, Cocteau honors the men and women of Villefranche, portray-

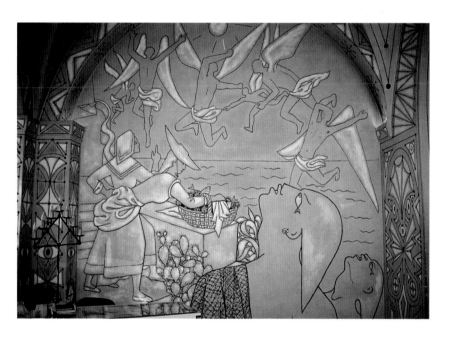

COCTEAU INCLUDED THE RESIDENTS OF VILLEFRANCHE-SUR-MER IN HIS MURALS FOR THE CHAPEL, PORTRAYING THEM IN TYPICAL LOCAL COSTUME, THE WOMEN WEARING TRADITIONAL STRAW HATS AND THE MEN THEIR FISHERMEN'S CAPS. LA CHAPELLE SAINT-PIERRE. PHOTO: MICHEL DE LORENZO

ing them in typical local costume, the women with baskets of fish and their straw hats known as *capelines*, the men with traditional fishermen's caps. To the right, he pays tribute to the gypsies who live not far away in Saintes-Marie-de-la-Mer, featuring a guitarist who accompanies a young girl's dance as a fisherman pulls in his net. Overhead, above the altar and in the chapel's antechamber, are biblical scenes in which Cocteau renders, with larger-than-life figures, episodes from the life of Saint Peter: the angels saving him from King Herod, the soldiers of Pilate, the crowing rooster, and Saint Peter walking on water.

After years of dreaming of decorating the chapel, followed by months of solitary hard work, the little chapel had once again been made suitable for worship. Cocteau participated in the celebration of a mass there in June of 1957.

Today, the Feast of Saint Peter is celebrated annually in the Chapelle Saint-Pierre on June 29th and the marriages of fishermen and their children are sometimes consecrated there, too. Cocteau concludes his *Sentimental and Technical Guide to Saint Peter's Chapel* with a revealing expression of his personal feelings about the newly completed structure:

> ". . . .Under the nets and plaster, a young Romanesque beauty was waiting to be uncovered, not by the kiss of a prince, but by a poet in love who decided to worship her memory and to embellish her for the festivals of Saint Peter."

COCTEAU DEDICATED THE RESTORED CHAPEL TO HIS FRIENDS, THE FISHERMEN, AND TO MEMORIES OF HIS YOUTH. LA CHAPELLE SAINT-PIERRE. PHOTO: MICHEL DE LORENZO

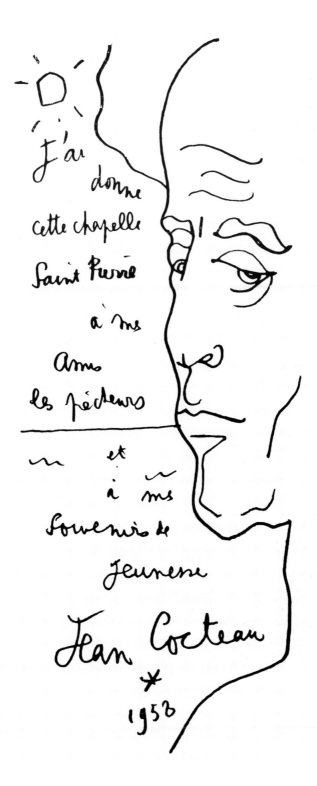

LA SALLE DES MARIAGES JEAN COCTEAU
JEAN COCTEAU'S MARRIAGE HALL

Hôtel de Ville, Rue de la République, 06500 Menton
Tel: 04–92–10–50–00

Open Monday to Friday from 9:30 A.M. to 12:30 P.M. and 1:30 P.M. to 5:00 P.M.
Closed Saturday, Sunday, and holidays.

B Y NATIONAL LAW all French marriages are civil ceremonies conducted in the local town hall. Only after this obligatory legal event may an optional religious ceremony be celebrated. As a result, the Mairie or Hôtel de Ville (City Hall) of all French towns, from the smallest village to the most sprawling metropolis, has a room designated for this occasion. In small towns, by necessity, this may be a multi-purpose room. In larger areas, a specially decorated Salle des Mariages (Marriage Hall) is reserved for this occasion alone. Unique in all of France is the Salle des Mariages in the Hôtel de Ville of Menton: the marriage hall which has the distinc-tion of having been hand-painted and decorated by Jean Cocteau.

Menton's Salle des Mariages wasn't the first public space that Cocteau was to paint and decorate. In fact, the invitation, in 1957, by Menton's mayor to redecorate his city's traditional Salle des Mariages was, in part, in response to Cocteau's hugely successful transformation of the 500-year-old Romanesque Chapelle Saint-Pierre in Villefranche-sur-Mer (see Chapter 18).

Menton's Hôtel de Ville presented a new and different set of problems.

This typical municipal building projected, in Cocteau's opinion, "an austere, almost hostile appearance," requiring him to "play all the tricks he could" to transform this room into a "poem to love." Inspired, as usual, by his personal motto of being "tempted by the impossible," the sixty-eight-year-old Cocteau—who claimed to be tired of writing—turned to the challenge of painting large murals and frescoes on the walls and ceilings of this important space, seeking, he said, "a cure for his fatigue on the mountain heights of the scaffolds" (erected for his work).

And so, as in murals he had done for the chapel in Villefranche, Cocteau combined the rich and romantic inspirations of his own fantasy life with his ever-present love of fairy tales, themes from Greek mythology, mythological creatures, and his own poetic view of local folklore. Basing his work on a series of sketches in several notebooks, Cocteau conceived of and decorated the Salle des Mariages in less than one year, inaugurating it in the spring of 1958.

Entering the Salle des Mariages from the rear provides an opportunity to fully appreciate Cocteau's setting,

all of which he personally designed. The room is brought to life with Cocteau's decorative elements: wall and ceiling murals, rich velvet chairs for the bridal couple and their guests, matching velvet curtains, a faux leopard-skin runner (a trademark Cocteau touch, similar to the leopard fabric and rugs in his country home in Milly-la-Forêt near Paris), and lamps in the shape of lyres. To the immediate left and right, Cocteau provided the obligatory salute to the French government by etching the mirrors with the profile of "Marianne," the traditional symbol of the *République Française* (French Republic) together with the initials R.F.

At the far end of the room, on the front wall, Cocteau has painted two huge profiles of the *innamorati*—the lovers who represent the bridal couple. They are simply but colorfully portrayed as a typical local couple: a Menton fisherman, one eye drawn in the form of a fish, his hair protected by the stylized fishing cap formerly worn by Mediterranean fishermen, and a young woman who wears the typical wide-brimmed straw hat known as a *capeline*. The fabled sun of the Riviera casts its glow over them and the symbolic blue waves of the Mediterranean surround them.

The side walls and ceiling are covered with the well-known Cocteau silhouettes—outlines of imaginary

and mythic figures that achieve the feeling of space and mass through the strength and ingenuity of his simple lines. Cocteau manages to give these figures the appearance of having been colored by the innovative use of intersecting colored lines. The wall to the left depicts a new interpretation of Cocteau's fascination with the Orpheus and Eurydice legend, first brought to life in his 1925 play, *Orphée*, produced as a film a quarter of a century later. In this instance, Cocteau illustrates the famous lines *"Orphée en tournant la tête perdit sa femme et ses chants. Les hommes devinrent bêtes et les animaux méchants."* ("Orpheus, turning around, loses his wife and her songs. Men become beasts and ravening animals.") We see his rendition of Orpheus, eyes closed, dropping his musical lyre as the men around him are turned into battling animals and centaurs. The dying Eurydice is led back to Hades.

On the opposite wall, to the right, Cocteau has given his imagination full rein with the illustration of a wedding in an imaginary setting, enriched by palm trees, flowers, turbaned men, and costumed women. Cocteau's decorative scenario highlights the young bridal couple astride a white horse, surrounded by an assortment of figures: a gypsy, friends bearing wedding gifts, others dancing and singing. At the bottom of the panel, the words *"La femme doit suivre son mari."* ("The wife's duty is to follow her husband") are inscribed. This phrase was still included in the traditional civil ceremony under the Napoleonic Code when Cocteau undertook the decoration of the Salle des Mariages in the summer of 1957. (To the satisfaction of many, it has since been eliminated.)

In contrast to the side wall decorations, Cocteau described his ceiling illustrations as allegorical, explaining in writing that he painted them with no conscious plan and only later interpreted their significance. "As I look up, I believe I see Poetry unsteadily riding (the winged horse) Pegasus, Science in tatters juggling with the planets, and Cupid (Love), as he is usually symbolized, but wearing no blindfold."

No other French wedding hall manages to compete with the fantasy and "the extraordinary tenderness" that Hugues de la Touche, director of the Museums of Menton, ascribes to the work that Cocteau created within the confines of Menton's Town Hall.

In this small room Cocteau's childhood obsession with what he called "the red-and-gold disease: theater-itis" clearly inspired his stage set for local wedding ceremonies. In explaining the decoration for his Salle des Mariages, Cocteau wrote, "A room for civil wedding ceremonies—unlike a chapel which must preserve a reserved atmosphere of purity—should have pomp and splendor. To offset the official aspect of a civil ceremony, I wanted to create a theatrical setting consisting of velvet and gold, deeming that the marriage between two people lends itself to a leopard-skin carpet in the style of a Greek temple, rich red Spanish chairs, luxurious draperies, torches, bamboo planters, and the traditional green plants in the vestibule—all of which help me soften the severity implicit in a marriage under the Napoleonic Code."

THE PROFILES OF THE LOVERS AT THE FAR END OF THE WEDDING HALL DEPICT COCTEAU'S RENDITION OF A TYPICAL LOCAL COUPLE: A MENTON FISHERMAN WITH A STYLIZED FISHING CAP AND HIS YOUNG BRIDE WEARING THE TRADITIONAL WIDE-BRIMMED STRAW HAT KNOWN AS A *CAPELINE*. LA SALLE DES MARIAGES JEAN COCTEAU. PHOTO: MICHEL DE LORENZO

LE MUSÉE JEAN COCTEAU
THE JEAN COCTEAU MUSEUM

Quai du Vieux Port, 06500 Menton
Tel: 04–93–57–72–30

Open Wednesday to Monday from 10:00 A.M. to Noon and
2:00 P.M. to 6:00 P.M.
Closed Tuesday and holidays.

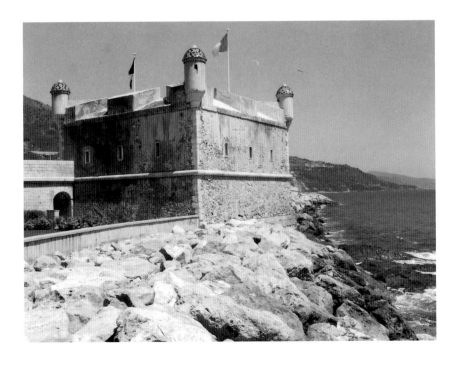

COCTEAU HIMSELF DISCOVERED AND THEN OVERSAW THE RESTORATION OF THE ABANDONED FORT, ONCE A DEFENSIVE STRUCTURE INTENDED TO PROTECT MENTON, THAT WAS DESTINED TO BECOME HIS MUSEUM. LE MUSÉE JEAN COCTEAU. PHOTO: MICHEL DE LORENZO

DESPITE THE PRESENCE of an art museum in his name, Jean Cocteau's early fame was not as a graphic artist. In fact, other than the much-praised caricatures he began doing as a young man and the well-known line drawings and "constructions" he did in the mid-1920s, Cocteau's career as an artist didn't really coalesce until he was in his sixties. The witty and charming Cocteau had always identified himself, first

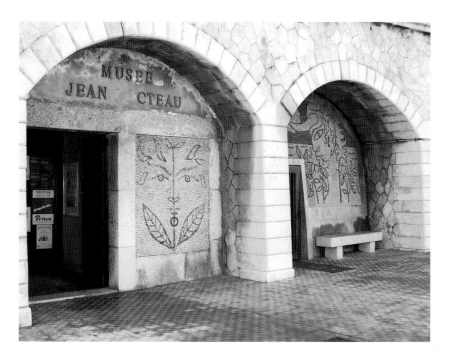

and foremost, as a poet—although he enjoyed world-wide celebrity for his vast literary and dramatic productions, functioning as a playwright, essayist, critic, and writer of ballet scenarios, as well as a film writer, producer, and director.

In the 1950s, during the later years of his life, Cocteau's passion and talents in the fine arts began to flourish. He experimented with pastels, started painting in oils and—inspired, in part, by Picasso's work in ceramics during these same years (see Chapter 5)—he began to work in clay. Later in the decade, Cocteau broadened his range when he undertook the decoration of a number of large public spaces. He first refurbished the waterfront "fishermen's chapel" in Villefranche-sur-Mer, the most famous of the several chapels he decorated (see Chapters 2 and 18). In addition, he painted the

murals and accompanying decorative features for the Menton Salle des Mariages (see Chapter 19), and designed the spectacular outdoor theater in nearby Cap d'Ail (see Chapter 22).

Cocteau was no stranger to the Riviera when he undertook these important projects in the late 1950s. The south of France had long been attractive to him and he described himself as "an adopted son of the South, a true Mediterranean." As early as 1904, when only 15 years old, Cocteau had run away from Paris to Marseille. During the next decade he first visited Menton, a city for which he held great affection. Interspersed among many trips to Provence and the Riviera were two extensive stays. The first was from approximately 1924–29, when he often frequented Villefranche-sur-Mer and its environs. The second began in 1950 when he and the painter/actor Edouard Dermit, (the companion for the last years of his life, who was to become his legal heir), began to spend long periods of time at Santo Sospir, the Saint-Jean-Cap-Ferrat home of Francine Weisweiller.

It isn't surprising then, that as Cocteau neared the completion of the Wedding Hall in Menton's Hôtel de Ville, he would express a heartfelt desire to see a museum established in his name. City officials, delighted with his work, were happy to honor him by granting his wish. Although almost seventy by this time, Cocteau played an active role in the selection of the site, having discovered an abandoned seventeenth-century fort that was destined to become his museum. Cocteau oversaw the restoration of the rundown structure,

designing the decorative elements for both the exterior and the interior. Unfortunately, he was not to live to see its inauguration in 1967, four years after his death.

Known sometimes as the Bastion, the little fort at the entrance to the town's old port was built in 1636 as a defensive structure to protect Menton. The small military structure was originally situated on a rocky little islet connected to the shore by a wooden gangway. In ensuing years, the little fortress lost its military character, serving as a salt cave, a prison, and, finally, as a lighthouse. Today, having been converted into Cocteau's museum, it is located in a privileged spot, sitting directly on the Mediterranean. Silhouetted against the changing tones of the sea and the sky, its tiled watch towers glistening in the sun, it sets the stage for the diverse expressions of Cocteau's work in mosaic, tapestry, ceramics, pastels, and painting.

The little museum's façade is graced by three small arches that protect three Cocteau mosaics. The first is a rendition of the profiles of a stylized young couple, reminiscent both of the betrothed couple in Menton's Wedding Hall and others who appear in Villefranche's fishermen's chapel. The second represents Orpheus, while the third captures, with an astonishing economy of line, the outline of a young, faun-like creature. The mosaic bears the words he had prepared to be inscribed on his tombstone in the chapel where he is buried: *"Je reste avec vous"* ("I remain among you"). Cocteau was also responsible for the salamander mosaic flooring at the entrance to the museum. All the mosaics, inside and out, are com-

THIS INTRIGUING CREATURE, A CERAMIC RENDERING OF A GOAT WITH A GRACEFUL LONG NECK, IS ENSHRINED IN A COCTEAU-DESIGNED DISPLAY CASE, AND SECLUDED IN A NICHE OVERLOOKING THE MEDITERRANEAN. LE MUSÉE JEAN COCTEAU. PHOTO: MICHEL DE LORENZO

THIS TAPESTRY, *JUDITH AND HOLOFERNES*, ONE OF TWO IN THE MUSEUM, WAS COCTEAU'S FIRST EFFORT IN THIS MEDIUM.
LE MUSÉE JEAN COCTEAU. PHOTO: MICHEL DE LORENZO

posed of the same little gray-and-white pebbles that are found on the streets and sidewalks throughout the old city of Menton.

The first floor of the museum is dominated by two tapestries. The largest and most famous, *Judith et Holopherne (Judith and Holofernes)*, was also Cocteau's first effort in tapestry. It was begun in 1948, and woven by the famous Aubusson workshops. The tapestry tells the story of the Jewish heroine, Judith, who saved the city of Bethulie by seducing the enemy general, Holofernes, and then cutting off his head when he was asleep. The tapestry portrays Judith, shrouded in a hooded cape, holding Holofernes' head in her hands as she slips by his sleeping guards. Cocteau was quite proud of his tapestry accomplishments, recording in his *Diaries* on March 17, 1953, with obvious pride, a colleague's reaction to this tapestry: "Matisse had telephoned, [saying], 'Your tapestry is splendid . . . it's the only authentic contemporary tapestry.' " Cocteau also noted that "Picasso had nothing to say. I think this success was intolerable to him." Cocteau later presented this tapestry to the city of Menton.

The second tapestry was designed specifically for the space it occupies at the top of the first-floor staircase. It is yet another variation on his profiled couples, surrounded by several characteristic geometric shapes with Cocteau's familiar piercing eyes. The drawings for both tapestries were executed in pastels, the medium Cocteau was working with in these later years. A series of pastels, done in the mid- and late-1950s complete the first-floor display and line the stairs leading to the sec-

ond floor. They include *L'Astrologue (The Astrologer)*, *La Femme Peintre (Woman Painter)*, and *Le Gitan (The Gypsy)*.

The feeling of the original bastion comes to life again on the museum's second floor where the view from the windows, projecting directly over the water, and the sound of the waves breaking against the side of the old fort create the sensation of being at sea. In contrast to the pastels, mosaics, and tapestry displayed on the entrance level, the second floor is dominated by Cocteau's work in ceramics and colored drawing pencils. Much of this work is evidence of the renewed relationship between Picasso and Cocteau during the last decade or so of Cocteau's life and of the influence Picasso had on Cocteau's artistic production.

Picasso and Cocteau had shared an early friendship in Paris during the height of World War I, working together there and in Rome on Cocteau's ballet *Parade*, for which Picasso designed the set and costumes. However, Cocteau's relationship with Picasso was one of alternating intimacy and alienation. Picasso represented a special challenge for Cocteau. For him, Picasso was always a genius and a source of great inspiration—"*The* great encounter for me," as he once stated. Whatever their early friendship had been, the mid-Twenties witnessed the beginning of Picasso's hostility toward Cocteau; their relationship was one of coolness until the fifties, when Cocteau returned to the Riviera and Picasso, who was then living in Vallauris, was willing to see him again. Cocteau would visit Picasso with some regularity, and it was in Vallauris that he

was exposed to Picasso's innovations and verve with ceramics.

While Picasso may have had nothing to say about Cocteau's tapestry, he seems to have bolstered Cocteau's ego with respect to ceramics. In one of his many diary references to Picasso, Cocteau writes that Picasso had said to Madame Ramié (the owner of the Madoura factory where Picasso produced his ceramics), "You can give seventy plates to Cocteau; he'll do them for you one after the next. . . . He and I are the only ones who have that kind of faculty for work." Inspired by Picasso's efforts with clay, it wasn't long until Cocteau tried his hand at the ancient art—a medium which he learned to love—preferring to forego colored glazes and leave the terra-cotta visible, expressing delight in the tone, which reminded him of tanned skin. Like Picasso, he concentrated on plates and figurines, but finished them in a completely different style—usually painting simple line drawings on them.

A collection of ten ceramic pieces—each enshrined in its own Cocteau-designed wrought iron and glass display case—surrounds the perimeter of the second floor. Every case has its own niche (several looking out over the Mediterranean), and each rests on an individual, pebbled floor mosaic. The range of ceramics displayed in this small collection reveals the diversity of his production. Initially, Cocteau only produced plates. Several exhibited here are in monochromatic colors upon which he incised or glazed profiles, images of faun profiles, and a variety of faces. Later in the decade, he began to create more whimsical three-dimensional figures, including several on view

here. Unique among these pieces are the *La chèvre-cou (Goat's Neck)*, a lovely terra-cotta piece with gentle goat's ears and graceful horns, only its large eyes and lips are glazed, the gentle *Petit faune boudeur (Small Sulking Faun)*, and *Arlequin avec une batte (Harlequin with Stick)*, an innocent-appearing Harlequin hiding a threatening stick, a work which, according to Cocteau scholar Hugues de la Touche, was constructed around a Saint-Emilion wine bottle.

It wasn't only in ceramics that Picasso was to influence Cocteau. He is quite explicit about his debt to Picasso in a series of colored pencil drawings done on colored paper called *Les Innamorati (The Lovers)*. In this series, displayed in its entirety in the museum, Cocteau expresses his wonder at Picasso's technique:

"I was astonished and intrigued by Picasso's use of colored drawing pencils. These are the same pencils that kids use but in his magical hands they achieve an extraordinary power. . . . He taught me his technique which was to superimpose their colors on a waxy surface so they didn't blend together. Since I try never to encroach on the territory of painters—but to remain a poet who draws and paints—these pencils allowed me, in effect, to paint without painting."

The eighteen drawings produced in this manner are filled with humor and local color, capturing Cocteau's goal of integrating local life in Menton and his recollections of the myths of Villefranche with classic Italian popular comedy that featured improvisational entertainers in masks. Whether it is the pink buildings of Villefranche, the colorful little fishing

EXHIBITED ON THE THICK STONE WALLS OF THE MUSEUM'S SECOND FLOOR IS MAC AVOY'S *PORTRAIT OF COCTEAU*, TOGETHER WITH FOUR OF COCTEAU'S EIGHTEEN COLORED PENCIL DRAWINGS KNOW AS *THE LOVERS*. LE MUSÉE JEAN COCTEAU. PHOTO: MICHEL DE LORENZO

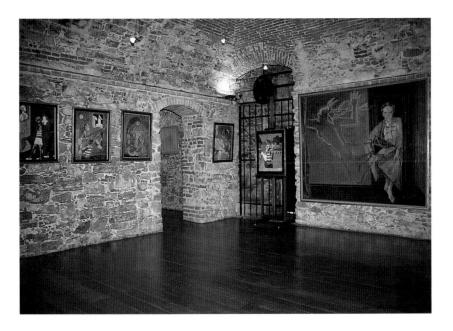

boats, the women in their traditional wide-brimmed straw hats, or a serenading fisherman with his lute, Cocteau achieves his goal of re-creating in painting his impression of Commèdia dell'arte.

Hugues de la Touche, curator of the Cocteau Museum, considers these examples of Picasso's influence on Cocteau "an important moment in the history of art and an indication of the relationship between these two men."

In addition to Cocteau's own work, the little museum stands as a memorial to the career of the poet-painter. Numerous photos and sketches of important moments in Cocteau's life are preserved on its walls and in its archives. Notable among them are photographs of his investiture in the Académie Française (for which Picasso designed one of his two swords), two Jacques-Henri Lartigue photographs of Cocteau working on the Salle des Mariages in Menton's City Hall, and the *Portrait du Poète* by Mac Avoy. Perhaps the homage he would most appreciate is a 1916 sketch inscribed by Picasso "*A mon ami Jean Cocteau.*" ("To my friend Jean Cocteau.").

In the vicinity:
Cap d'Ail: Cocteau's Théatre de la Jeunesse—Centre Méditerranéen d'Études Françaises (see Chapter 22)

LE PALAIS CARNOLÈS—LE MUSÉE DES BEAUX-ARTS
THE CARNOLÈS PALACE—THE MUSEUM OF FINE ARTS

3 Avenue de la Madone, 06500 Menton
Tel: 04–93–35–49–71

Open Wednesday to Monday from 10:00 A.M. to Noon and
2:00 P.M. to 6:00 P.M.
Closed Tuesday and holidays.

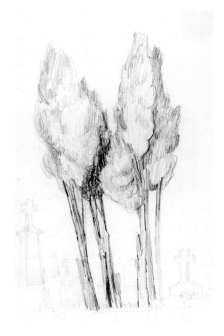

MENTON, AS IS TRUE OF THE ENTIRETY OF THE THE RIVIERA, IS ENHANCED BY THE RICH CONTRASTS OF ITS LANDSCAPE, WHICH HAS PROVIDED INSPIRATION TO ITS ARTISTS—THE SPARKLING SEA, DRAMATIC MARITIME ALPS, AND DISTINCTIVE TREES, SUCH AS THOSE SHOWN HERE. SKETCH BY MAURICE FREED, 1960–61.

ONCE, BACK WHEN Menton belonged to the Principality of Monaco, the Palais Carnolès was the warm-weather playground of the princes of Monaco. This, their imposing summer palace, was built in the early eighteenth century in a style reminiscent of Versaille's Grand Trianon. Toward the turn of the century, Menton was annexed by France, and the building and its gardens became the property of the French state.

It was later auctioned off, and during much of the nineteenth century, served a variety of owners and purposes until it was purchased by a wealthy American physician, Edward P. Allis, in 1896. Dr. Allis transformed the building into his private residence, enhancing the already highly decorated interior with pilasters sculpted with rosettes and foliage, friezes with decorative lions, ceiling frescoes on ancient themes, marble fireplaces, and a façade embellished with the decorative garlands that are still there today.

In the early 1960s the building was taken over by the city of Menton, and in 1969 it was declared an historic monument. In 1977 it was transformed into a museum,

AMONG THE MANY PIECES OF SCULPTURE IN THE RESPLENDENT CITRUS GARDEN IS DE SIGALDI'S IRON SCULPTURE, *TENTACLES*. LE PALAIS CARNOLÈS—LE MUSÉE DES BEAUX-ARTS. PHOTO: MICHEL DE LORENZO

TERZIEF'S SCULPTURE, *THE BATHER*, EMBELLISHES THE GARDENS OF THE ELEGANT EIGHTEENTH-CENTURY PALAIS CARNOLÈS. THIS FORMER SUMMER PALACE OF THE LORDS OF MONACO WAS DECLARED AN HISTORIC MONUMENT IN 1969. LE PALAIS CARNOLÈS—LE MUSÉE DES BEAUX-ARTS. PHOTO: MICHEL DE LORENZO

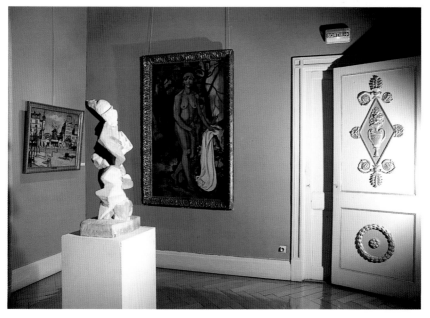

(top) IN THE MIDST OF A CITRUS GARDEN OF FIFTY DIFFERENT VARIETIES OF CITRUS TREES, CAN BE FOUND GUY FAGES'S SCULPTURE, *REVERIE*. LE PALAIS CARNOLÈS—LE MUSÉE DES BEAUX-ARTS. PHOTO: MICHEL DE LORENZO

(bottom) VALADON'S *NUDE NÉGRESSE*, CAMOIN'S *MOULIN ROUGE*, AND BORGEY'S SCULPTURE, *WOMAN AND CHILD*, ARE EXHIBITED IN ONE OF THE MUSEUM'S LAVISHLY DECORATED ROOMS. LE PALAIS CARNOLÈS—LE MUSÉE DES BEAUX-ARTS. PHOTO: MICHEL DE LORENZO

inheriting the collection of Menton's former museum. Its primary acquisition at the time was the diverse collection of English art connoisseur Charles Wakefield-Mori, which he had bequeathed to the city of Menton.

Today, the museum retains much of its former grandeur. The floors range from multicolored decorative mosaics to intricate, patterned and highly polished wood parquet. Displayed above its circular staircase is a large seventeenth-century Gobelins tapestry—*The Victory of Alexander the Great*. Hung throughout this opulent setting is a varied collection of art work ranging from the thirteenth to the twentieth centuries. These include a small group of Italian Primitives, a number of Italian and French paintings of the Virgin and Child, several oils attributed to Leonardo da Vinci, and a collection from the French tradition (including one attributed to Fragonard), as well as a series of drawings by Felix Ziem and Auguste Rodin.

In the midst of this eclectic collection, the visitor interested in modern art will be pleased to find paintings by members of the School of Paris. Suzanne Valadon is represented by three pieces: *La Négresse nue (Nude Negresse)*, *Madame Coquiot*, and *Portrait de M. Mori*, Charles Camoin by his *Moulin Rouge*, Raoul Dufy by a *Portrait de Madame Mori*, and Moïse Kisling with his *Rue de Vieux St-Tropez*. The modern art collection has been further enriched with a series of paintings acquired during the twelve years of the Menton Biennial (which were initiated in 1951 under the auspices of Henri Matisse). As a result of these shows and subsequent contributions by the French government, the museum now owns works by Francis Picabia *(Espagnole à la mantille) (Spanish Woman with a Mantilla)*, several watercolors by poet Max Jacob, *Bord de Marne (Banks of the Marne)* by Maurice de Vlaminck, and *Crucifixion* by Antonio Saura.

Some of these works occasionally compete for hanging space in the major exhibit hall on the ground floor with a series of temporary exhibits by major contemporary artists. Fortunately, always on display is the delightful surprise of a sculpture collection in the Citrus Garden, on the museum's magnificent rear grounds.

For some, the discovery of the Citrus Garden, inaugurated in 1994, will be the highlight of a visit to the Palais Carnolès. Spaciously displayed in this fragrant haven of some 400 trees are sculptures representing different periods by artists from around the world. They compete for the visitor's attention, not only with each other, but with the tempting fruits of the fifty different species of citrus trees—clementine, lemon, lime, grapefruit, bitter orange, kumquat, and bergamot—that grace this garden.

Wandering in this peaceful setting, most resplendent between the months of December and March when the trees are spectacular with fruit, the visitor will find a sculpture collection of contrasting sizes, shapes, forms, and materials. Standing beside, or nestled under, the abundant foliage are works as diverse as a small classic bronze bust of Grace Kelly, Princess Grace of Monaco, by Dutch artist Kees Verkade, and the mysteriously haunting life-size figures of Thomas Gleb's *Moines (Monks)*. The presence of these four dominant

THE MUSEUM'S RICH, ECLECTIC COLLECTION INCLUDES SEVERAL PAINTINGS BY MEMBERS OF THE SCHOOL OF PARIS, INCLUDING VALADON'S PORTRAITS OF *MADAME COQUIOT* AND *M. MORI*. TO THE LEFT IS OTHON FRIESZ'S *THE MONEY-EXCHANGE BRIDGE*. LE PALAIS CARNOLÈS—LE MUSÉE DES BEAUX-ARTS. PHOTO: MICHEL DE LORENZO

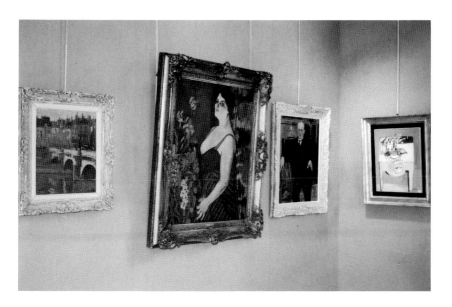

figures is counterbalanced by Nicole Durand's wood and resin nude, *Source de vie (Source of Life)*, and Max Siffredi's *Aegina*. This softly-rounded nude, reclining on a low marble bench was inspired by the Greek island whose Latin name is *Aegina*, spiritual home of the artist. Not far away are additional pieces by Gleb, two pieces carved in stone in a form inspired by the Hebrew alphabet. Totally different in spirit are the wonderfully expressive faces of Bruno Tripodi's three marble pieces, *Pablo Picasso*, *Clown*, and *Charlie Chaplin*.

Wandering further, additional surprises await: The strongly-muscled body of Nicolas Lavarenne's *Grand Guetteur (Man on the Lookout)*, gazes intensely out over the garden, while Jean-Yves Lechevallier's *Aile entravée (Fettered Wing)*, a massive modern conception in aluminum and marble,

captures the very essence of captivity. Hidden at the rear of the garden is a standing sculpture of poet-artist Jean Cocteau by Cyril de La Patellière. (Cocteau's own work is represented in Menton both in the city's Town Hall and his own museum—see Chapters 19 and 20.)

Although the grounds of the Palais Carnolès were once home to the royal princes of Monaco, who hunted there during the summer months centuries ago, a visit to Menton's gentle climate and the delights of this museum is a pleasure at any time of the year. One might note though, in the admittedly biased words of Jean-Claude Guibal, mayor of Menton, that discovering "sculpture in the very midst of kumquats, mandarins, and orange trees, makes this exceptional spot . . . a true Garden of Eden."

SEVEN ADDITIONAL MODERN ART SITES ON THE RIVIERA

LE CHÂTEAU DE LA NAPOULE ET LA FONDATION D'ART
THE CHÂTEAU AND ART FOUNDATION OF LA NAPOULE

Avenue Henry Clews,
06210 Mandelieu-La Napoule
Tel: 04–93–49–95–05

Guided tours daily at 3:00 P.M. and 4:00 P.M. March through October.
Closed Tuesday, holidays, and November through February.

LOCATED A FEW short miles west of Cannes in the seaside village of La Napoule is a fairy-tale castle aptly named "Once upon a Time" by its owners. The two-thousand-year-old structure, which retains its Saracen and Roman towers, was purchased by American sculptor Henry Clews and his wife, Marie, in 1918. The Clews spent seventeen years restoring the Château, enhancing it with columns, arches, grilles, balconies, terraces, and fountains, much of it hand-carved by Henry, himself, in a style evocative of the Middle Ages. In addition to the architectural beauty of the building is the phantasmagorical collection of Clews' sculpture. Carved in marble, alabaster, and wood, a series of whimsical, sometimes grotesque, often humorous, pot-bellied figures of Clews' imagination adorn the public rooms, cloister, gardens, and ocean-front terraces of the Château. The courtyard is dominated by his large sculpture, *God of Humormystics*, whom the artist identified with his own concept of Don Quixote.

Clews lived and worked here until his death in 1937. During World War II, the Italians and then the Germans occupied the building, which Marie Clews refused to leave. Living for many years in the gatehouse, she survived the war, and, in 1951, established La Fondation d'Art to preserve her husband's artwork and to create a center that encourages intercultural creative expression. Throughout the year, but especially during the summer months, exhibitions of the work produced by an artists-in-residence program are available for viewing.

LE MUSÉE DE LA PHOTOGRAPHIE
THE PHOTOGRAPHY MUSEUM

Porte Sarrazine, 06250 Mougins
Tel: 04–93–75–85–67

Open Wednesday to Monday from 1:00 P.M. to 6:00 P.M.
September through June;
from 2:00 P.M. to 11:00 P.M. July and August.
Closed Tuesday (except July and August), holidays, and November.

IN THE LATER YEARS of his life, Pablo Picasso moved to the outskirts of Mougins, the tiny medieval village located seven kilometers north of Cannes. Here he lived in the protected privacy of his final home, Notre-Dame-de-Vie, just opposite the twelfth-century hermitage of the same name. The houses of the ancient village—perched for protection on a height in the Maritime Alps—are organized (as were most Provençal villages of the time), in a circular fashion and protected by its surrounding defensive ramparts.

Among the small restored houses in the old village is one which, in 1989, was converted into the Musée de la Photographie (Photography Museum). The museum's temporary exhibits and small permanent collection are dispersed throughout its three floors. The top floor serves to memorialize Picasso's many years in the area with a diverse collection of personal photographs of the artist at work and at play. They were taken by some of the world's most famous photographers: Ralph Gatti, Robert Doisneau, David Douglas Duncan, Jacques Henri Lartigue, Sanford Roth, Edward Quinn, Lucien Clergue

and, especially, André Villers, who was to become known as "Picasso's photographer," and who was personally responsible for the creation of the museum. The second floor is home to a collection of antique cameras, as well as photographs of Mougins in the early 1900s. The first floor of the museum serves to showcase a series of monthly exhibits that demonstrate various aspects of photographic art.

LA CHAPELLE TOBIASSE / CHAPELLE SAINT-SAUVEUR
THE TOBIASSE CHAPEL / SAINT-SAUVEUR CHAPEL

Rue Saint-Sauveur, 06110 Le Cannet
Tel: 04–93–46–68–79

Open every day.
Hours subject to change.

LE CANNET, ONCE A modest village just north of Cannes, has burgeoned into a small town essentially indistinguishable from the adjacent glittering seaside city of Cannes. Le Cannet was the source of inspiration for many of Pierre Bonnard's (1867–1947) most luminous and colorful paintings. In 1926 he purchased the villa, "Le Bosquet," on Avenue Victoria, high above the village, and lived there until his death in 1947.

Preserved on a pedestrian street in what remains of the old village of Le Cannet is the tiny oratory, the Chapelle Saint-Sauveur, believed to date from the fourteenth century, and recently renamed Chapelle Tobiasse, in honor of the contemporary artist Théo Tobiasse (1927–) who decorated the chapel in 1989.

The site of this mini-chapel, just off the winding cobblestoned street, the Rue des Ardissons, has a special significance for Tobiasse. The Rue des Ardissons was, in ancient times, the street where Le Cannet's Jewish families lived. This historical fact spoke to the personal story of Tobiasse, a Jew of Lithuanian origin who made France his home of exodus.

With the joy that Tobiasse has made central to all his work, the small chapel has been brought festively back to life with Tobiasse's vibrant decorations in stained glass, sculpture, mosaic, and fresco. Adopting the theme "*La vie est une fête*" (*Life is a celebration*), Tobiasse welcomes visitors to the chapel with his sculpture, "*L'oiseau de lumière*" *(Bird of Light)*, which sits on the miniature square in front of the chapel. The mosaic on the chapel's façade features a bursting sun, while the painted murals mounted on a series of panels in the chapel's interior present universal themes of joy, spirituality, and nostalgia derived largely from the Bible. Tobiasse's whirlwind of warm and radiant colors infuse his human figures, birds, and flowers with a poetry that is uniquely his own. Other work by Tobiasse, who lives in the area, may also be seen in the stained-glass windows of the Synagogue Principale (Main Synagogue) on the Rue Deloye in Nice, and in a canvas in the Château-Musée of Haut-de-Cagnes (see Chapter 10).

LE CHÂTEAU DE VILLENEUVE—LA FONDATION EMILE HUGUES
THE VILLENEUVE CHÂTEAU—THE EMILE HUGUES
FOUNDATION

3 Place du Frêne, 06140 Vence
Tel: 04-93-24-24-23

Open Wednesday to Monday from 11:00 A.M. to 7:00 P.M.
Closed Tuesday and the month of November.

VENCE, FONDLY KNOWN as "the city of arts and artists," has been the residence of some of the twentieth century's greatest artists—including Marc Chagall, Jean Dubuffet, Raoul Dufy, Henri Matisse, Chaim Soutine and, more recently, Jean-Charles Blais and Arman. It has also been a showplace for their art and that of their contemporaries. Unique among the many regional institutions whose exhibitions are limited to temporary shows, is the Château de Villeneuve—La Fondation Emile Hugues. This splendid building, with its warmly colored walls and grand staircase, was once the home of the Lords of Vence, the Barons of Villeneuve. Today, the Château is devoted to exhibitions that focus on rare retrospectives devoted to the "Vence periods" of these artists, as well as to a regular series of exhibits addressing important aspects of contemporary art in France.

The Foundation, named in honor of the town's former mayor, Emile Hugues, sits in the very heart of the old village of Vence, close to the Cathedral with its Chagall mosaic and the Place du Frêne with its lovely ash tree, memorialized in the work of Soutine. While it is impossible to predict which particular exhibition will be on view at any particular time, a visit to this beautifully restored seventeenth-century building is a worthy stop when in this artistically rich town.

LES CHAPELLES DU CALVAIRE
THE CALVARY CHAPELS

Le Quartier de l'Ara,
Le Chemin du Calvaire, 06140 Vence

No hours of admission.
Just walk over and look in.

SECLUDED, ALMOST concealed, on a winding residential street close to the town's main square, La Place du Grand Jardin, in the old hill town of Vence is a series of minuscule oratories. These chapels are believed to date from the early 1700s, when they were built to house a group of sculpted wooden statues, each representing a different scene in the story of the Passion of Christ. In the ensuing years, many of these statues disappeared, some stolen, others destroyed. A number of those that remained were placed for their protection in the main Cathedral of Vence, where they may still be seen. The chapels themselves, though prized, fell into a state of neglect, even while the city tried to find a means of restoring them.

In 1954, an inspired project was conceived. The largest of these chapels was to become the home for Marc Chagall's biblically inspired suite of paintings. For a variety of reasons this project never came to fruition, and Chagall's masterpieces were destined to have their own home in the new museum built in his name in Nice (see Chapter 12).

While the artistic destiny of the chapels has not yet been determined, they have been the inspiration for a series of contemporary pieces designed by internationally known French artists who have participated in a project to restore these unique chapels.

LES MUSÉES DE LA CITADELLE
THE MUSEUMS OF THE CITADEL

La Citadelle, 06230 Villefranche-sur-Mer
Tel: 04–93–76–33–27

Open from 10:00 A.M. to Noon and 2:00 P.M. to 5:00 P.M. October through May;
from 9:00 A.M. to Noon and 3:00 P.M. to 6:00 P.M. June and September;
from 10:00 A.M. to Noon and 3:00 P.M. to 7:00 P.M. July and August.
Closed Sunday morning and Tuesday.

WITHIN WALKING distance of Villefranche's port and Cocteau's Chapelle Saint-Pierre is the Citadel—a sixteenth-century fortified bastion that was renovated in the mid-1960s to serve as a new home to Villefranche's Town Hall and a small group of mini-museums.

Two of these museums, dedicated to the work of contemporary artists, are particularly interesting both for the pieces they contain and for the charm of the ancient setting within which they are displayed.

The first—La Fondation-Musée Volti—is devoted to the work of Villefranche-born sculptor Antoniucci Volti (1915–1989). Volti's sculpture, in a variety of sizes and shapes, represents the figures of women in a variety of poses. The softly-rounded realistic pieces—in bronze, copper, and terra-cotta—are displayed to exceptional advantage in a series of small vaulted chambers, arches, hidden niches, and open patios. In addition to the sculpted works are a series of red chalk drawings and a tapestry, *Women Bathers*.

Le Musée Goetz-Boumeester, the second of the two "mini-museums" is dedicated to the works of American artist and former Villefranche

resident, Henri Goetz (1909–1989) and his wife Christine Boumeester (1904–1971). Goetz was well-known for his engravings as well as his abstract paintings. Hanging on the ancient walls of this museum are fifty of his works, in oil, pastel, and watercolor, together with a similar number in the same media by Boumeester. In addition, there are gifts to the couple by some of the century's great artists: Joan Miró, Francis Picabia, Pablo Picasso, and Hans Hartung.

LE THÉÂTRE DE LA JEUNESSE
THE YOUTH THEATER (COCTEAU)

Located in Le Centre Méditerranéen d'Études Françaises
Chemin des Oliviers, 06320 Cap d'Ail
Tel: 04–93–78–21–59

Not formally open to the public,
but may be seen as part of a visit to the
Mediterranean Center of French Studies.

THE COMMUNE OF Cap d'Ail is home to one of the last works of the artist-poet Jean Cocteau (see Chapters 2, 18, 19, and 20). Situated in an extraordinarily dazzling site—open to the changing colors of the Mediterranean sky, with a plummeting view down toward the sea, and surrounded by pine, cypress, and olive trees—is a Classical Age Greece-inspired outdoor amphitheater, which was decorated by Cocteau.

Secluded on the private grounds of Le Centre Méditerranéen d'Études Françaises (Mediterranean Center of French Studies), an educational center that provides French language courses, this open-air theater is the stage for many of the Center's cultural and educational activities.

The setting offers the perfect context for Cocteau's often-flamboyant style. The entrance to the theater, down a small flower-strewn lane, is guarded by a protective gate, decorated on one side with Cocteau's sketched profiles and emblazoned on the other with his golden signature stars. Etched on large blocks of stone nearby are several persistent Cocteau images—a rose rising from a stem whose leaves are in the shape of two piercing eyes, a flute-playing faun surrounded by the sun and sea, and several profiles similar to others that appear in Cocteau's mosaics and frescoes on display elsewhere on the Riviera. Perched high on the rear wall of the amphitheater, overlooking its arena-like stage and silhouetted against the sky, are huge letters of the Greek alphabet that transliterate the words *Comedia* and *Tragedia*. The floor of the circular stage, decorated with large mosaic profiles in black and white, is reached by descending the terraced stone, step-like seats— traditional to ancient Greek theaters—guided by an enormous green, turquoise, and golden banister in the undulating shape of a serpent.

The simple but dramatically decorated open-air amphitheater— enhanced by the luxurious surrounding foliage—offers a spectacular view of the Mediterranean and is a tribute to Cocteau's extraordinary imagination. The theater is not a public site, but, with permission, it may be seen as part of a visit to the Center.

Bibliography

Alberola, Jean-Michel, et al.
Pour les Chapelles de Vence.
Vence: Château de Villeneuve—
Fondation Emile Hugues, 1994

Albers-Barrier, Sybil.
Espace Libéré.
Mouans-Sartoux: Espace de l'Art
Concret, 1993

Barr, Alfred
Matisse, His Art and His Public.
New York: Museum of Modern Art, 1951

Bauquier, Georges.
Fernand Léger: Vivre dans le vrai.
Paris: A. Maeght, 1988

Bernier, Rosamond.
Matisse, Picasso, Miró as I Knew Them.
New York: Alfred A. Knopf, 1991

Berthier, Jacques.
Fernand Léger et son Musée à Biot
[videocassette].
Northbrook, Ill.: Roland Collection
of Films on Art, 1968

Blume, Mary.
*Côte d'Azur: Inventing the French
Riviera.*
London: Thames and Hudson, 1992

Bonnard, Pierre; and Matisse, Henri.
*Bonnard/Matisse: Letters Between
Friends.*
Translated by Richard Howard.
New York: Harry N. Abrams, Inc., 1991

Cachin, Françoise.
"L'Arrivée de Signac à Saint-Tropez."
In *Signac et Saint Tropez 1892–1913.*
Musée de l'Annonciade.
St. Tropez 20 Juin–6 Octobre 1992.
Saint-Tropez: Le Musée, 1992

Castellan, Georges, et al.
Vence.
Connaissance des Arts
Hors Série no. 57 (1994)

Chagall, Marc.
*Marc Chagall: Juin–Octobre 1959,
Palais du Louvre, Pavillon de Marsan.*
Paris: Musée des Arts Décoratifs, 1959

*Marc Chagall: Les Années
Méditerranéenes 1949–85.*
Paris: Réunion des Musées Nationaux;
Arcueil: Anthèse, 1994

My Life.
1960; rpt. New York: Da Capo, 1994

*Chagall at Maeght: Retrospective
de l'Oeuvre Peinte.*
Paris: Fondation Maeght, 1984

Château-Musée de Vallauris.
*Céramiques Art Nouveau: De Clement
Massier à Jean Barol—Collection
Jean et Paulette Declein.*
Vallauris: Château-Musée, 1994

*Céramiques Précolombiennes: La
Terre et le Feu—Collection Jean et
Paulette Declein.*
Paris: Éditions du Moniteur, 1992

**Chilvers, Ian; and Osborne, Harold,
eds.**
The Oxford Dictionary of Art.
Oxford: Oxford University Press, 1988

Cocteau, Jean.
*La Chapelle Saint-Pierre:
Villefranche-sur-Mer.*
Monaco: Éditions du Rocher, 1957

*Cocteau's World: An Anthology
of Writings.*
New York: Dodd, Mead, 1973

*Jean Cocteau par Jean Cocteau:
Entretiens avec William Fifield.*
Paris: Éditions Stock, 1973

Journals. Edited and translated
by Wallace Fowlie.
New York: Criterion, 1956

Journals of Jean Cocteau.
Edited and translated by Wallace Fowlie.
Bloomington: Indiana University Press,
1964

Past Tense: Diaries.
New York: Harcourt Brace Jovanovich,
1987–1989

*Professional Secrets: An Autobiography
of Jean Cocteau, drawn, from his
lifetime writings, by Robert Phelps.*
Translated from the French by Richard
Howard.
New York: Farrar, Strauss & Giroux, 1970

*Souvenir Portraits: Paris in the Belle
Époque.* Translated by Jesse Browner.
New York: Paragon House, 1990

Compton, Susan.
*Marc Chagall: My Life, My Dreams—
Berlin and Paris, 1922–1940.*
Munich: Prestel, 1994

Cowart, Jack; Flam, Jack; Fourcade,
Dominique; and Neff, John Hallmark.
Henri Matisse Paper Cut-Outs.
Detroit: The St. Louis Art Museum and
the Detroit Institute of Arts, 1977

Cowart, Jack; and Fourcade,
Dominique.
*Henri Matisse: The Early Years in Nice,
1916–1930.*
Washington: National Gallery of Art; New
York: Harry N. Abrams, Inc., 1986

Dors de la Souchère, Romuald.
Picasso in Antibes.
London: Lund Humphries, 1960

Dussaule, Georges.
Renoir à Cagnes et aux Collettes.
Cagnes-sur-Mer: Musée Renoir, 1995

Elderfield, John.
Henri Matisse: A Retrospective.
New York: Museum of Modern Art;
Distributed by Harry N. Abrams, Inc.,
1992

Embolden, William A.
*Jean Cocteau: Dessins, Peintures,
Sculptures*
Paris: Editions Nathan, 1989

Fauchereau, Serge.
Fernand Léger: Un Peintre dans la Cité.
Paris: Albin Michel,1994

*Fernand Léger: Grand Palais,
October 1971–January 1972.*
Paris: Ministère des Affaires Culturelles,
Réunion des Musées Nationaux, [1971]

Flam, Jack, ed.
Matisse: A Retrospective.
New York: H. L. Levin Associates, 1988

Flam, Jack,
*Matisse, the Man and His Art,
1869–1918.*
London: Thames & Hudson, 1986

La Fondation Maeght.
Connaissance des Arts
Hors Série No. 43 (1993)

Fondation Maeght.
*La Fondation Marguerite et Aimé
Maeght.*
Paris: Maeght, 1993

*La Fondation Marguerite et Aimé
Maeght.*
Derrière Le Miroir special issue (1974)

Forest, Dominique.
*Vallauris 1950: Un Grand Atelier
Céramique.*
L'Estampille/L'Objet d'Art 282
(July–August 1994): 52–63

Vallauris de Massier à Picasso.
L'Estampille/L'Objet d'Art
Hors Serie No. 12H (1995)

Forestier, Sylvie.
Pablo Picasso, la Guerre et la Paix.
Paris: Réunion des Musées Nationaux,
1995

Fournet, Claude, et al.
Matisse: Musée de Nice.
Connaissance des Arts
Hors Série No. 54 (1994)

Museums of Nice.
Connaissance des Arts
special issue (1990)

de la Touche, Hugues.
La Riviera de Jean Cocteau
Menton: Édition ROM, 1996

Gilot, Françoise.
Matisse and Picasso: A Friendship in Art.
New York: Doubleday, 1990

Girard, Xavier.
La Chapelle du Rosaire, 1948–1951.
Nice-Cimiez: Musée Matisse; Paris: Réunion des Musées Nationaux, 1992

Girard, Xavier.
Les Chefs-d'Oeuvres du Musée Matisse, Nice-Cimiez.
Dijon: Réunion des Musées Nationaux; Nice-Cimiez: Musée Matisse, 1991

Matisse: Une Splendeur Inouïe.
Paris: Gallimard, 1993

Girard, Xavier; and Arthaus, Christian.
Henri Matisse, Hommage.
Vence: Ville de Vence, 1990

Girard, Xavier; and Perez-Tibi, Dora.
Dufy, le peintre décorateur.
Arcueil: Anthèse, 1993

Giraudy, Danièle.
The Picasso Museum, Antibes.
Paris: Fondation Paribas, 1989

Hanson, Lawrence.
Renoir: The Man, The Painter and His World.
New York: Dodd, Mead, 1968

Haesaerts, Paul.
Renoir, Sculpteur.
[Brussels]: Hermes, [1954]

Herrera, Hayden.
Matisse: A Portrait.
New York: Harcourt Brace Jovanovich, 1993

Hild, Eric.
Musée de l'Annonciade.
Saint-Tropez: Le Musée, 1989

Honegger, Gottfried.
Nous Vivons une Crise Morale.
[Mouans-Sartoux: Espace de l'Art Concret, 1992]

Soeur Jacques-Marie.
Henri Matisse: La Chapelle de Vence.
Nice: Gardette, 1992

Le Jardin de Sculptures.
Menton: Palais Carnolès—Musée des Beaux-Arts, [n.d.]

Knapp, Bettina L.
Jean Cocteau.
Boston: Twayne, 1989

Kosinski, Dorothy, ed.
Fernand Léger 1911–1924: The Rhythm of Modern Life.
Munich: Prestel, 1994

Lajoix, Anne.
L'Âge d'Or de Vallauris.
Paris: Amateur, 1995

Le Page, Jacques.
L'Emploi du Temps: 50 Ans d'Art, 50 Ans de Critique, d'Arman à Zadkine.
Nice: Z'éditions, 1994

Lord, James.
Picasso and Dora.
New York: Farrar Straus Giroux, 1993

Lottman, Herbert R.
The Left Bank: Writers, Artists, and Politics from the Popular Front to the Cold War.
San Francisco: Halo Books, 1991

Maeght, Adrien, et al.
La Fondation Maeght.
Connaissance des Arts
Hors Série no. 43 (1993)

Maisonnier-Lochard, Anne.
*Les Magnelli de Vallauris: Étapes
d'une Abstraction Formelle.*
Paris: Réunion des Musées Nationaux,
1994

Marais, Jean, et al.
*Jean Cocteau 1889/1989: Le Sud
d'un Poète.*
Marseille: Tacussel; Société des Amis
de Jean Cocteau/Méditerranée, 1989

Martin-Chauffier, Jean
Sainte-Roseline des Arcs-sur-Argens.
[Villeneuve: s.n., 1992]

Matisse, Henri.
*Chapelle du Rosaire des Dominicaines
de Vence.*
Vence: [La Chapelle], 1996

Matisse on Art. Edited by Jack Flam.
Berkeley: University of California Press,
1973.

Matisse, Henri; Couturier, M.-A.; and
Raysiguier, L.-B.
*La Chapelle de Vence: Journal d'une
Création.*
Houston,Texas: Menil Foundation/
Éditions d'Art Albert Skira, 1993

Mayer, Ralph.
*The Harper Collins Dictionary of Art
Terms and Techniques.* 2nd ed.
New York: Harper Perennial, 1991

Mejean, Paul.
*Vallauris—Golfe-Juan: 3,000 Ans
d'Histoire et de Céramiques.*
Paris: Edité pour la Municipalité de
Vallauris—Golfe-Juan avec le concours
des Éditions Foucher, 1975

Meyer, Franz.
Marc Chagall.
Paris: Flammarion, 1964

Monery, Jean-Paul.
"1870–1920: Un Midi surprenant,
attirant, influent créatif. Véritable lieu
privilégié de l'avant-garde picturale."
*In Peintres de la Couleur en Provence
1875-1920.*
Marseille: Office Régional de la Culture
Provence-Alpes-Côte d'Azur; Paris:
Réunion des Musées Nationaux, 1995

Mossa, Alexis; and Mossa,
Gustav-Adolf.
*Alexis et Gustav-Adolf Mossa:
Galerie-Musée.*
Nice: Direction des Musées de Nice par
A.C.M.E., 1990

Musée d'Art Moderne et d'Art
Contemporain.
Chroniques Niçoises: Genèse d'un Musée.
Tome 1: 1945–1972.
Nice: Le Musée, 1991

Musée de l'Annonciade, Saint-Tropez.
Paris: Fondation Paribas; Saint-Tropez:
Ville de Saint-Tropez; Paris: Réunion
des Musées Nationaux, 1993

*Musée de la Photographie, Ville de
Mougins.*
Mougins: Edition CERIP, 1991

Musée des Beaux-Arts de Nice.
*Musée des Beaux-Arts—Jules Chéret:
Catalog-Promenade.*
[Nice: Musée des Beaux Arts; Direction
des Musées de Nice; A.C.M.E., 1986]

Musée International d'Art Naïf
Anatole Jakovsky.
*Dépôt du Musée National d'Art Moderne,
Centre Georges Pompidou.*
Nice: Direction des Musées de Nice;
Action Culturelle Municipale, 1991

Rétrospective: Gertrude O'Brady.
Nice: Direction des Musées de Nice;
Action Culturelle Municipale, [1985]

Musée International d'Art Naïf Anatole Jakovsky.
Nice: Action Culturelle Municipale; Direction des Musées de Nice, 1982

Musée National Message Biblique Marc Chagall, Nice: Catalogue des Collections.
Paris: Réunion des Musées Nationaux, 1990.

Notre-Dame de Jérusalem: La Chapelle, Jean Cocteau.
La Tour de Mare: [s.n.], 1989

Osborne, Harold, ed.
The Oxford Companion to Art.
Oxford: Clarendon Press, 1970

The Oxford Companion to Twentieth Century Art.
Oxford: Oxford University Press, 1981

Penrose, Roland.
Picasso: His Life and Work.
Berkeley: University of California Press, 1981

Peters, Arthur King.
Jean Cocteau and His World: An Illustrated Biography.
New York: Vendôme Press, 1986

Prat, Jean-Louis.
L'Univers d'Aimé et Marguerite Maeght.
Saint-Paul: Fondation Maeght, 1992

Raymon, Victor.
"Le Château de Vallauris: Histoire d'un Prieuré Devenu Musée." [n.d.]

Renoir, Jean.
Pierre-Auguste Renoir, Mon Père.
1962; rpt. Paris: Gallimard, 1981

Rubin, William.
Pablo Picasso: A Retrospective. 2nd ed.
New York: Museum of Modern Art: distributed by the Boston Graphic Society, 1980

Rubin, William, ed.

Picasso and Portraiture: Representation and Transformation.
New York: Museum of Modern Art, 1996

Russell, John.
The World of Matisse, 1869–1954.
New York: Time-Life Books, 1969

La Salle des Mariages décorée par Jean Cocteau.
Menton: Hôtel de Ville. [n.d.]

Serota, Nicholas, ed.
Fernand Léger: The Later Years.
Munich: Prestel, 1987

Steegmuller, Francis.
Cocteau.
Boston: Nonpareil Books, 1986

Taylor, Karen.
"Mediterranean Jewels: The Small Museums of the Côte d'Azur."
France Magazine (spring 1990)

Terrasse, Michel.
Bonnard et Le Cannet.
Paris: Éditions Herscher, 1987

Turner, Jane, ed.
The Dictionary of Art.
New York: Grove, 1996

Vallauris: Céramiques de peintres et de sculpteurs.
Vallauris: Musée de Céramique et d'Art Moderne, 1995

Index

Credits

Artists' copyrights

Agencies and estates representing artists
named in the picture captions:

© 1998 Succession Henri Matisse/
 Artists Rights Society (ARS), New York
© 1998 Estate of Pablo Picasso/
 Artists Rights Society (ARS), New York
© 1998 Andy Warhol Foundation for the Visual
 Arts/Artists Rights Society (ARS), New York
© 1998 Artists Rights Society (ARS),
 New York/ADAGP, Paris: Arman, Mac Avoy,
 André Bauchant, Ben (Benjamin Vautier),
 Pierre Bonnard, Georges Braque, Pol Bury,
 Alexander Calder, Charles Camoin,
 Marc Chagall, César, Jean Cocteau, André
 Derain, Charles Despiau, Raoul Dufy,
 Achille–Émile–Othon Friesz, Diego Giacometti,
 Alberto Giacometti, Moïse Kisling, Yves Klein,
 Fernand Léger, Aristide Maillol, Alberto
 Magnelli, Henri Manguin, Albert Marquet,
 Joan Miró, Alfred Ernest Peter, Martial Raysse,
 Germaine Richier, Jean–Paul Riopelle,
 Séraphine de Senlis, Paul Signac, Cornelius
 (Kees) Van Dongen, and Louis Vivin
© 1998 Christo
© 1998 Roy Lichtenstein
© 1998 Tom Wesselman/VAGA, New York, NY